LUTON

PAINTING
PORTRAITS

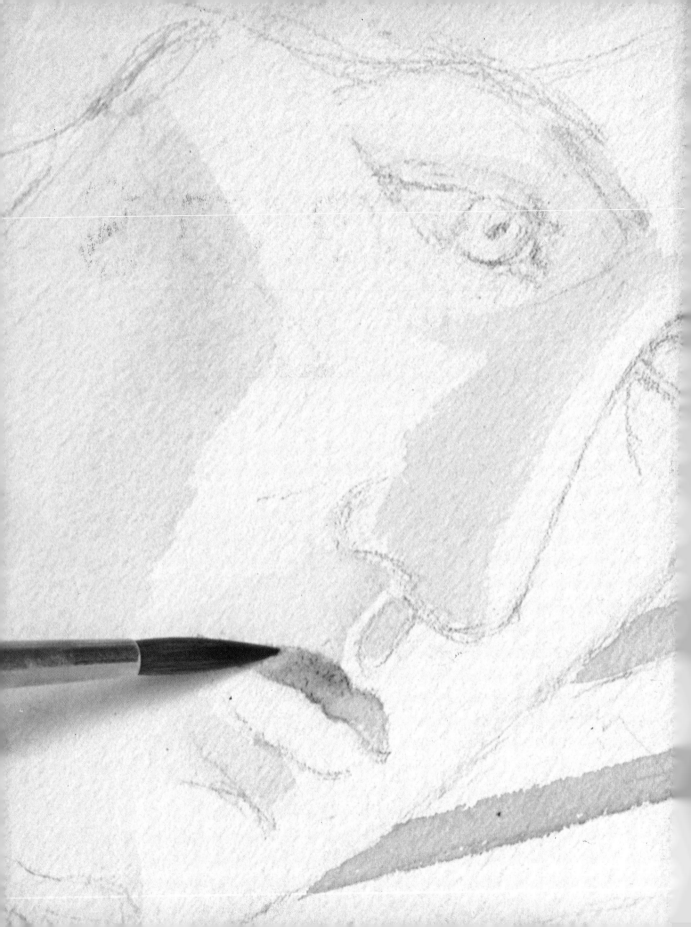

PAINTING
PORTRAITS

*25 portrait painting projects illustrated step-by-step
with advice on materials and techniques*

Jenny Rodwell

Macdonald

A **Macdonald** Book

Copyright © 1986 Quarto Publishing Ltd
First published in Great Britain in 1986
by Macdonald & Co (Publishers) Ltd
London & Sydney
A Member of BPCC plc

British Cataloguing in Publication Data
Rodwell, Jenny
Painting portraits
1. Portrait painting — Technique
I. Title
751.4 ND1302

ISBN 0-356-12378-2

This book was designed and produced by
Quarto Publishing Ltd
The Old Brewery, 6 Blundell Street, London N7
9BH

Senior Editor Sandy Shepherd
Art Editor Marnie Searchwell

Editor Jane Rollason

Designer James Culver
Design Assistant Gill Elsbury

Photographer Ian Howes
Photography coordinated by Rob Norridge

Paste-up Graphikos

Art Director Alastair Campbell
Editorial Director Jim Miles

Typeset by Lynne Shippam, QV Typesetting Ltd
Manufactured in Hong Kong by Regent
Publishing Services Ltd
Printed by Leefung-Asco Printers Ltd, Hong Kong

Macdonald & Co (Publishers) Ltd
Greater London House
Hampstead Rd
London NW1 7QX

CONTENTS

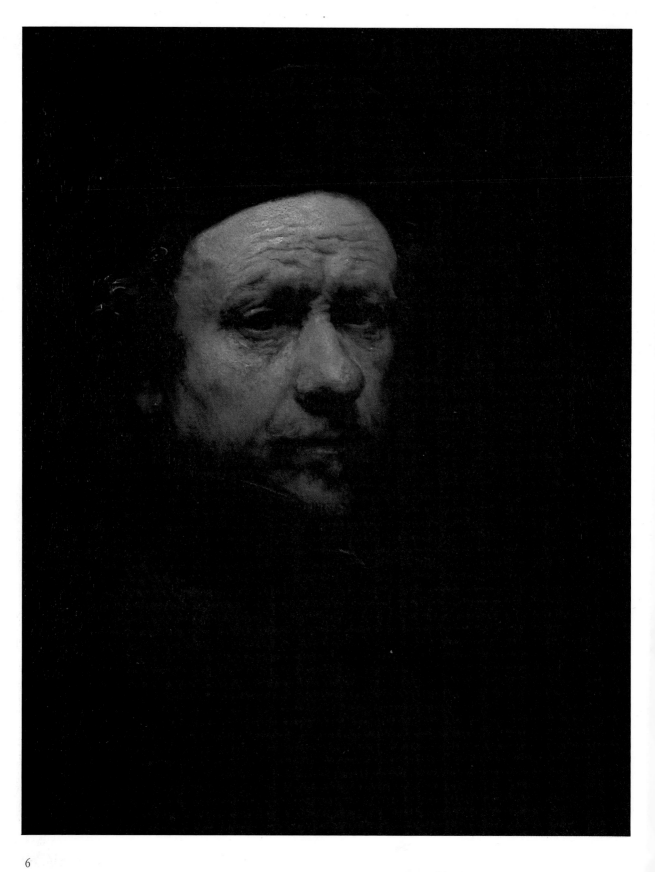

THE PREPARATION

Portraits involve more preparation and planning than almost any other form of art. When all the sittings have been planned, the pose decided to artist's and sitter's mutual satisfaction, the background chosen and the lighting arranged, then — and only then — can you get on with the real job of drawing or painting the portrait.

Professional portrait painters often spend as much time planning the picture as they do making it. Many artists spend weeks researching and talking to a prospective client. This time is ostensibly spent discussing and planning, but for the artist it is also an opportunity to get to know and observe the subject. The time is rarely wasted. By the time the first sitting takes place, the painter often has firm ideas about how the finished portrait will look.

For most of us such extensive groundwork is unnecessary and impractical, but there is a lot of sense in thinking about the basics before your subject arrives. Whether it is a friend, client or model, it is a waste of their time and yours if you have to spend ages looking for chairs, backgrounds and painting materials during the sitting. So be prepared. This will enable you to devote all your energy and attention to the work in hand as well as making it more enjoyable.

Self-Portrait by Rembrandt (1606-1669). The subject is in a darkened room apparently lit from one direction. Closer scrutiny reveals that the light, however realistic, is not 'logical', and the artist has invented highlights to lend emphasis to certain parts of the face.

WHY A PORTRAIT?

If you are asked to do a portrait, either by a friend or as a commission, try to find out what the picture is for. This can often be helpful in deciding what sort of portrait to paint, and can also affect your approach to the work. For instance, if the picture is to be a present, it is useful to know the recipient's taste. If it is a gift for a new home, then it will help to know whether it is to hang alongside antiques or in high-tech surroundings. A family group would probably be done on a large scale, whereas a souvenir portrait or memento for a friend might be better small, even a miniature. Should the pose be formal or informal?

It is always useful to know where the finished portrait will be hung. If you know that, then you know exactly what size to make it and will even be able to visualize how it will look while you are working on it.

Don't be afraid of settling these seemingly mundane matters before starting work. It will prevent disappointment, and in the long run will enable you to be more creative rather than less, because you will be free of worry about whether or not your work is suitable.

YOUR SUBJECT

From the outset, it is important to have a good working

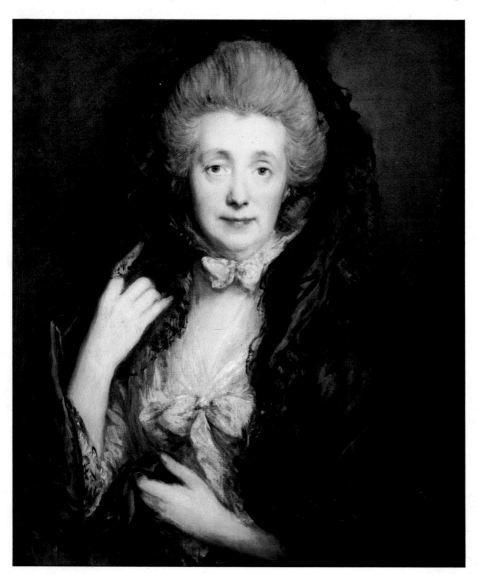

FORMAL PORTRAIT
Portrait of the Artist's Wife by Thomas Gainsborough (1726-1788), *left*, shows how a formal portrait need be neither stiff or unnatural. The painting of the artist's wife has great warmth and vitality, despite its elegance.

INFORMAL PORTRAIT
The Guitar Player by Jan Vermeer (1632-1675), *above right,* is one of the artist's late works and shows a relaxed, everyday scene in a domestic setting. The subject is not looking at the artist; instead her attention is held by something outside the picture area.

GROUP PORTRAIT
In the *Banquet of the Officers of the Saint George Civic Guard Company* by Frans Hals (1581/5-1666), *right*, the artist solves the problem of composing a portrait of a number of people by not giving prominence to any one of them.

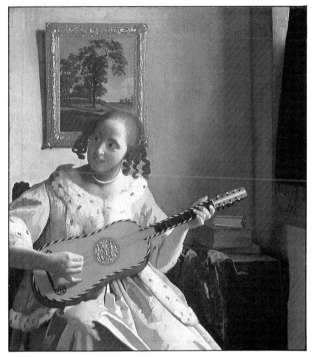

relationship with your sitter. If you happen to be working on a commissioned portrait or have been lucky enough to get a friend to sit for you, try not to encroach on their time any more than is absolutely necessary. You can often save time by making sketches or taking photographs. In this way it is possible to keep the sittings to a minimum, filling in background, clothing and so on from these references.

Often a sitter will feel self-conscious, especially if he or she is not used to being painted. It may take a while for your subject to relax, and your own attitude can go a long way in helping to achieve this. If you are nervous and apprehensive, your feelings will almost certainly be passed on; if you are calm and confident, your subject will be reassured and an easy working atmosphere can be established. The first few minutes of each sitting are always slightly tense, and the pose and expression will inevitably change a little. It is not unusual for a pose to start off rigidly upright, only to collapse as the sitter relaxes. Experienced artists always allow for this settling down period.

Many painters talk as they work, encouraging their

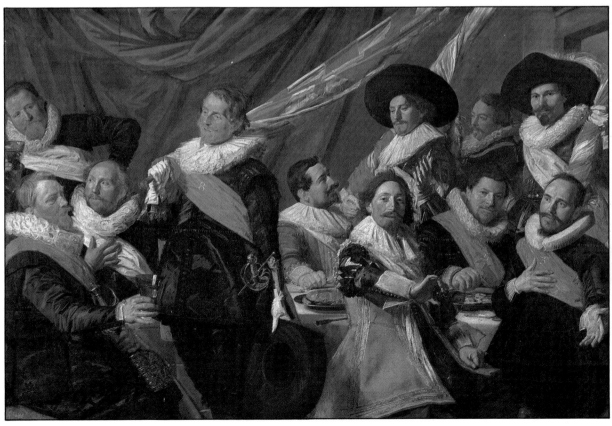

sitters to do the same. This is usually a deliberate tactic, designed to bring a natural or animated expression to the subject's face. If you find that constant chat affects your concentration, yet you feel uncomfortable with absolute silence, try playing music on a tape or listening to the radio as you work.

Keep the sittings as short as possible and allow plenty of rests during a session. If the pose is particularly tiring, a break every 15 or 20 minutes is a good idea; more comfortable positions can often be held for 45 minutes or an hour. Make sure you mark the subject's position carefully before allowing him or her to move. Use tape or chalk to mark the precise position of the body, hands and even feet, so that the exact pose can be resumed easily after a break. If the chair or couch your sitter is on has to be moved between sessions, mark this also.

FOR PROFIT AND PLEASURE

A professional attitude is essential if you intend to take portrait painting seriously. Even though at the moment you might feel that clients and commissions are problems for the future, it is never too soon to think about the possibilities of extending your interest to reach a wider audience. Most portrait painters begin by painting friends and relatives, building up a reputation slowly as their work becomes known to a wider circle of people. It is important to be reliable and to keep promises, even to members of your own family, completing the work within a given time. Learning your limitations in this way will help you to cope with the more difficult task of working for people that you don't know very well.

If you are working for a fee, settle the details before you start work — however difficult or awkward you find this. It will be far less embarrassing than negotiating a price with the finished portrait in front of you, by which time it can be painfully apparent that you and your subject have widely differing ideas about your artistic worth!

Most successful portrait artists are happier when working to a specific brief, regarding the subject's wishes as a challenge rather than a restriction. Such artists are usually good at their job because they can be creative within certain pre-set limitations. Other painters find working to another person's taste totally intolerable, and would not accept a commission at any price. This attitude is perfectly understandable, and many eminent artists

enjoy portraiture, doing it only to satisfy themselves.

Whether your approach is commercial or otherwise, portrait painting is unlike other painting in that it almost always involves a third party — the subject. Sometimes it is possible to become so immersed in what you are doing that you escape the personality of the sitter, regarding your subject merely as an absorbing arrangement of light, shade, colour and tone. But if you do this, sooner or later your human still life will be standing beside you, perhaps saying, 'It just isn't me!' As the artist, you have to decide whether this matters to you or not.

THE SETTING

Attitudes to backgrounds vary enormously. Some artists prefer to keep the area behind the sitter as simple as possible, an expanse of neutral tone which does not detract from the sitter in any way. Others choose an appropriate scene or a sketchily painted backcloth which provides a suitable setting but does not dominate the main picture. Some portrait painters consider the background almost as important as the subject itself, revelling in a busy composition filled with minutiae and detail.

The most important thing is to plan the setting carefully as an integral part of the painting, and not to put it in as an afterthought when the rest of the painting is almost finished. Your background should be something you choose, and even if you intend to paint the sitter against a plain wall, the colour and tone of the wall should be used to complement the subject. Dark skin, hair and clothing are generally more effective against a light tone, whereas fair subjects are more suited to a darker background — but you might well decide to reverse this convention. The choice is up to you, but it should really be made in the very early planning stages of the portrait.

A collection of drapes and backcloths is invaluable. If you have these to hand, you can quickly try out the various colours, patterns and textures, seeing instantly what the possibilities are. A sombre dark background might be best for a formal arrangement, a series of colourful patterns for an informal one. The more alternatives you provide yourself with, the more creative your composition can be.

Space is essential in most portraits. If your subject is painted in three-dimensional terms, with light and shade to suggest the form, then an illusion of space is already created on the canvas. This is why the background is hardly

ever painted as a flat colour in realistically painted portraits. A plain wall will usually be graded from light to dark — an indication that normal light never falls evenly — or the subject's shadow will be put in to suggest the space between the figure and the background.

If you plan a complicated background, perhaps an interior or a landscape, the problem of creating space becomes less difficult. Familiar objects, such as trees, buildings and furniture, naturally create spatial relationships and a three-dimensional environment.

Many people like their portraits to reflect something of themselves in the background. Traditional double portraits, set in appropriate surroundings — usually the sitters' house or garden — are known as conversation pieces. Such paintings hold a special fascination, recording not only the people but also their lifestyle and home environment. Here the background should be chosen carefully, so as to give clues about the subject's personality. A favourite armchair or shelf of books, or even a kitchen, can provide an interesting backdrop for a portrait.

THE RIGHT POSE

The word 'pose' is perhaps slightly misleading in this context. It suggests a forced, rather artificial position, whereas the aim of the portrait artist is usually to get a sitter to look as natural as possible. However, it is the word generally used in all portrait and figure work to describe the way in which a subject is presented to the artist.

If your subject is sitting — or perhaps standing — in a position which does not come naturally, you start at a disadvantage, as his, or her, awkwardness will be reflected in your picture. It is worth trying several alternative positions, asking your subject which positions feel right and which don't. A natural position will be more comfortable and easier to keep for longer periods of time. In the majority of portraits, the subject is looking directly at the artist. Sometimes the figure is slightly turned to offset the symmetry, but quite often a composition will consist simply of the full-frontal view of a head and shoulders. This sort of approach works well for some artists, usually those whose chief concern is with the character of the subject, and who prefer to focus their attention on the subtle colour and texture of the skin, hair and facial features.

Alternatively, a portrait can be painted in profile

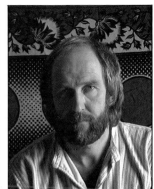

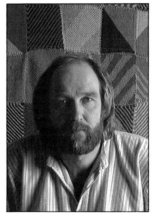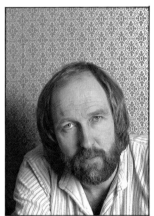

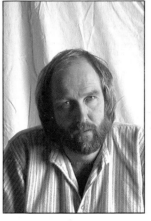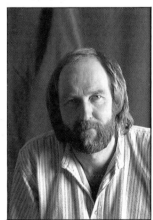

Backgrounds are important in determining the mood of a portrait. In the six pictures, *above*, we see how the colour and pattern behind the subject dictate not only the overall effect but also how we perceive the subject; for example, the brown background emphasizes the warm brown tones of the hair and beard.

CHOOSING A POSE
The angle of the head can be
crucial to the success of a
painting. Traditionally, the
portrait poses are, *left to right*,
full-face, three-quarters, and
profile.

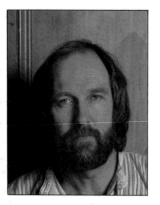
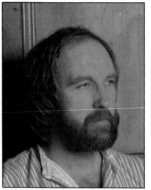
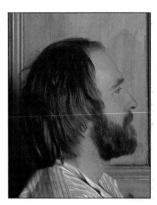

presenting a perfect side view of the subject. This can be particularly effective if the face possesses prominent, well defined or otherwise distinctive features. A more natural aspect of the face is that which is usually referred to as a three-quarters view. This is halfway between a profile and a full-frontal portrait, and often creates a softer impression of the subject than either of these extremes.

Another important consideration is how much of the subject to include and whether or not you want the hands in the picture. Hands play an important part in the composition of portraits. They echo the tones of the face, often preventing this from standing out as a stark oval, unrelated to the colour and tone of the rest of the painting. And they can also be an important part of the composition, guiding the viewer's eyes according to how and where they are placed. Don't shy away from hands just because they might prove difficult. It is surprising how many artists paint hands effectively by dealing with them in the most sketchy and general terms.

Many portraits include a large part of the figure, sometimes the whole top half of the body, and sometimes — usually when the subject is sitting — the legs as well. The main difficulty here is that because the face takes up such a relatively small space compared with everything else it becomes lost, and you end up with a figure painting instead of a portrait.

WARTS AND ALL!

Society portrait painters often flatter their subjects to a scandalous degree, turning out paintings in which every sitter fits into the fashion type of the moment — whatever his or her actual size, shape or colouring might be. Such flagrant disregard for the evidence of the eyes is doubtless

a lucrative pursuit, but the result is usually sterile, painted ·to a formula, and deserving of the label it is often given — chocolate-box art.

It is not difficult to paint away unwanted flesh, put a youthful twinkle in the eye, or soften the contours of the face, but it is difficult to produce a worthwhile portrait in this way. A good likeness is the indirect result of honest observation and can best be achieved by concentrating on the basic structure and main forms within the subject rather than attending to superficial detail.

LIGHTING

Most artists prefer working by natural light if this is at all possible. A northern light is the best, providing a clear, constant light source which does not cast heavy, changing shadows across the sitter's face. Light from other directions is subject to shadows and reflections, a southerly light being the most difficult of all to work by. All natural light is short-lived and inconsistent, increasing and diminishing throughout the day. For this reason many artists prefer to paint entirely by artificial lighting, secure in the knowledge that they can work when and where they please and still remain in control of the environment.

Modern fluorescent 'daylight' bulbs are an excellent substitute for the real thing. They can be used in place of natural lighting, or can be arranged across a window and used to replace the daylight as it fades and changes. Artificial lighting can be supplemented with fill-in lights to counteract the directional beam from the main source.

An alternative method is to use a main light source and reflector screens, sheets of white which produce a soft, reflected glow on the subject's face. By placing a screen opposite the main light source, you can illuminate one side

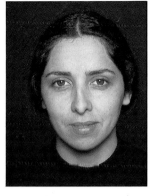 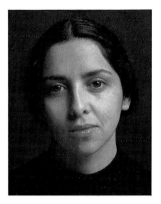

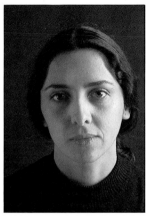 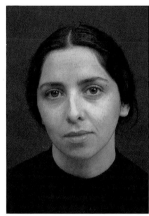

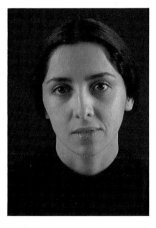 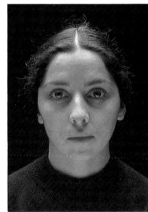

of the face quite dramatically and use the screen gently to light the other side, thus avoiding harsh contrasting areas of light and shade.

Since the Renaissance, Western art has nearly always used light and shade to describe the contours and form of the subject. The portraits of Leonardo da Vinci (1452-1519) are illuminated by a broad light from above. He realized that the closer the lighting resembled natural sunlight, the more realistic and convincing the painting would be. Light from above is the light by which most of us recognize people we know, and indeed, as Leonardo pointed out, if you meet a close friend 'lit from below you would find it difficult to recognize him'.

Other artists have deliberately chosen unnatural or dramatic lighting for the special atmosphere it can create. Joseph Wright of Derby (1734-97) specialized in lighting effects. His dramatic scenes, often illuminated by moonlight or candlelight, are reminiscent of many seventeenth-century Dutch painters, who in turn took their lead from the Italian artist, Caravaggio (1573-1610).

Caravaggio used an emphatic balance of light and shade to create movement and volume in his painting. The technique is known as chiaroscuro (in French *clair-obscur*) and the portraits and figures created in this way often seem to have been literally sculpted out of a dark, shadowy background and to catch the light as they come to the surface.

Different lighting techniques tend to become associated with the portrait painters who employ them. Often the lighting in a painting can look completely natural, but on close observation we realize it can only be either the result of an intricate lighting system or the product of a fertile imagination. Rembrandt (1606-69), who has probably had more influence in the field of portrait painting than any other artist, used light in just such a way. He introduced highlights to emphasize a particular contour or area of the face, regardless of logic or of the probability of such effects occurring in real life.

Bending the rules of nature is fine and there is nothing wrong with taking a little artistic licence in the interests of creating a more interesting painting, but it can be overdone. Too much fragmented light and over-zealous highlighting will soon destroy what it was intended to achieve. Instead of describing the contours and volumes it can eventually flatten them.

LIGHTING
In everyday life we see the human face in a complexity of simultaneous light sources. For the beginner, it is a good idea to limit the light sources, and later to experiment by changing or strengthening them. The effects here, *above*, were achieved with a combination of direct, artificial lights.

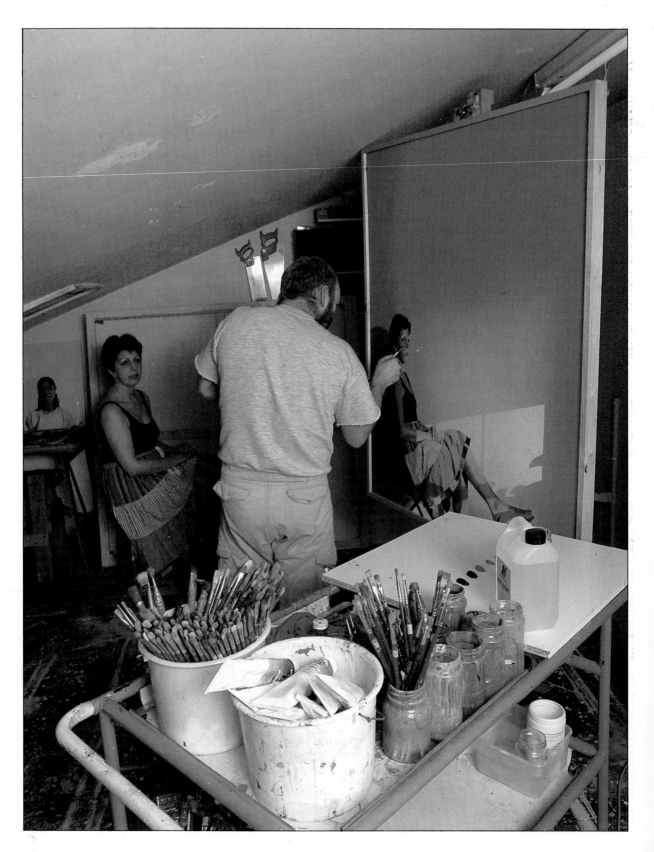

INTRODUCTION
TO
MATERIALS

Portrait painting can be divided into two distinct categories — those done in the studio and those painted on location. Working in the studio gives you the advantage of familiarity, of knowing where everything is, and of being in control of the environment. Painting away from base is often unavoidable, and although it can also be stimulating and exciting, it usually gives you less control over the situation — the lighting, background and general working atmosphere. In such cases you will need to plan carefully and take some special items of equipment.

This chapter looks at some basic materials and tools, paying particular attention to the special requirements of working away from the studio. Where possible, I suggest inexpensive alternatives to professional equipment.

The professional portrait painter's studio, *left*, is well-ordered and convenient — a workshop where equipment and materials are to hand, and where both artist and sitter can feel at ease. North-facing overhead windows eliminate harsh shadows and keep the problem of changing light to a minimum.

IN THE STUDIO

The professional portrait artist's studio is usually a highly organized workshop, arranged in such a way as to provide a convenient and relaxed environment with as few distractions and irritations as possible. It is a place where a model or sitter can feel at home, and where the artist can work in comfort with all the materials to hand, thus avoiding disruptive and time-consuming rummaging and searching during painting sessions.

Whether you are lucky enough to have a studio or room set aside specially for painting, or whether your working space is a more temporary affair — perhaps a makeshift space in the living area of your home — an orderly approach is essential. Time is precious, and when the subject is there in front of you, the more time spent in direct observation and painting the better. Many artists, once they know the basic skin colour of the subject, actually have a range of general flesh tones mixed on the palette before the session starts, adjusting these slightly to fit the specific requirements.

Labelled filing cabinets, chests of drawers and office storage systems can be used to keep paints, brushes and other materials in an orderly way which does not impinge on the working environment. A trolley for holding those materials currently in use can organize your working area and can be pushed aside when not needed.

THE MODEL STAND

Most portraits are painted with the subject seated, for obvious reasons. The majority of portrait painters work standing, to enable them to stand back from their work and make an occasional overall assessment of it. Unless the artist wants to see his or her subject from this high vantage point, with a good view of the top of the head, the subject must be raised approximately to the painter's eye level. The professional way of doing this is to use a model stand, a platform which is large enough and strong enough to take the weight of the model and a chair or sofa.

A suitable stand can be made from wood or by cutting down the legs of an unwanted, sturdy old table. Or you can improvise by using planks of wood across blocks or bricks, providing these are stable enough to carry the weight. For quick sketches and paintings, a high stool will often suffice, although this offers no support for the subject's back and will be too uncomfortable for long sittings.

FRENCH OR BOX EASEL

WATERCOLOUR OR SKETCHING EAS[EL]

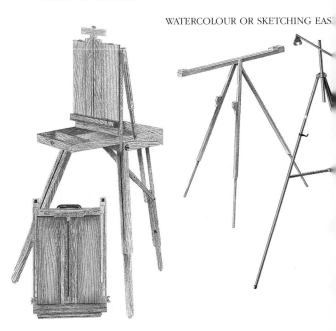

DRAPES AND SCREENS

A selection of background drapes is invaluable. Keep a collection of old sheets and curtains, plain and patterned, so that you have a choice of background for every portrait you paint. There is no need to be restricted by the colour of the wall or the accidental surroundings of your studio just because they happen to be there.

The colour of the sitter's skin and hair will often suggest the tone and colour of background required, and what the subject is wearing will usually dictate whether this should be plain or patterned. You may decide on a totally plain composition, perhaps predominantly white or black, or you might choose a cacophony of colour and conflicting patterns. Either way, you will be limited by the materials available, so the more choice you have, the more exciting and interesting your composition will be.

Background drapes can be pinned to the wall, although a more portable device provides greater scope. Folding screens — the type used in hospitals — are ideal because they can be adjusted to the required shape. Metal clothes

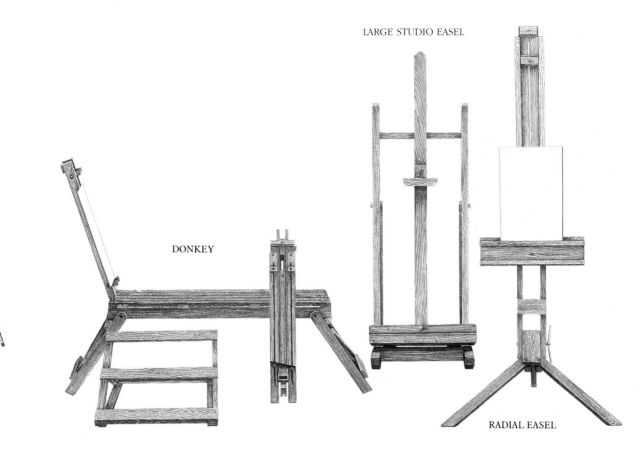

LARGE STUDIO EASEL

DONKEY

RADIAL EASEL

racks, used in shops and second-hand clothing stalls, are a good alternative. Keep a stock of paper clips, bulldog clips and safety pins to secure the drapes in place.

EASELS

A large studio easel provides the best support for large canvases and boards. Its size and bulk, however, makes it awkward for the 'occasional' painting space and limits its use to the permanent studio.

A good alternative to the studio easel is the more manageable radial easel. Again, this offers quite adequate support for most canvases and drawing boards, and has the added advantage of being foldable. This makes it easy to store, although it is still usually considered too heavy and cumbersome for extensive painting trips, painting outdoors and for location work.

If you prefer to work sitting down, the artist's 'donkey' provides both a seat and a support for your work. This type of easel does not allow free movement for the artist, however, and has the disadvantage of making it difficult to

move back and see the work from a distance. It is also fairly low and − for the portrait painter − generally offers a restricted view of the subject.

The table easel is a useful, compact piece of equipment for smaller paintings and drawings, if you have a suitable desk or table to work on.

For watercolour painters, an adjustable watercolour easel is essential. Various models are available, made in metal or wood. These can be adjusted to a horizontal position to allow areas of wet paint and wash to be applied without the colour running down the paper.

AWAY FROM THE STUDIO

Many people prefer their portrait to be painted in their own home. In some cases this is because they want the background in the painting to reflect their personality, and thus wish to be surrounded by their own furniture and familiar objects. Other people find an artist's studio intimidating, while for some − especially elderly people − going out may be difficult or impossible.

Working in new places can be challenging, forcing you to take a fresh look at new backgrounds in unfamiliar lighting conditions. It can also counteract complacency, 'blowing away the cobwebs' and getting rid of a certain staleness which inevitably occurs if you paint the same situation time and time again. The success of your painting trip will depend largely on how you plan it, and on having the right equipment to cope with it. Make a list of everything you are likely to need from the large items of equipment down to old rags and tissues — and take it all. There is nothing more detrimental to confidence or concentration than the insecurity which comes from the feeling of having forgotten something.

CARRYING PAINTING GEAR

Portable painting sets are excellent. If the bought ones are too small for all your materials, a wooden box with a handle can be adapted to your personal needs. If you are using oils, acrylic or watercolour, plastic jars with screw lids are ideal for carrying water, or any other medium.

Paintbrushes travel badly, especially soft watercolour brushes. If possible, keep the plastic protector caps which come with most new brushes and use these to prevent the bristles from getting damaged. Lightweight metal and plastic tubular brush cases are available from artists' suppliers, and these should be carried upright to preserve the shape of the bristles.

Wet canvases can present a problem unless you make provision for carrying them. Almost-dry pictures can sometimes be covered in newspaper, but this often flattens the texture and deadens the surface. A better idea is to equip yourself with a special clamp or with a set of four canvas separators, also available from artists' suppliers. Both these carrying devices work by holding two surfaces apart, and require two canvases or boards of the same size.

PORTABLE EASELS

Lightweight, portable sketching easels are adequate for small and medium-sized canvases or boards. These come in metal or wood and are specially designed for the peripatetic painter. If you plan a larger painting, then a folding studio easel — a cross between a sketching easel and the bulky radial easel — could be the answer.

French, or box, easels have a useful compartment for paints, brushes and rags. This type of easel collapses into a handy carrying case and often incorporates its own palette.

Whichever easel you choose, buy the best you can afford. It will last a lifetime and is a good investment. Many artists can boast of easels which belonged to their grandparents and great-grandparents and which will very likely be used by generations to come.

MATERIALS

It is all too easy to be intimidated by the vast choice of materials and equipment now available. Most artist's suppliers, though fascinating and wondrous places to browse in, seem frightening and inhospitable when it comes to selecting and paying for the materials you want — or think you want!

The first rule is to start with the minimum. There may well be an enormous range to choose from, but that doesn't mean you have to buy every single item. This book introduces most of the materials you will need and gives advice on how to control costs, buying only what is necessary, and adding to these basics as your experience and confidence increases.

DRAWING MATERIALS

Most portrait painters make drawings and sketches before committing the image to the canvas. This not only helps with the technical problems of the picture, with the

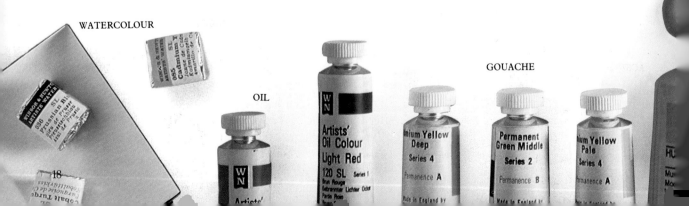

WATERCOLOUR

OIL

GOUACHE

Artists'
Oil Colour
Light Red
120 SL Series 1

mium Yellow
Deep
Series 4

Permanent
Green Middle
Series 2

ium Yellow
Pale
Series 4

18

composition, tone, structure and so on, but also gives the artist a precious opportunity to become familiar with the character and facial expressions of the subject. Almost any medium can be used, depending on the artist and the method of working.

If a painting is particularly complicated, several preliminary sketches may be necessary. A group portrait can be assembled from a series of individual sketches, by means of changing and experimenting with the order of the components until the right composition emerges. Choose the materials according to your requirement. Pastels and coloured pencils are useful for making sketches; chalk and charcoal, for establishing the light and shade; pencil or pen and ink, for form, line and detail.

Drawing is invaluable for preliminary and exploratory work, but it can also be an end in itself. Finished portraits are not necessarily painted ones – some of the finest portraits ever done are drawings. Leonardo da Vinci drew portraits in ink, chalk and silverpoint. Contemporary artists have used coloured pencils, felt-tipped pens and children's wax crayons with great success.

There is no restriction on your choice of drawing materials, and it is important for you to feel free to experiment, discovering your own favourites and combining different media to get the effect you want. Portraits can be done in any medium, including pencil, pen, pastel and a wide variety of lesser-known drawing materials. Most drawing equipment is relatively inexpensive and offers you ample opportunity to develop your skills without feeling inhibited by cost.

PAINTS

Traditional painting media are oils, watercolour and gouache. Acrylic is a relatively new paint, but is becoming increasingly popular for portrait painting.

Oil is the most common painting medium. It is slow drying and can be moved and manipulated on the support for several hours before it dries. Its potential is enormous, and it can be used in an almost infinite number of ways. Artists whose styles and attitudes are intrinsically different in every other respect often have this medium in common. The paint can be used thickly, either with a knife or brush, or it can be diluted and applied in layers of thin glazes. Portrait painters have exploited both methods for a variety of subjects, but the technique of glazing, building up layer upon layer of transparent colour, is particularly effective when painting skin tones.

Acrylic paints are extremely quick drying and very durable. The medium has not yet been fully explored, and suffers from unfair comparison with other paints. The colour, once laid, cannot easily be moved or changed, and demands a different approach from that needed with either oil or watercolour.

Watercolour can be applied loosely, with free washes and expressive brushstrokes, or it can be used quite tightly for highly finished portraits. Practice and patience are needed to get the best results, but these are richly rewarded by the characteristic transparency and delicacy of watercolour effects.

Gouache is an opaque form of watercolour. It is a lively spontaneous medium, equally suited to both quick colour sketches and more exacting work. Many portrait painters have taken advantage of the immediacy of the medium to capture the fleeting expressions and short-lived poses of their subjects.

The projects in the later chapters of this book include paintings done in each of these media. Their differences and the many effects possible with each of the paints can be seen in the finished pictures, with demonstrations of the techniques used to achieve them.

RAPIDOGRAPH

ACRYLIC

OIL PASTELS

WATERCOLOUR PENCILS

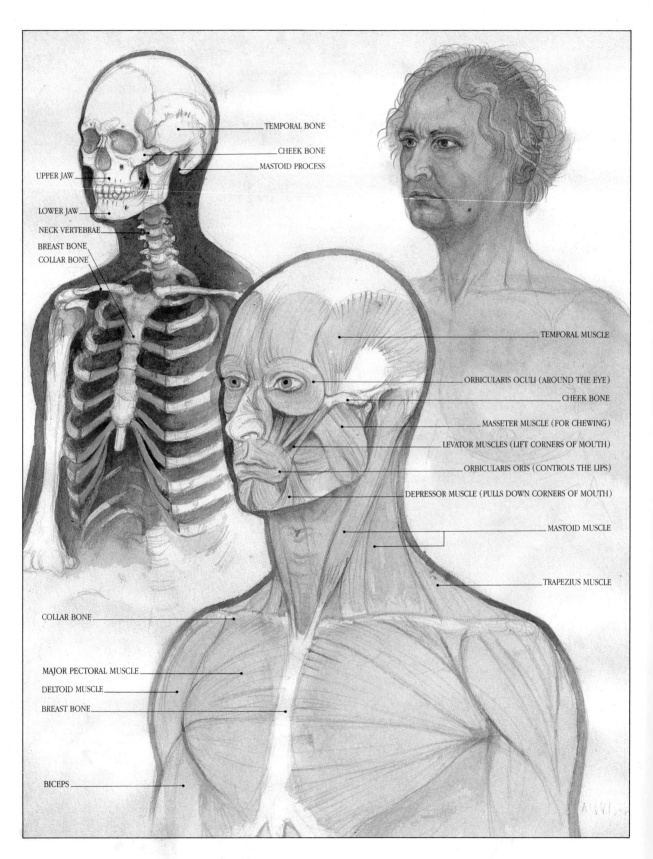

TEMPORAL BONE

CHEEK BONE

MASTOID PROCESS

UPPER JAW

LOWER JAW

NECK VERTEBRAE

BREAST BONE
COLLAR BONE

TEMPORAL MUSCLE

ORBICULARIS OCULI (AROUND THE EYE)

CHEEK BONE

MASSETER MUSCLE (FOR CHEWING)

LEVATOR MUSCLES (LIFT CORNERS OF MOUTH)

ORBICULARIS ORIS (CONTROLS THE LIPS)

DEPRESSOR MUSCLE (PULLS DOWN CORNERS OF MOUTH)

MASTOID MUSCLE

TRAPEZIUS MUSCLE

COLLAR BONE

MAJOR PECTORAL MUSCLE

DELTOID MUSCLE

BREAST BONE

BICEPS

CHAPTER THREE

ANATOMY
FOR THE
PORTRAIT ARTIST

Portraiture is infinitely easier if you have some idea of what lies beneath the face of the subject. Obviously it is not necessary to remember the name of every bone and muscle, but a working knowledge of how they function and their effect on the external form and shape of the subject can be a great help.

The sketchbooks of Leonardo da Vinci demonstrate a depth of understanding and knowledge of the human body which was unique in his own lifetime and which few artists possess today, despite the advanced technical and medical material now available. Leonardo's faces reflect his lifelong interest in anatomy, and the deep sympathy and humanity of his portrait drawings and paintings are more a product of an accurate understanding of the underlying structure than of insight into his subjects' characters.

Facial expressions are not 'stuck' on to the surface of the face. A smile or grimace cannot be portrayed by merely making the corners of the mouth turn up or down. These expressions are muscular movements which affect not only the mouth, but the whole of the face, so to paint a convincing smile, you must also paint a smiling jaw, nose, eyes and forehead! And to do this, you must understand the muscles that lie beneath the surface of the skin.

Every portrait painter should have a basic knowledge of anatomy — of the bones and muscles that lie under the skin. The drawings on the opposite page show the bones of the head, neck and shoulders, *top left*; the muscles and ligaments, *bottom*; and the head complete with skin and hair, *top right*.

THE SKULL

A human skull is made up of two parts – the cranium, which encloses the brain, and the jaws. Surprisingly, there are 22 bones in the skull, eight of which form the cranium. It is not important for the artist to know exactly what, or even where, all these bones are, but it is useful to know something about them.

The shape of the cranium dictates the shape of the head. It varies considerably in different individuals, but is roughly oval whether viewed from the top or from the side. Its shape also varies between individuals.

It is helpful to think of the cranium as having a roof, or vault, which covers the top of the head, and a base, which is completely covered by the face and neck. The roof is thicker than the sides, being made up of two layers of bone with a spongy bone layer sandwiched between them. More vulnerable is the thin, translucent bone which makes up the sides of the cranium. Although this structure is often totally hidden under a thick head of hair, it is important to remember that the shape of the hair is partly dictated by the shape of the cranium underneath.

In young babies the cranium is much larger in relation to the face than in older children or adults. The distance from the top of the eye sockets to the lower edge of the jaw accounts for half of a baby's head length, but in adults it takes up about two-thirds. Within the first year of the child's life the bones of the cranium grow and fuse together and the jaw becomes more prominent as the face and features mature.

THE JAWBONES

The bones of the face and cranium are firmly joined to one another, with the exception of the lower jawbone, or mandible. In newborn babies the mandible consists of two halves. These meet at the chin and join together in early infancy to form one bone. This is hinged to the cranium just in front of the ear. The upper jaw, which is fixed, consists throughout life of two separate bones – the *maxillae*. Each *maxilla* forms half the roof of the mouth, much of the side of the nose, and the hard bony base of the eye socket. Thus, to a large extent the *maxillae* dictate the shape of the upper part of the face.

Newborn babies have small, undeveloped lower jaws in relation to the rest of the face. When the teeth begin to grow, the jaw expands to accommodate these, becoming

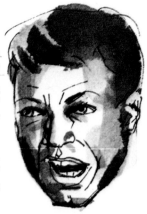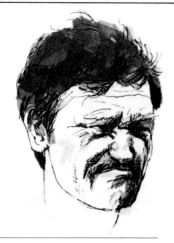

FACIAL EXPRESSIONS
Our feelings and reactions are reflected in our faces. Anger, *above*, distorts the facial muscles; the scowling man uses the forehead muscles to furrow his brow, and his nose and cheek muscles to wrinkle his nose.

more prominent and so lengthening the shape of the whole face. Adult bones, once formed, do not change significantly in shape, although their position may change in relation to each other. This is because adjoining cartilage dries in old age, causing a shrunken look. In the skull, the loss of teeth causes the jaw to recede.

THE MUSCLES

Facial expressions are made by the muscles moving under the skin of the face, scalp and neck. It is difficult to move any one of these muscles without affecting its neighbours – as we find if we try to raise an eyebrow or wink at someone without distorting the rest of our face. Although most of us know someone who boasts of being able to wiggle his ears, wobble his scalp or twitch his nose, these feats require much practice and are beyond the capabilities of most people. To the majority of us, the expression 'pulling a face' means exactly what it says, pulling and stretching the muscles so that they contort the face to make a particular facial expression.

We use muscles to close and open our eyes and mouth, to speak and eat, even to sniff. The muscles, therefore, are directly related to the orifices – the mouth, eyes and nose.

The muscles around the mouth are particularly important to the portrait painter. They are responsible for the movement of the lips and are the reason why the mouth stands considerably proud of the lower half of the face – a

A baby's skin is supple and
unlined, whatever its facial
expression *right*. The
octogenarian man, *far right*, has
a wrinkled, furrowed face. There
is little fat under the skin so the
bones and muscles are easy to
distinguish. The diagrams
below, left to right, show the
human skull in babyhood,
young adulthood and old age.

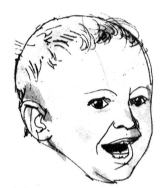

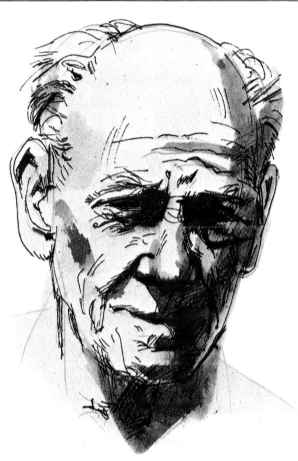

fact often overlooked by inexperienced artists, many of whom paint the lips directly on to a mistakenly flattened face. This 'mound' beneath the mouth, the *orbicularis oris,* is made up of several muscles which enter the lips from below and above. Another muscle, the buccinator, passes horizontally from the side of the mouth and into the cheek.

Surrounding the cavity of each eye, and allowing the eye to close tightly or gently, is the *orbicularis oculi* muscle. The eyes can also be moved indirectly by the large, flat muscles which run from the top of the scalp through the forehead. You can demonstrate this by tightly creasing your forehead, noticing how it inevitably widens the eyes, and by moving the nose.

The neck and shoulders are of great importance to the portrait artist. How the head is attached to the neck, and how the head is affected by the neck movement, is crucial to the pose and how you perceive it. An upward or sideways tilt of the chin must always be accompanied by a corresponding tension in the neck, however slight. The ability to notice and interpret these subtle movements is a quality which you, as a portrait painter, should aim to develop. Such observation can create the difference between a living likeness and a wooden-looking portrait which captures nothing of the vitality, character or the pose of your sitter.

The most important muscle in the neck passes from behind the ears to the inside of the clavicle. This muscle,

the sternocleidomastoid muscle, is situated on both sides of the neck and enables the head and neck to bend forward and the head to turn from side to side. The neck should never be overlooked. It is far from being an uninteresting piece of flesh which joins the head to the body. Many people have well-developed neck muscles, which can be elegant, sinewy, solid or scraggy. If you overlook these particular characteristics, you will lose an important key to the final likeness.

Your knowledge of anatomy will be of use only if you can put it into practice. Obviously if you know where the *orbicularis oculi* is, but not what it looks like, then merely knowing the name isn't going to help you draw or paint it. One excellent way of learning practical anatomy is to observe yourself in a mirror. Pull faces, move your head from side to side, and try out various poses and expressions. Notice which muscles you use and how they look, making sketches if necessary to help you to remember. You will be surprised how quickly you become familiar with the structure underneath the skin.

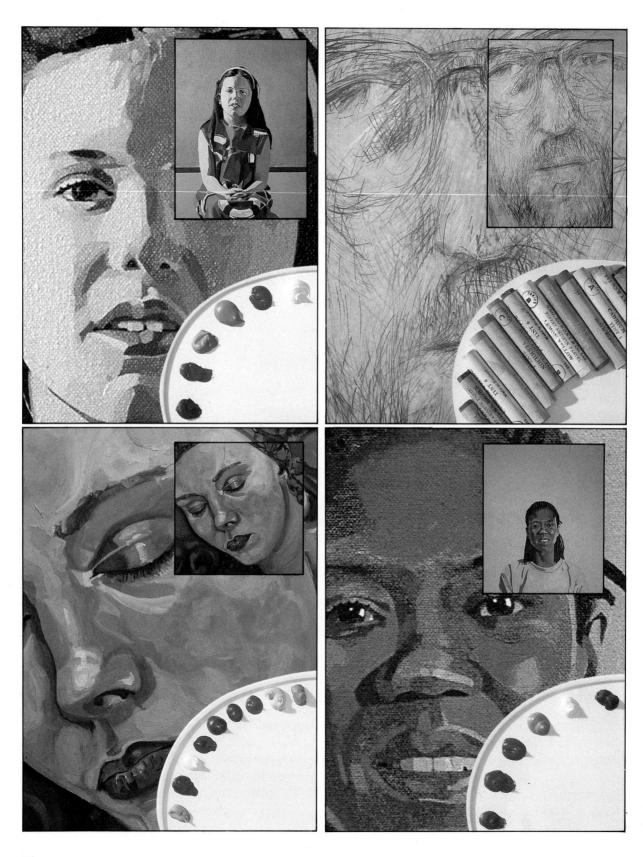

MIXING COLOUR

Whether you are using oil, acrylic, watercolour, pastel or coloured pencils for your portraits, it is helpful to have a basic understanding of colour theory and to know a little about how to mix the different pigments. In the case of paints and sometimes pastels, each colour has a name, making it easier to learn and remember the various colour combinations. Pencils are usually identified by a number only, so it is a question of finding and identifying equivalent colours.

Almost all painting and drawing media come in a wide range of colours, and you will always be able to find the exact one you want. The problem is more likely to be one of deciding which colours to leave out. For the novice, who has not yet developed a personal colour range, it is an enormous temptation to try to use every possible colour simply because they look so beautiful when they are laid out side by side in the shop or as they appear on the colour chart. The result is almost always disappointing. It is far better to start with a few colours, increasing these as you become familiar with the media and as your technique improves to accommodate a more complex palette. The fewer colours you use, the more you are forced to mix them, and the greater the chance of pictorial harmony as each colour is repeated throughout the composition.

There is no 'correct' way of painting flesh tones. In the four portraits *opposite* we see some of the ways in which different artists tackle the subject, and the colours they used.

When you choose your materials, remember that no colours can be mixed to make the primaries – red, yellow and blue – and that it is quite possible to work with these three colours alone, with the addition of white. Use the primary colours as your starting point, adding gradually to these as the need arises. Every artist develops a personal preference for certain colours, and you will find it helpful to note which colours the artists used in the step-by-step portraits in the later chapters of this book. Only by mixing and using colours is it really possible to become acquainted with the properties of the different pigments. There are no rules, and only experience will determine which are right for you.

PRIMARIES, SECONDARIES AND TERTIARIES

The primary colours are red, blue and yellow. Cadmium red, cadmium yellow and ultramarine blue are the pigments that come closest to the pure primaries, and these are to be found on most artists' palettes. Secondary colours are mixed from two primaries: blue and red make violet, yellow and blue make green, and yellow and red make orange. It should not be essential to have these colours because you can mix them yourself from red, yellow and blue. However, the theory of colour is based on the colours of the spectrum, which are pure, but artists' colours behave differently, as you will see if you try to mix violet from cadmium red and ultramarine blue. The result will be a dead, muddy, purplish brown. For this reason, painters usually prefer to buy the proprietary equivalent of the secondary colours, choosing bright oranges, violets and greens to suit their purpose.

Tertiary colours are those created from mixing a primary and a secondary colour together. For example, blue and green combine to make a bluish green, red and orange to make a reddish orange and so on.

COMPLEMENTARY COLOURS

Primary, secondary and tertiary colours are often arranged in a wheel – the so-called colour wheel. Those pairs of colours which fall opposite each other in the wheel are known as 'complementary'. Thus, orange and blue, red and green, and blue and yellow are all complementary to each other. It is useful to remember these because they have a practical application. One of the best ways to subdue or reduce the brightness of a colour without causing it to go grey is to mix it with a little of its complementary. Alternatively, any colour can be made to look brighter and more vibrant on the canvas by placing it next to its complementary colour.

TONAL VALUE

Every colour has a tonal value. If you can imagine how a colour would look in a black and white photograph, you are close to understanding its tonal value. Yellow, for instance, photographs as a light grey and therefore has a high tonal value; dark red or blue reproduces as dark grey, and has a low or dark tonal value. The tonal, or achromatic, scale ranges from black to white, and every colour has a grey equivalent somewhere between those two extremes. It is important to understand how tone works because it affects the way you use colour, and even the most brightly coloured composition can look flat and monotonous if it lacks tonal contrast.

Many artists make a 'tonal' drawing of their subject before starting work, to establish the light and dark areas. This can be done in pencil, charcoal, or white paint used with black or one other colour. Good lighting can also dictate the tonal interest in a portrait because it creates contrasting planes of light and shade across the subject's face and elsewhere in the composition. A background that is lighter or darker than the subject's hair or clothing can often help to vary the tonal pattern of a portrait composition and it is worth experimenting with different combinations.

HUE AND INTENSITY

The actual colour of a pigment is known as the 'hue'. When we talk of yellow, green or red, for example, what we are

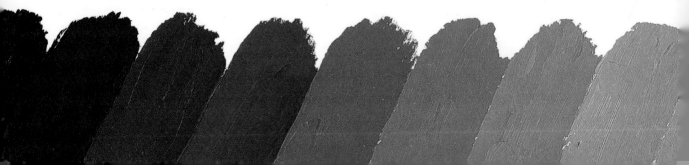

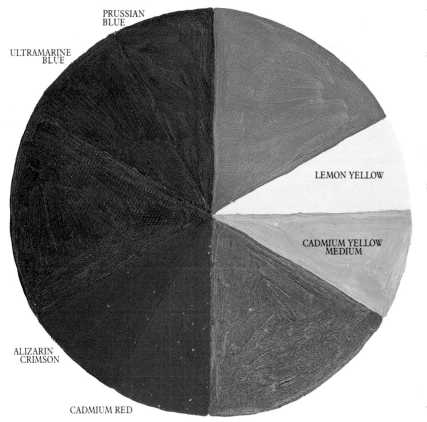

PRUSSIAN BLUE

ULTRAMARINE BLUE

LEMON YELLOW

CADMIUM YELLOW MEDIUM

ALIZARIN CRIMSON

CADMIUM RED

COLOUR WHEEL

In theory, the primary colours — red, yellow and blue — can be mixed to produce orange, green and violet (the secondary colours). Practically, the primary colours do not necessarily produce the brightest secondary colours when it comes to mixing paint. For example, the pigment equivalents of primary red and blue are cadmium red and ultramarine. But if you try to mix these to make violet, the result will be muddy brown. Our 'painter's' colour wheel, *left*, suggests more effective ways of obtaining green, violet and orange, and you will soon discover your own version.

actually referring to is the hue. When we describe the brightness of a particular colour, we refer to the 'intensity' (occasionally called 'chroma') of that colour. Again, it is the practical application which is important, not the terminology, and you will know whether or not your colour is bright enough by how it looks in the painting.

SOME BASIC COLOURS

The following list is not comprehensive, but provides a guide to some of the basic colours used by many portrait painters. The colours apply to oils and watercolours. Acrylics sometimes have the same name, but in some cases they are different. The acrylic name, or the equivalent acrylic colour, is given in brackets where relevant.

Cadmium red. Cadmium red medium is close to primary red. Cadmium light and dark are versions of the same colour. They are opaque and mix well with yellow to make orange, making them almost essential for bright, warm flesh tones. The cadmium reds cannot be mixed with blue to make violet and purple; they will merely produce a dull brown colour.

Alizarin (phthalocyanine crimson). A cool, bluish red often used with ultramarine blue to mix cool, purplish flesh shadows. Also mixes with white to make basic pink.

Rose (naphthol crimson). A vivid pinkish red is a useful addition to the portrait painter's palette. Different manufacturers produce different versions under different names (Rowney Rose is one example in the oil-paint

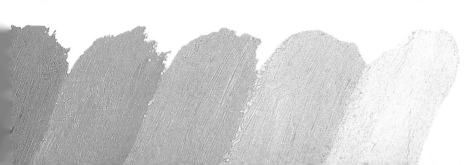

The tonal scale, *left*, runs from black to white, and every colour has a tonal equivalent somewhere on that scale.

Some of the most popular colours are shown here *right*. The list is not comprehensive, but offers an extensive range from which you can select your initial palette. Names apply to oil or watercolour. Where the acrylic name differs, the name of the equivalent acrylic colour is given in brackets.

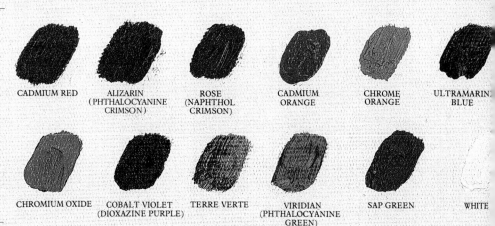

CADMIUM RED ALIZARIN (PHTHALOCYANINE CRIMSON) ROSE (NAPHTHOL CRIMSON) CADMIUM ORANGE CHROME ORANGE ULTRAMARINE BLUE

CHROMIUM OXIDE COBALT VIOLET (DIOXAZINE PURPLE) TERRE VERTE VIRIDIAN (PHTHALOCYANINE GREEN) SAP GREEN WHITE

range). Rose, geranium, madder and magenta are all good strong pink reds, although the precise names vary according to whether you are working in oil, acrylic or watercolour.

Cadmium orange. A bright orange, pre-mixed with cadmium reds and yellow.

Chrome orange. Vivid orange with strong tinting power. Cheaper than cadmium orange, but should be regarded as an alternative in certain cases only because it is considered incompatible with the cadmium colours.

Ultramarine blue. Regarded as the 'primary' blue, ultramarine is used by nearly all artists. It can be mixed with crimson and pink reds to make purples and violets, and is often used in the cooler skin tones.

Monestial blue (phthalocyanine blue). Cold, bright blue with very strong tinting power. Monestial blue must be used sparingly if it is not to dominate other colours. Makes purple when mixed with crimson and pink reds, and bright greens when mixed with yellow.

Cobalt blue. Particularly popular with portrait painters for the cool shadows it produces, cobalt blue is subtle without being particularly opaque or stongly tinted.

Cerulean blue. A gentle, sky blue used for its opacity and distinctive colour.

Cadmium yellow. This standard, primary yellow is used for making strong greens and oranges when mixed with blue and red respectively. It is strong and opaque and comes in three tones – light, medium and dark.

Lemon yellow. A light, cool yellow with slightly weaker tinting power than the cadmiums. Transparent and clear, it can be used to mix vivid oranges and greens.

Yellow ochre (yellow oxide). Used by the majority of portrait painters, this dull, dark yellow is fairly opaque and almost essential for making white flesh tones, when it is often mixed with burnt sienna, white and a little blue.

Hooker's green. A subtle green which mixes well with earth pigments. It is traditionally a landscape colour, but is also used by many portrait painters.

Chromium oxide. This dull grey-green is opaque and occasionally used for the underpainting of flesh tones.

Cobalt violet (dioxazine purple). A strong, pre-mixed violet useful in cool white, flesh tones.

Terre verte. A dull green traditionally used for underpainting flesh tones.

Viridian (phthalocyanine green). A vivid, darkish green sometimes used in cool skin tones.

Sap green. A rich green usually used by landscape artists but occasionally found on the portrait painter's palette.

Indian red. A deep brick red, sometimes used in flesh tones when a more dominant red is not required.

Raw umber. Often used instead of black to tone down other colours, raw umber is found on the majority of artists' palettes. Its yellow-brown pigment has relatively poor tinting power.

Burnt umber. This warm brown is used mainly for mixing with other colours to produce a range of rich tones. It is reasonably opaque.

Raw sienna. A fairly opaque, sandy colour, raw sienna is a mixture of ochre, orange and brown. When mixed with greens, blues and purples, it produces a range of rich earth tones suitable for many subjects.

Burnt sienna. A warm, transparent colour which is often

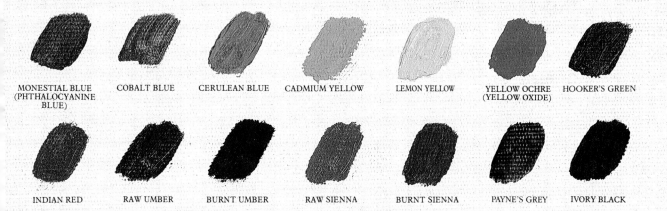

MONESTIAL BLUE (PHTHALOCYANINE BLUE) COBALT BLUE CERULEAN BLUE CADMIUM YELLOW LEMON YELLOW YELLOW OCHRE (YELLOW OXIDE) HOOKER'S GREEN

INDIAN RED RAW UMBER BURNT UMBER RAW SIENNA BURNT SIENNA PAYNE'S GREY IVORY BLACK

used for glazing flesh tones. It is rich and coppery, usually used when a bright red is not wanted.

Payne's grey. A cold dark grey, this is often used instead of black. Payne's grey is especially useful for modifying other colours.

Titanium white. An opaque white with good covering power. Only a small amount of titanium white is necessary to lighten a colour, in this way preserving the transparency of the colour.

Ivory black. A popular, dense black which should be used sparingly for mixing. Many artists use no black at all, preferring to darken colours with an alternative dark pigment, such as raw umber.

PAINTING FLESH TONES

In the above list we have mentioned those pigments popularly used by many artists, but the choice is ultimately a personal one, depending on experience and your approach to the subject. For white-skinned subjects you will obviously need white, a red and a yellow, plus a green or blue to produce the cool shadow areas. But, as you will see from the paintings in this book, the options are extremely wide because skin colour varies from person to person.

A good basic range of colours for a portrait painter to start with would possibly be white, black, chromium oxide, cerulean blue, ultramarine blue, alizarin crimson, light red, cadmium red, raw umber, burnt sienna, raw sienna, cadmium yellow and yellow ochre. Many painters work with far fewer colours, and you may eventually find some of these are superfluous. But do not be hesitant to experiment and introduce new variations to your palette.

Professional portrait painters are usually highly organized when mixing flesh tones. The local colour of a subject's face usually varies very little, though the tonal differences created by lighting can be enormous, ranging not only from light to dark, but also from warm to cool. Shadows tend to be cool; illuminated areas are generally warmer. Artists often prefer to mix an approximate range of these visible tones at the outset, adding to these where necessary, instead of trying to mix each new tone separately as the need arises. The planes of the face are rounded, subtle and undefined, each area of tone merging into the next in an almost indiscernible way. To mix every tone as you come to it is an impossible task.

Some modern portrait painters have exaggerated the subtle tones found in the skin without forfeiting either the likeness or the character of the subject. Such interpretation can often enhance the image, underlining and emphasizing those characteristics which the artist wishes to draw attention to. Van Gogh's self-portraits are far from being straightforward colour copies of his own face. Henri Matisse (1869-1934), in his *Portrait of André Derain*, chose the Fauvist approach of expressive brushstrokes and intense colours, juxtaposing brilliant viridian shadows against cadmium orange and red flesh tones.

As you will see from the way the artists in this book work, there is no single 'correct' approach to painting or drawing flesh. Every artist approaches the subject in a different way, according to how they perceive the sitter, and it would be a pity if you restricted yourself without first trying the alternatives.

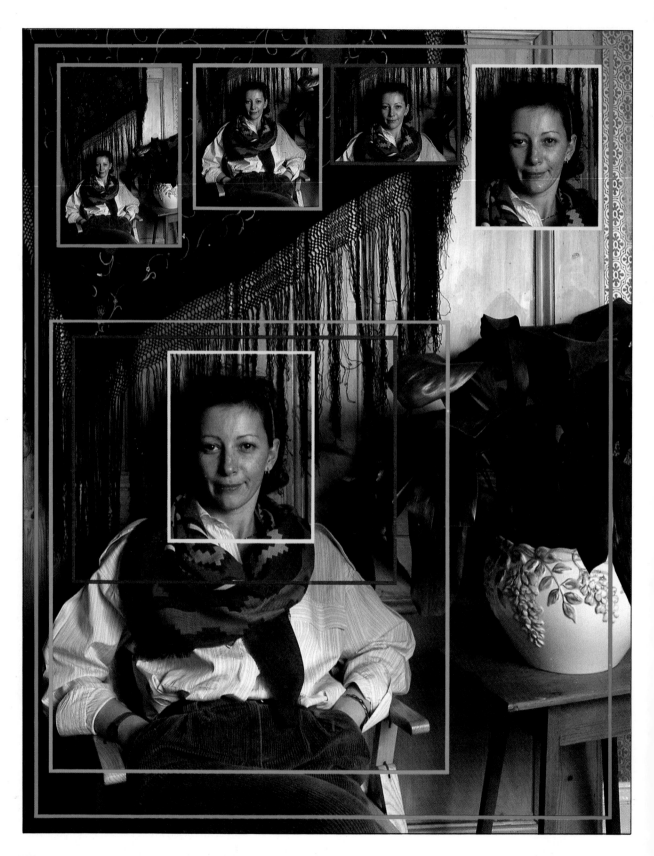

30

CHAPTER FIVE

THE
PORTRAIT

Composition is an important element in any painting; even a seemingly straightforward head-and-shoulders portrait needs to be 'composed' to some extent if it is to succeed, while the scale of the picture is another vital consideration. Sketches and photographs are useful in helping to organize the portrait in advance, so that you do not waste valuable time by changing your mind halfway through.

Keep your initial materials and equipment as simple as possible. Whether you are working in paint or doing a drawing, take a good look at the subject, decide what you will probably need and make sure it is to hand. Obviously the clothing and background will dictate to some extent which colours you will need, and if you have to compromise on these, it will spoil the overall result.

You may want to start immediately, working directly on the support without making initial sketches or taking photographs. In this case, you must know in your own mind what sort of composition you want and be fairly confident about your general approach. Some aspects of the portrait can only be resolved once you have begun. Tones and colours cannot generally be planned in advance — they will relate to each other in the picture and will be determined as the image develops by what is already established on the canvas or paper.

Composition is all-important when planning your portrait. Even when your subject is a comparatively uncomplicated one, such as the seated figure *opposite*, you must decide whether to use your canvas vertically and how much of the figure to include in the composition.

THE COMPOSITION

Composition in portraiture is often sadly neglected. This is because it is not immediately obvious why a portrait — which is, after all, often no more than a head and shoulders placed in a rectangular shape — should need 'composing' at all. And this is a pity because it is precisely the simplicity of the subject which makes it so important to give as much thought as possible to its presentation.

Even if you intend your portrait to be a full-frontal view of a head and shoulders, placed against the plainest possible background, you should still consider the composition. For instance, if there is too much empty space around the subject, this can look monotonous; if you leave too little background area, your portrait might well seem cramped. Do you want a symmetrical picture, with the figure placed centrally? Or would you prefer to place the subject to one side for a more unusual effect? All these possibilities should be considered at the outset. There is always a choice, and it rarely pays to make the obvious one without first considering the alternatives.

If you were painting a landscape or a still life, you would probably try to create a harmonious arrangement within the picture, avoiding anything which looked discordant, out of place or disruptive. It is generally unwise to lead the eye out of the picture, and a successful composition is usually one which retains the viewer's attention instead of diverting it.

Creating harmony within the picture is less of a problem with a portrait than with other subjects because the human face is a natural focal point. Even so, it is possible to spoil this by clumsy handling. A figure placed too close to the edge of a picture and looking outwards past the frame can destroy compositional harmony. A clumsily placed hand or arm can also be a discordant element.

Double and group portraits are usually arranged so that all the subjects are equally important in the composition. This can be an elaborate arrangement against a complex backdrop, as in *Mr and Mrs Robert Andrews,* the famous conversation piece by Thomas Gainsborough (1727-88). Or the composition might be simple, a grouping of heads against a plain background, such as *The Artist's Servants* by William Hogarth (1697-1764).

There is a fine distinction between a portrait with a background of trees and hills and a landscape that happens to contain a face or figure. The difference is one of emphasis. This is sometimes merely a question of scale — in a portrait, the figure can dominate because of its size and the proportion of picture surface which it fills. Or the definition may be more to do with how the different components are treated. If the face is painted in sharp detail and the background scenery sketchily depicted, then you have a 'portrait', however small the subject might be.

SKETCHES

The role of preliminary sketches is twofold. Their main purpose is to work out certain aspects of the portrait before starting the final work. Sketches can also be a valuable reference to be used in the absence of the actual subject. Some artists work entirely from drawings and sketches, needing only one short session with their subject to equip themselves with enough information to enable them to complete the work.

To a certain extent, finding a successful composition is a matter of trial and error. It may be necessary to try several possibilities before arriving at the right one. Small drawings, sometimes called thumbnail sketches, are a useful device. Make a number of these, trying out various arrangements and different ways of composing your subject. Each drawing may only take a few seconds and will help you to work out a satisfactory composition for the final portrait. It is possible that you will want to take elements from different drawings, preferring the position of the hands in one, the type of chair in another, the angle of the head in a third, and so on.

Sketches can also help you to decide what scale your subject should be. A larger drawing may also be useful here. Make a rough sketch of the subject, allowing plenty of space all round. Take a piece of card and cut a hole of the same proportion as your support and use this as a viewfinder. By moving the window around on the drawing you will be able to see the best position for your subject. Try windows of various sizes and shapes to help you decide how much background to include and what shaped support would be best for the purpose.

Many artists make elaborate sketches. Some even produce so-called 'sketches' in colour which are almost indistinguishable from the finished painting, differing only in the amount of detail and blended finish which is included in the final picture. Such sketches are done relatively quickly, sometimes when the subject is too busy

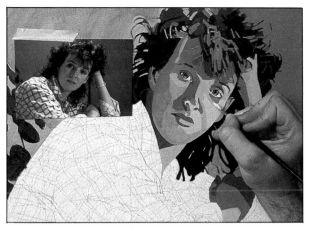

Most portrait artists work from a reference at some stage during a painting. Many make preparatory black and white drawings, *far left*, or quick colour sketches *left*. Others rely on photographic reference *above*.

to give a series of lengthy sittings. Often a painter can produce a highly finished portrait from such reference.

PHOTOGRAPHS

Photography should never be used as a substitute for observation and creative thinking, but its value to portrait painters can be enormous. In the past, a rather purist attitude has prevented many artists from using photographs in a constructive and helpful way. Nowadays most artists realize the value of a camera, particularly a polaroid one, in the field of portraiture.

A polaroid camera can be used instead of the sketchbook when deciding on a suitable pose or looking for the best lighting effects. The camera is also better able to capture fleeting expressions than the time-consuming process of drawing and painting. This is one of the reasons why many old portraits tend to look stiff and expressionless – the sitter could not maintain a lively look

throughout long, exhausting sittings. Today's artists can capture the gesture of a split second in a photograph, then take as long as necessary to translate this on the canvas.

With good reference photographs to help, the portrait painter can work for long periods without needing the sitter to be there at all. Certainly the clothing, background and much of the rest of the picture can often be done directly from photographs, making life easier for both the artist and the sitter.

But despite its great advantages for the artist, photography has definite limitations and should always be used as a tool rather than as an end in itself, your real concern being with creating a living image of the subject. One of the disadvantages of photography is its tendency to distort. It is now so much part of our lives that we usually believe what we see in photographs, without realizing that our eyes are actually much more sensitive and accurate than the camera lens. The photographed face can be subtly

distorted, perhaps with an enlarged nose or with a too-wide or too-narrow face. The experienced portrait painter, trained to observe, sees and corrects these discrepancies. Always believe your own eyes, and check to see whether your camera is actually telling the truth.

Your camera has another shortcoming. It is not selective. Depending on the lens, the camera will normally give you a photograph with the details on any one plane uniformly recorded. The task of deciding what to emphasize and what to leave out is yours.

GETTING A LIKENESS

The ability to 'get a good likeness' is often thought of as something beyond the mere technical skill of the artist, a sort of heaven-sent gift which exists independently of artistic talent and which has more to do with some mysterious insight into the character of the subject than with being able to draw or paint a face.

Portrait painters are usually the first to refute this. Although a good likeness is not entirely a question of correct proportions, technical ability and experience have much to do with it. Obviously it is helpful to be able to pinpoint special characteristics and to know the idiosyncratic gestures peculiar to your subject, but the actual 'likeness' is something which emerges naturally, an indirect result of your ability to paint what you see.

SKIN

A common error when mixing flesh tones is to assume we know what colour skin is. When painting white people, school children are taught to mix white and red with a little yellow to make it look 'real'; black people are usually coloured a standard brown, often with exaggerated highlights; oriental faces are quite frequently portrayed as flat yellow shapes. As children we also 'know' that the sky is blue, clouds are white, and that grass is green.

Such preconceptions are difficult to overcome. For the artist it means close observation and hard work. If we look carefully at the work of most landscape artists, we see that the grass is painted in a whole range of tones and colours, and the sky often contains little or no blue. In many of the landscapes of the English painter John Constable (1776-1837), yellows, browns, blacks, blues and reds are dominant colours in the 'green' grass and trees.

In the same way, the portrait artist must learn to look at the subject through fresh eyes. Local colour is important, but it should not be taken for granted. Shadows and highlights must be carefully analysed and should never be simply a darkened or lightened version of the general colour. Every shadow and highlight has its own colour and tone, and each will be affected by the reflections of any surrounding colours.

Flesh tones are a subtle mix of light and dark, and warm and cool. All portrait painters use green or blue, sometimes both, for the elusive cool shadow tones present in all skin types. In the illustrated demonstrations in the later chapters of this book you will see how different artists approach the problem.

In his *Portrait of André Derain,* Matisse takes a refreshingly new look at the variety of colours in his subject's face, breaking down the planes of light and shade into well-defined areas of coolness and warmth. The shadows are emphatic, depicted in strong purples and greens; the rich warm planes on the illuminated side of the face are depicted in bright reds, oranges and pinks. The loose, textural brushwork in no way detracts from the 'likeness'. Instead, Matisse has used the rugged finish to emphasize the character and mood of the pose in an individual and perceptive way.

Painters of the Renaissance often gave areas of flesh a coat of terre verte undercoat which was allowed to show through the skin tones, lending a cool glow to the shadow areas. This technique is still employed by some artists, and is particularly effective when acrylic is used as an underpainting. The acrylic dries quickly, enabling layers of thin, transparent colour to be built up over the cool base colour. The method is further described in Chapter 7.

Although the solid bone structure of the head and face is covered with a disguising layer of flesh and skin, this should not be your major preoccupation in the initial stages, nor should it prevent you from seeing the more important underlying structure. It is a common mistake to overwork the skin in an effort to reproduce its smooth texture and subtly blended planes. When this happens, the face quickly becomes flat and dead. Avoid this by constantly standing back from your work to appraise it and by treating the skin tones in broad, general terms, using a large brush if you are doing a painting. Superficial characteristics, such as patches of local colour, wrinkles and cushions of soft flesh can be helpful when describing

PAINTING FLESH

There is no easy formula for painting flesh tones. Every artist develops a personal technique, and no two artists approach the subject in exactly the same way. Duccio (active 1278-1319) and many other early Renaissance artists, underpainted all flesh areas in green earth mixed with lead white. In *The Virgin and Child* (detail,) *right,* you can see how Duccio allowed the greenish undercoat to show through to represent the cool shadows. *Madame Moitessier Seated* (detail), *below left,* by Ingres (1780-1867) shows a subtle, highly finished painting, with the muted cools and warms blended to form realistically smooth flesh. Paul Cézanne (1829-1906) used broken colour and strong directional brushstrokes to depict areas of shade, highlight and local colour in his *Self-portrait* (detail) *below right.*

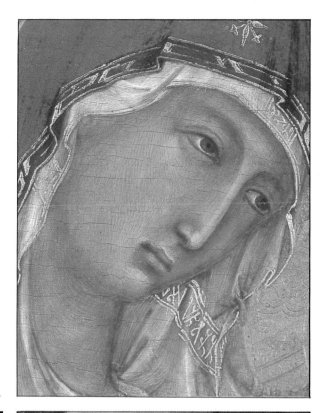

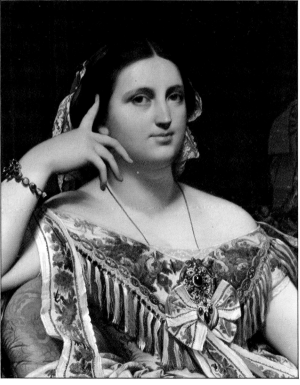

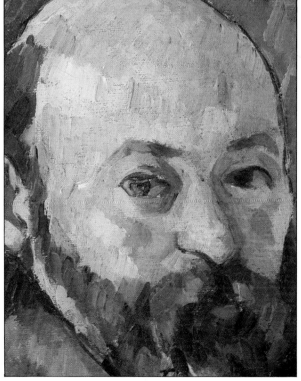

form and volume, but they can also be a hindrance if you become obsessively concerned with these to the detriment of the rest of the portrait.

HANDS

Hands are important. If you are going to include them in the portrait, their position and treatment should be carefully considered. Hands can make an image seem alive, giving a feeling of movement to the pose, or they can create an informal atmosphere if they are held in a natural and relaxed way. They are, however, a focal point in the picture, and if they are badly done, there is little chance of their being overlooked.

Unless your portrait is a formal one, perhaps with the subject's hands resting on a table or desk, try to avoid putting both hands on the same level. Hands and face stand out because they are the same tone and colour, and it is all too easy to create an uncomfortable pyramid effect with the head as the top of the triangle and the hands as the base. Instead, try to use the similar tones of these features to advantage, arranging the hands to complement the face and to create a harmonious balance in the composition.

Many portrait artists have developed the technique of positioning the hands to a fine degree. The portraits of Gwen John (1876-1939), almost without exception, sit with their hands together on their laps — the perfect relationship between the hands and face creates an atmosphere of peace.

It is almost always a bad idea to allow part of the hands or fingers to go off the bottom of the picture. The eye is immediately directed to this cut-off point and the bottom edge of the picture becomes unduly important, holding the viewer's attention when it should be concentrating on the face and the rest of the painting. For the same reason, bare arms should not be taken out beyond the edge of the composition.

Hands are not as difficult as they might appear, although it often pays to practise by making some studies of your own hands. A common mistake is to attempt to draw or paint each finger separately without regard for the hand as a whole. The result invariably resembles a bunch of sausages, but if you can first establish the planes across the hand, knuckles and wrist — the fingers follow on naturally.

It is not unusual for hands to be sketchily treated in portraits, even in the most finished and detailed of paintings they may be represented by no more than a few well-placed brushstrokes. One reason for doing this is to prevent the hands from competing with the face. We have already noted that hands tend to draw attention, and this is especially true when every finger, knuckle and nail is rendered in minute detail — particularly if they are in the foreground of the composition. It is surprising how minimally drawn and painted hands can actually be without losing either their structure or their credibility.

CLOTHING

You and your subject will possibly have different ideas about which clothes should be worn for the portrait. Sitters may be keen to wear something in keeping with their image of themselves, a sweater or shirt which has special associations, or a garment which they feel suits them particularly well. You, the artist, will be looking for effects of tone and colour, for textural contrast, and for the overall shape as it will look in the composition.

The painter who likes bright colours and patterns may be dismayed if the subject insists on wearing plain grey, but in this case a striking and contrasting background can often solve the problem. Usually a compromise is not hard to find, and serious disagreements are rare.

Nor should drawing and painting fabrics present any real problem. As with skin, it is a mistake to overwork the clothes, which are usually best treated in broad terms in the early stages. Clothes should be developed as part of the image, and should not be allowed to become more explicit than other elements in the picture.

Different fabrics call for different treatments. Artists of the past have perfected the depiction of lace, velvet, brocade and other richly textured materials to an amazing degree. The Elizabethans, with their jewelled and extravagant costumes, are prime examples of this. Many North European painters of the seventeenth century, notably Frans Hals (1581/5-1666), were also expert in this field. In his portraits, Hals painted lace and embroidery in masterly detail.

Whatever the texture of the fabric, its shape is almost always dictated by what is underneath. This is true of all but very stiff or heavily gathered fabrics. Softer ones, such as satin and thin cottons, generally reveal the contours and volumes of the underlying form, and

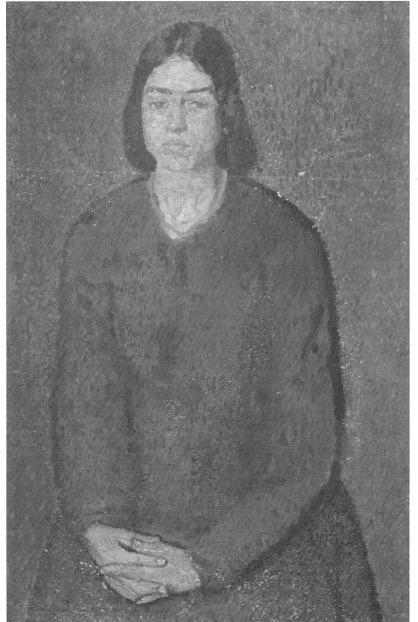

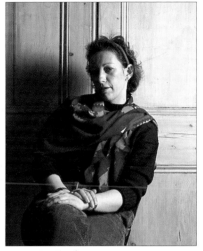

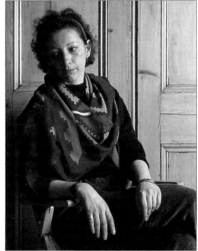

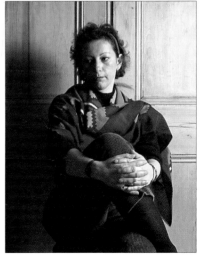

HANDS

The position of the hands plays an important role in a portrait. Gwen John (1876-1939) deliberately used hands to create a feeling of harmony in her paintings — in *Girl in a Green Dress, above,* the sitter's hands are placed restfully on her lap. The three photographs, *right,* demonstrate how the position of the model's hands affects both the mood and composition of the portrait.

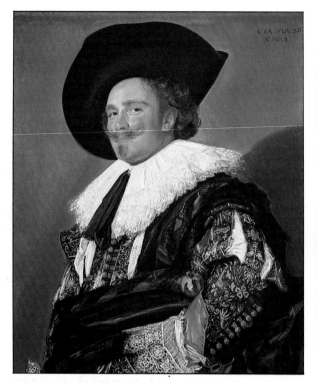

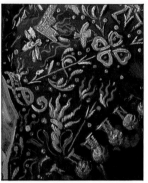

textiles with a surface pattern are often helpful in describing form.

A popular exercise with art teachers is to drape an object for the students to draw. The objective is to draw this in a structural way, using the folds and creases of the cloth to indicate what is underneath. The abstract nature of this exercise makes it imperative to concentrate on the underlying forms, without which the drawing would be nonsensical. For portrait painters there is always a dangerous and unconscious temptation to rely on recognizable elements, such as the head and hands, to tell the viewer that a body lies beneath the clothes.

THE EYES AND MOUTH

Inexperienced portrait painters frequently overestimate the importance of the eyes. Although they are the natural focal point of the face, it is a mistake to devote a disproportionate amount of time to the eyes — especially in the early stages of the painting. Any feature which is given too much attention often threatens the unity of the face as a whole.

Remember that the eyelid naturally covers the top part of the iris. A mistake often made by amateurs is to allow the white to show all round the iris, giving the eyes an abnormal stare. Notice too that the whites of the eyes vary more than is commonly supposed, from very bright to extremely dark. It will help your picture if you establish the tone of these 'white' areas correctly. You will probably be surprised at the difference in tone between the eye on the shady side of the head and that on the illuminated side.

It is essential to treat the eyes as structures, not as superficial details. Bear in mind that the eye is part of the eyeball which lies in a socket and which is protected by an upper and lower lid. Depending on the direction of the light, the lid casts a shadow onto the eyeball itself.

When painting or drawing the mouth, always place it in the context of the entire lower part of the face. As we have already seen, the muscles around the lips cause the whole mouth to project out of the surface of the face. The shape of these muscles can be seen as distinct areas of light and shadow, so do not be tempted to portray the mouth and lips as flat shapes.

HAIR

Hair, especially thick hair, can often obscure the shape of

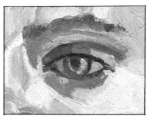

EYES

It is a common mistake to overwork the eyes. They should always be looked at in the context of the rest of the painting — the close-ups, *left*, are taken from demonstrations in this book and show how the artist tackles the problem of painting the eyes in both oils and watercolour.

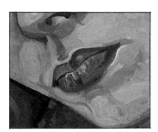

MOUTHS

Always look at the mouth in the context of the lower half of the face. It is not a flat shape, but is raised from the face by the underlying muscles. The two close-ups, *left*, are in oil and pastel respectively.

HAIR

Treat hair as a solid mass, looking for planes of light and shade. In the details, *left*, both the painter and the watercolour artist simplify the forms within the hair into broad areas of dark and light.

the scalp and the structure of the head. This makes it easy to overlook the fact that the hair grows from the scalp and that the shape of the hair is dictated partly by the shape of the head underneath. The line where the hair starts and the face stops is a superficial one.

The most striking thing about hair is its texture. We see the thousands of individual hairs which make up the whole and we wonder how it can possibly be interpreted in a drawing or painting.

Most artists treat the hair as a solid mass, looking for planes of light and shade within the overall shape. Texture is sometimes introduced into this established form, although many painters prefer to leave the hair in a comparatively simplified state. Even when the hair looks extremely realistic, as in some of the portraits of Frans Hals and Rembrandt, it has first been established in more substantial terms.

THE SELF-PORTRAIT

The great advantage of the self-portrait is that you are your own model and are therefore cheap, reliable and available at times that suit you. Approach the work just as you would any other subject, making sure that you are comfortable and have a good view of yourself in the mirror. Above all do not neglect to mark the position of the easel, the mirror and your feet so that when you come back to the painting you will be able to take up your position again.

Strangely, it is usually difficult to 'see' ourselves properly. Most of us have special expressions which we reserve for the mirror, and which friends insist are nothing like our real selves. The same thing happens with the self-portrait, and the pose you select can be stiff and odd-looking, so try to relax and to forget who the subject is.

It is also true that human eyesight is not perfect. Many people have slight astigmatism which only becomes noticeable when they look at one of their portraits — especially a self-portrait — in a mirror. The reflected image often reveals a slightly distorted face — possibly bulging at one side, unevenly placed eyes, and many other irregularities which were not noticeable before. This eyesight deficiency has long been recognized by portrait painters, and the 'mirror test' is a common method of checking the slight distortions it can cause.

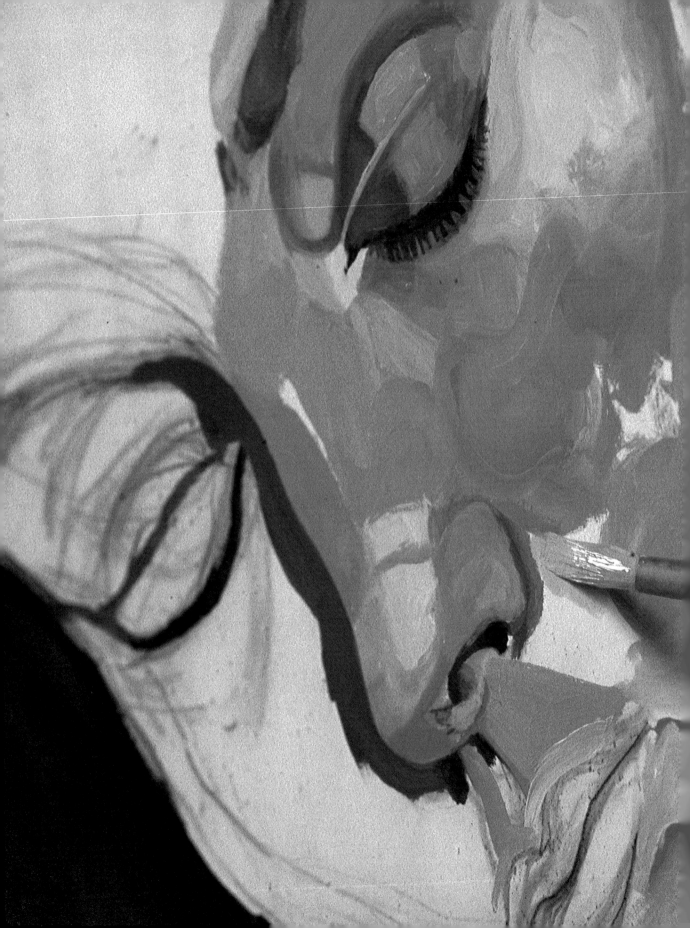

CHAPTER SIX

OIL

Oil paints are the traditional medium for portrait painting, and when we talk of the history of portraiture what we really mean is the history of painting portraits in oil. The early fifteenth-century Dutch painter, Jan van Eyck, popularly credited with the invention of oil paint, was also a major figure in the field of portrait painting. Most portraits done since that time are oil paintings, and even today, when artists are experimenting with an ever-increasing range of new materials, the majority of professional portrait painters work in oil.

There are two basic approaches to using oil paint. The traditional method is first to draw the image onto the support and then to apply a monochrome underpainting before painting the main colour. This approach, often referred to as 'classical' painting, allows the tonal composition to be worked out before any colour is added. By separating the stages in this way, many artists find the whole painting process is made considerably easier, because it enables them to concentrate on one element of the picture at a time.

The alternative, or 'direct' approach (also called alla prima painting) involves working directly on to the support with the minimum of drawing or preliminary sketching. This method relies on freshness of colour and a lively or textured picture surface. The painting should not be overworked, and it is often better to work quickly, producing several paintings in rapid succession rather than making laborious corrections which can destroy the very qualities which the 'direct' method sets out to achieve.

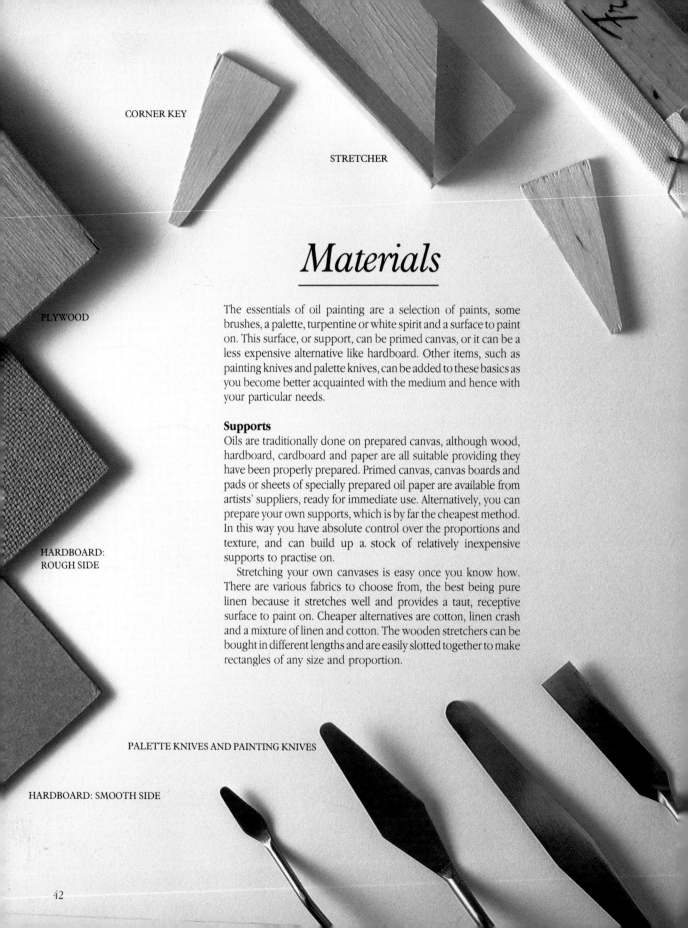

CORNER KEY

STRETCHER

PLYWOOD

HARDBOARD:
ROUGH SIDE

Materials

The essentials of oil painting are a selection of paints, some brushes, a palette, turpentine or white spirit and a surface to paint on. This surface, or support, can be primed canvas, or it can be a less expensive alternative like hardboard. Other items, such as painting knives and palette knives, can be added to these basics as you become better acquainted with the medium and hence with your particular needs.

Supports

Oils are traditionally done on prepared canvas, although wood, hardboard, cardboard and paper are all suitable providing they have been properly prepared. Primed canvas, canvas boards and pads or sheets of specially prepared oil paper are available from artists' suppliers, ready for immediate use. Alternatively, you can prepare your own supports, which is by far the cheapest method. In this way you have absolute control over the proportions and texture, and can build up a stock of relatively inexpensive supports to practise on.

Stretching your own canvases is easy once you know how. There are various fabrics to choose from, the best being pure linen because it stretches well and provides a taut, receptive surface to paint on. Cheaper alternatives are cotton, linen crash and a mixture of linen and cotton. The wooden stretchers can be bought in different lengths and are easily slotted together to make rectangles of any size and proportion.

PALETTE KNIVES AND PAINTING KNIVES

HARDBOARD: SMOOTH SIDE

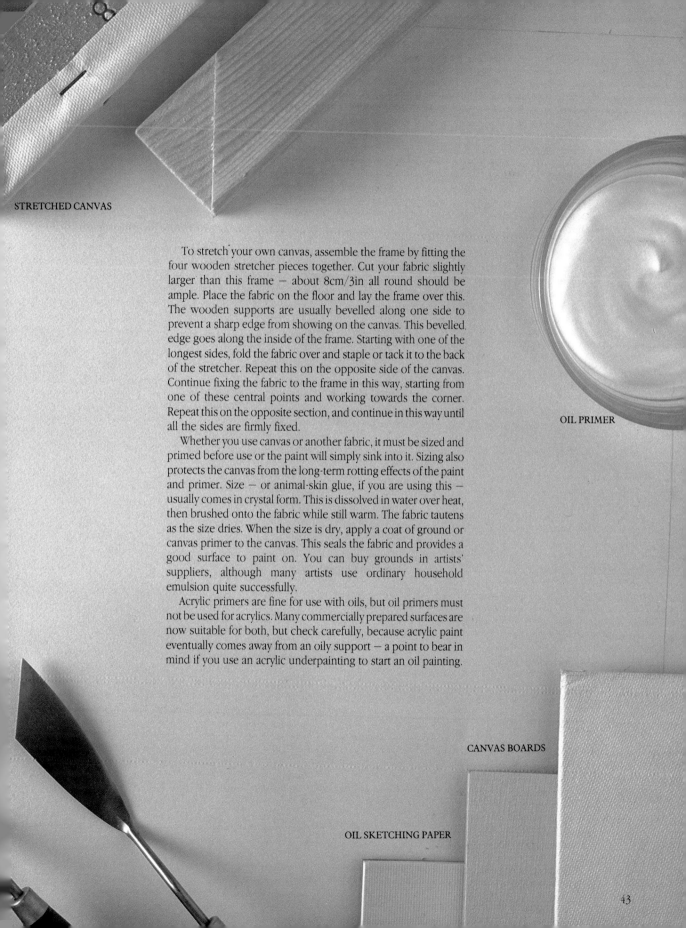

STRETCHED CANVAS

OIL PRIMER

To stretch your own canvas, assemble the frame by fitting the four wooden stretcher pieces together. Cut your fabric slightly larger than this frame — about 8cm/3in all round should be ample. Place the fabric on the floor and lay the frame over this. The wooden supports are usually bevelled along one side to prevent a sharp edge from showing on the canvas. This bevelled edge goes along the inside of the frame. Starting with one of the longest sides, fold the fabric over and staple or tack it to the back of the stretcher. Repeat this on the opposite side of the canvas. Continue fixing the fabric to the frame in this way, starting from one of these central points and working towards the corner. Repeat this on the opposite section, and continue in this way until all the sides are firmly fixed.

Whether you use canvas or another fabric, it must be sized and primed before use or the paint will simply sink into it. Sizing also protects the canvas from the long-term rotting effects of the paint and primer. Size — or animal-skin glue, if you are using this — usually comes in crystal form. This is dissolved in water over heat, then brushed onto the fabric while still warm. The fabric tautens as the size dries. When the size is dry, apply a coat of ground or canvas primer to the canvas. This seals the fabric and provides a good surface to paint on. You can buy grounds in artists' suppliers, although many artists use ordinary household emulsion quite successfully.

Acrylic primers are fine for use with oils, but oil primers must not be used for acrylics. Many commercially prepared surfaces are now suitable for both, but check carefully, because acrylic paint eventually comes away from an oily support — a point to bear in mind if you use an acrylic underpainting to start an oil painting.

CANVAS BOARDS

OIL SKETCHING PAPER

43

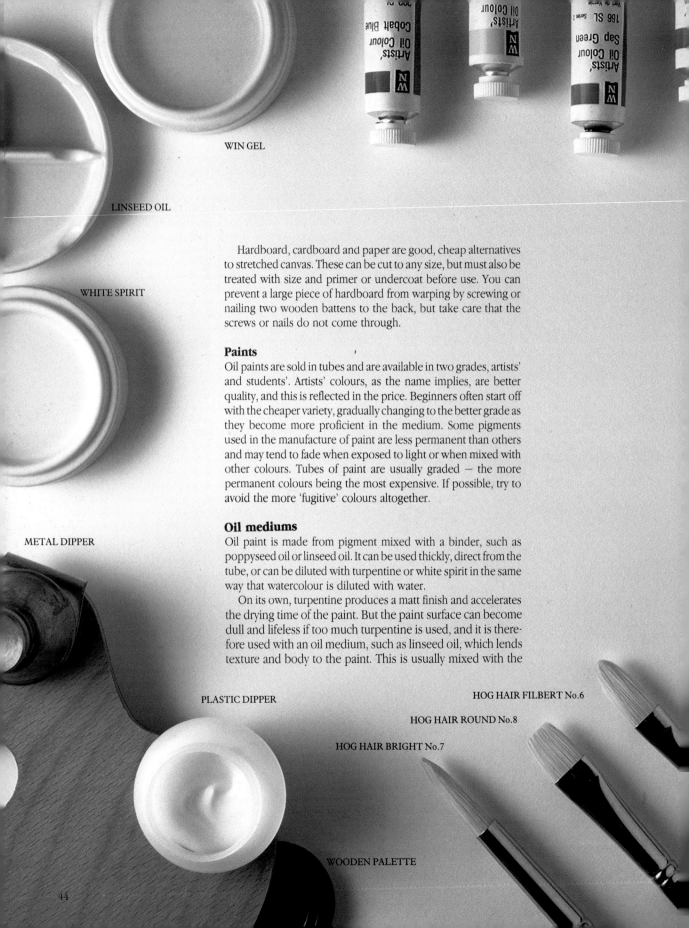

WIN GEL

LINSEED OIL

WHITE SPIRIT

METAL DIPPER

PLASTIC DIPPER

WOODEN PALETTE

HOG HAIR FILBERT No.6

HOG HAIR ROUND No.8

HOG HAIR BRIGHT No.7

Hardboard, cardboard and paper are good, cheap alternatives to stretched canvas. These can be cut to any size, but must also be treated with size and primer or undercoat before use. You can prevent a large piece of hardboard from warping by screwing or nailing two wooden battens to the back, but take care that the screws or nails do not come through.

Paints

Oil paints are sold in tubes and are available in two grades, artists' and students'. Artists' colours, as the name implies, are better quality, and this is reflected in the price. Beginners often start off with the cheaper variety, gradually changing to the better grade as they become more proficient in the medium. Some pigments used in the manufacture of paint are less permanent than others and may tend to fade when exposed to light or when mixed with other colours. Tubes of paint are usually graded — the more permanent colours being the most expensive. If possible, try to avoid the more 'fugitive' colours altogether.

Oil mediums

Oil paint is made from pigment mixed with a binder, such as poppyseed oil or linseed oil. It can be used thickly, direct from the tube, or can be diluted with turpentine or white spirit in the same way that watercolour is diluted with water.

On its own, turpentine produces a matt finish and accelerates the drying time of the paint. But the paint surface can become dull and lifeless if too much turpentine is used, and it is therefore used with an oil medium, such as linseed oil, which lends texture and body to the paint. This is usually mixed with the

ARTIST'S OIL COLOURS

PAPER PALETTE

turpentine in a ratio of approximately 60:40. For a thicker consistency, which dries more quickly, you can add a little varnish to the oil and turpentine.

Brushes

Aim for a selection of good-quality brushes. The stiff ones are made from hog hair, softer ones from sable or squirrel. An increasingly large selection of synthetic brushes is available in both the stiffer and softer varieties. Synthetic brushes are usually considerably cheaper than natural bristles.

Brushes come in a variety of shapes — round, bright, filbert and flat. Brights and flats are similar, but flats have longer bristles and are especially good for long, tapering strokes; rounds are good, general-purpose brushes, and a wide range of sizes of this type is useful. Filberts are flattened with slightly rounded ends to produce more controlled strokes. There are also several 'specialist' brushes which can be used to obtain a variety of effects. Of these, the fan brush is probably the most common.

Palettes

Oil-painting palettes are traditionally made of wood. These come in a range of sizes and should be treated with linseed oil before use. Disposable palettes are also available, consisting of sheets of specially prepared paper which are thrown away after use.

Painting and palette knives

Palette knives are long and flexible, and can be used for cleaning the palette and mixing paint as well as applying it to the painting. Painting knives are specifically designed for laying paint on the support, usually to achieve a thickly impastoed effect.

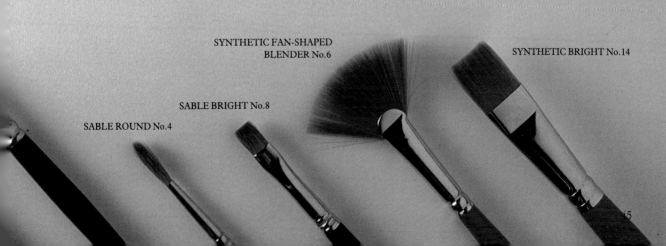

SYNTHETIC FAN-SHAPED
BLENDER No.6

SYNTHETIC BRIGHT No.14

SABLE BRIGHT No.8

SABLE ROUND No.4

Anita in Miniature

To reduce this strong and colourful subject to a miniature portrait was something of an experiment for the artist. She normally works slowly on a much larger scale, and here she was required to produce a tiny portrait comparatively quickly.

This artist works in a bright colour key, relating a set of strong, bright tones to each other. She lays these separately on the canvas, placing pure colours side by side. The boldness of this approach has given an intense, almost jewellike appearance to this miniature. Colour was applied very locally, in small blocks, and then blended with a sable brush to form a continuous plane.

For a palette, the artist used a piece of cardboard, which absorbed some of the oil from the paints, helping the colours to dry faster between applications and therefore speeding up the whole process. This artist prefers a matt finish, and getting rid of some of the oil also helped her to achieve this.

Sable brushes — most usually used for watercolours — enabled the artist to paint in the tiny, intricate strokes necessary for a miniature. She managed to translate her normal bold style into the smaller format, bringing out the bright earthiness of the girl's headgear and the glow of her skin.

1 Anita, *right*, frequently models for the artist. Usually the paintings are large, and this miniature is something of an experiment.

2 A preliminary pencil drawing establishes the position of the head and shoulders on the rectangular support. The features are drawn accurately at this stage *below*. The pencil line is then rubbed down with a cloth to remove excess graphite and dust which might mix with the paint and distort the colours.

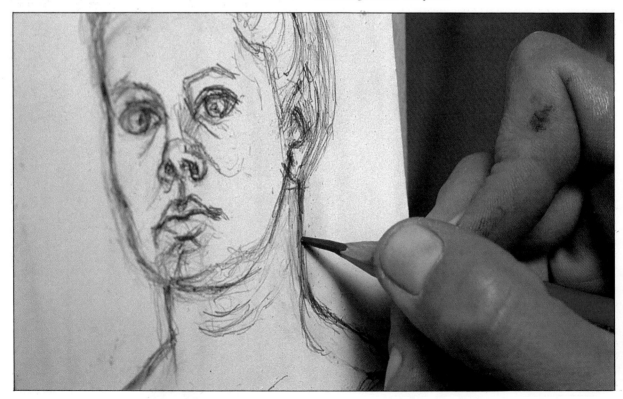

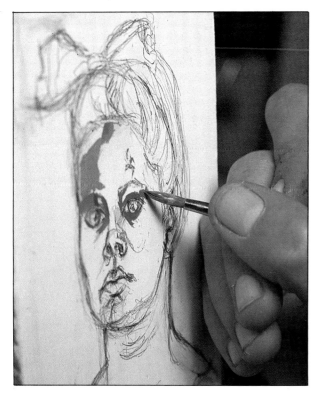

3 Using yellow ochre, alizarin crimson, titanium white, violet, terre verte, ultramarine, cobalt blue, Naples yellow and cerulean blue, the artist begins to block in the flesh tones *left*. All the flesh tints are mixed from these basic colours. The artist refers to the subject constantly as she works, exaggerating both the local and reflected colours found in the face. Each plane is clearly defined, and the colours and tones are treated as separate elements of the whole face. Black is used only to represent a local colour — it is never used to tone down a bright colour. The artist always works directly onto a white support without any underpainting. White shows through the paint, creating a range of bright, luminous colours across the picture surface.

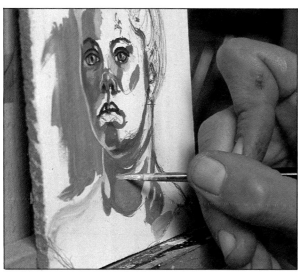

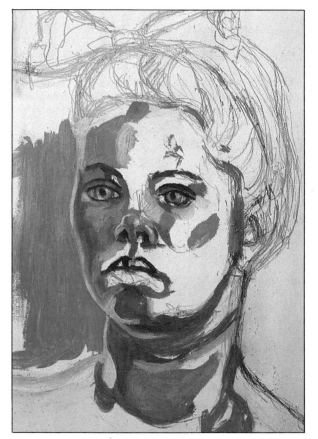

4 A small area of light blue is established behind the subject. This is an approximate colour of the eventual background and helps the artist to mix the correct flesh tones by relating them to a background tone. Here the artist applies cool dark tones to the shaded parts of the neck *above*.

5 The form of the face emerges as the planes of light and shade are established. A narrow strip of cold reflected light down the shaded side of the face prevents that side of the head from merging into the blue background *above*.

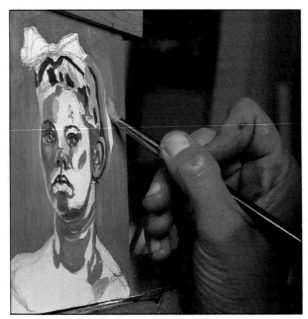

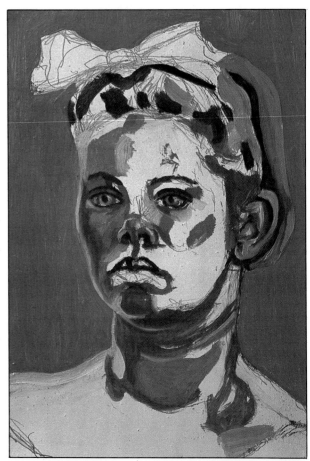

6 At this stage the artist completes the light blue background, taking this right up to the outline of the subject with a No. 8 sable brush *above*. The flat blue is a simplified version of the real background, which the artist considers too complex for a small portrait.

7 The painting so far shows the partially established facial tones against the final background *right*. To offset the distorting effect of unpainted white canvas, the artist breaks up these areas with dabs of tone and local colour.

8 Working across the painting, the artist blocks in pale warm flesh tones on the light side of the neck. The warm tones are mixed mainly from red, yellow ochre and white. Cool areas are generally painted in green-blue or purple-red. Here, *right*, the light flesh tones are taken up to the background and, because the paint is used fairly thickly, the colour is opaque enough to cover the edge of the blue and produce a sharp outline.

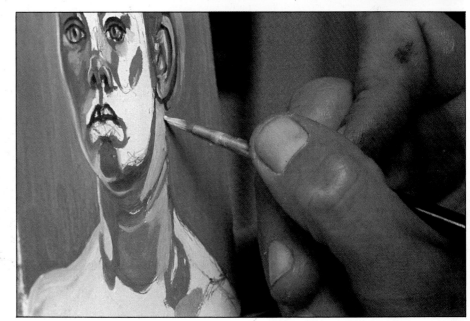

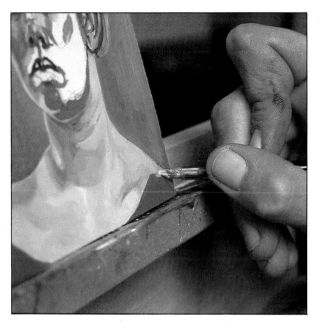

9 Rowney rose is lightened with white to make the basic bright pink of Anita's blouse. Initially this is applied as a solid flat shape, *left,* the colour picking out the warm pinks of the face. Again, the thick opaque paint is taken up to and over the flesh colour to form a sharp edge.

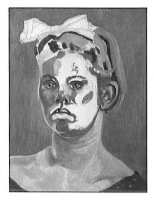

10 A touch of alizarin crimson is blended with the bright pink to suggest the rounded form of the shoulders *above.*

CHOOSING A COLOUR KEY

Some artists choose a low colour key, working from a range of subdued hues. Others prefer brighter colours, or a high colour key. The choice is a personal one, the important thing being how the colours relate to each other in the picture.

Here the artist uses comparatively bright colours. The initial blocking-in is done in fairly vivid tones, the blues, reds and greens being quite discernible in the overall image. This blocking-in sets the 'key' for the rest of the painting, and the subtle tones and planes of the face are well observed in a range of distinct, clear colours.

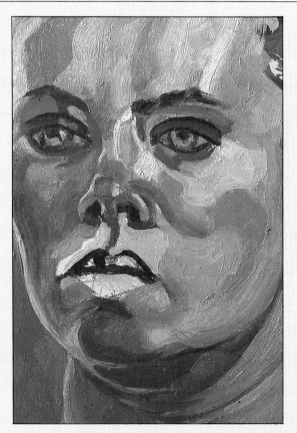

11 Moving back to the face, the artist continues to block in the flesh tones *right*. The bright pink around the eye reflects the Rowney rose and the white of the blouse.

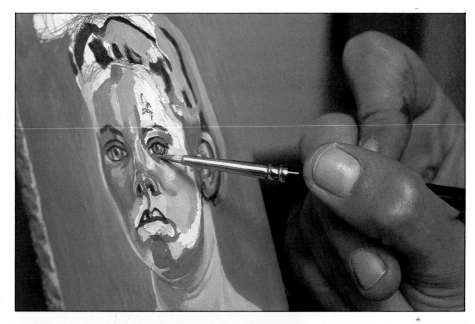

12 All the general skin tones are now complete *below*. The round form of the neck and the volumes within the head and face can be seen clearly, created from a systematic filling in of flat shapes.

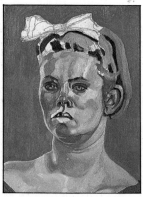

13 Exaggerating the brightness of the real colours, the artist paints in the patterned scarf *right*. Each of these colours is a key colour in the various flesh mixtures, and the vividly depicted headscarf has a 'lifting' effect on the whole portrait by bringing out and heightening the important skin colours.

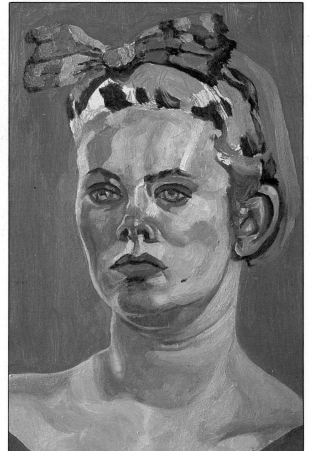

What the artist used

The small hardboard support measuring approximately 15.5cm×12.5cm (6in×5in) was cut from a larger sheet of hardboard and treated with oil primer. A selection of round sable brushes, Nos. 2, 3, 5 and 8, was used to apply the oil colour which was mixed with turpentine. The artist worked from a palette of titanium white, yellow ochre, alizarin crimson, violet, terre verte, cobalt blue, ultramarine, cerulean blue, Naples yellow, cadmium yellow, cadmium red and Rowney rose. A B pencil was used for the preliminary drawing.

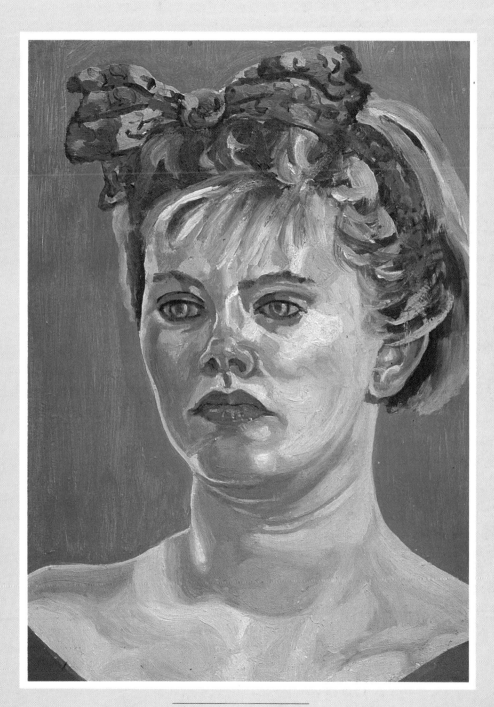

Anita in Miniature

51

Girl in a Yellow T-shirt

This portrait has been composed in a straightforward, simple way, using a lot of plain space, with the figure low down in the picture. There is nothing to distract attention from the expressive face and the strikingly bright shirt.

At an earlier stage in the painting, the artist put in a shadow, giving a specific space between the figure and the background. This gave the background reality as a surface, making it appear as a wall or board. However, the artist then decided to concentrate instead on the graphic qualities of the figure, and removed the shadow. This made the background change, so that it ceased to exist in space, becoming flat, with nothing to indicate any dimension. Rather the three-dimensional qualities of the picture are provided by the well-observed, sculpted form of the figure.

The portrait takes a full-frontal, completely symmetrical view of its subject. This simple approach has been made to look slightly out of the ordinary by placing the figure well down in the picture. Exactly the same margin of space around the figure might have been monotonous, but the lower position of the subject has created an airiness, emphasizing the carefree, youthful and fresh look of the whole portrait.

One of the most interesting tasks in this portrait was to capture the variety of tones and colours in the girl's face. The local facial colour of people of different races can be very different, but the light and shade largely determines the tone — just as it does with anything else. For both dark-skinned and light-skinned people, the local colour must determine the basic tone to some degree, but it is the strength and direction of the light falling on the facial planes which really creates the final colour variations.

The artist has drawn out the shapes of the tonal planes in pencil, and has filled them in as areas of flat colour. On the face, for instance, the artist mixed several tones of each colour required, then looked carefully to relate them to each other. The slow-drying quality of oil paint enabled these to be blended together to give the impression of soft, rounded form.

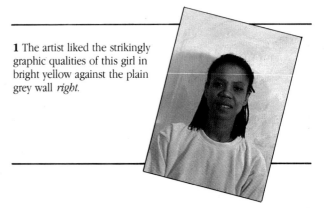

1 The artist liked the strikingly graphic qualities of this girl in bright yellow against the plain grey wall *right*.

2 The outline of the subject is drawn with a well-sharpened F pencil, indicating the areas of light and shade *right*. The drawing is kept deliberately simple to act as a guide in the initial painting stages.

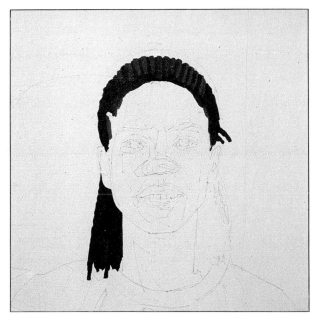

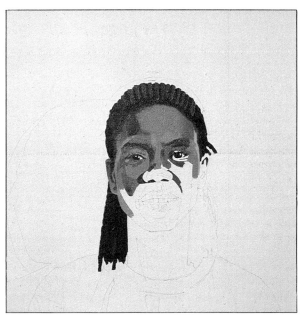

3 *Above*, the hair is painted in a mixture of black, raw umber and cobalt blue, with a No. 4 round synthetic brush.

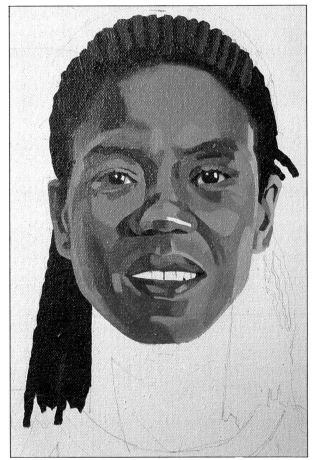

4 With a basic mixture of burnt sienna, cadmium red, cobalt blue and chrome orange, the artist starts to block in the skin tones *above*. By working from the top down, he avoids smudging the wet paint.

5 The completed face *left* shows a range of tones obtained from the basic mixture. The planes of light and shade meet and overlap in carefully observed, natural shapes.

SKIN TONES

This artist prefers to work from the top of the head downwards to avoid smudging the work already done. The skin tones here are built up patch by patch, rather like a jigsaw puzzle, each one being carefully related to those already established. Occasionally the artist goes back over the work, changing or modifying particular areas.

Black skin is more affected by reflected light than white skin, and the artist has used these strong planes of light to describe the form and contours of the face.

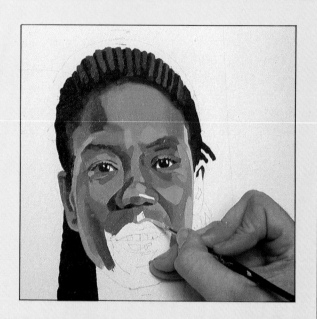

6 Using cerulean blue, titanium white and black, the artist starts to block in the background *above*. Colour is applied as evenly as possible with a No. 8 flat bristle brush. A No. 3 sable brush is used to take the colour up to the outline of the subject, care being taken to preserve the irregular, complex shape of the hairline and the contours of the face and shoulders.

7 Cadmium yellow, titanium white, yellow ochre and a little black are used for the T-shirt *above*. The shadows are indicated in grey.

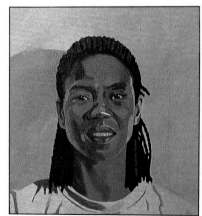

8 A darker background colour is used for the bold shadow *right*. The artist decides that this spoils the simplicity of the composition, and completes the portrait by removing the heavy shadow and brightening the colour of the girl's T-shirt.

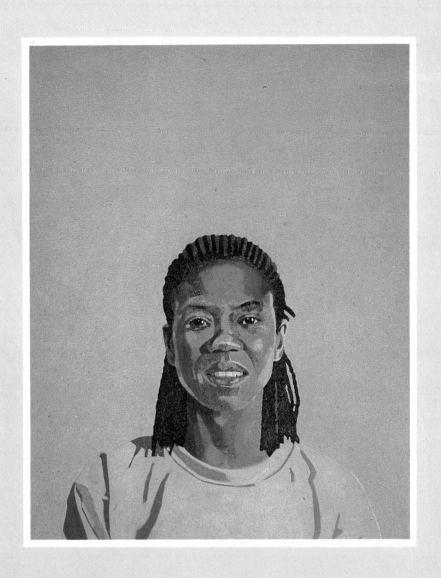

Girl in a Yellow T-shirt

What the artist used

For this portrait in oils the artist chose to work on stretched Herston flax canvas. This was pre-primed for oil paint. He worked from a palette of titanium white, burnt sienna, cadmium red, chrome orange, cobalt blue, ivory black, raw umber, cerulean blue, cadmium yellow and yellow ochre. The paint was mixed with Rowney's Alkyd Medium. For the background and other large areas, the artist blocked in the colour with a No. 8 flat bristle brush. Other brushes used were a No. 6 flat; a No. 4 synthetic round; and sable brushes, Nos. 2 and 3. The preliminary drawing was done with an F pencil.

Girl in Profile

The girl's profile, standing out strongly against a dark flat background, provides the opportunity for the use of space as a 'negative shape'. The artist has done this deliberately, by cutting off the top and the back of the head, resulting in two interlocking shapes — the head and the space into which it faces.

A straight profile against a flat grey background runs the risk of becoming a rather boring picture, but the artist has avoided this by paying detailed attention to the interplay of the main shapes. The hair forms a definite shape, and the negative shape, opposite the face, is an important part of the composition. If you could forget that a face is represented here, the division of the space would work well as an abstract. For instance, before the face was fully painted in, you could imagine the picture as two abstract shapes separated by a taut and disciplined dividing line, and your attention could be flicked from one shape to the other, treating each one in turn as the subject and the other as the background.

The artist has used glazing to build up the flesh tones in the face, avoiding wedges of opaque colour for different patches of light and shade. Flesh does not consist of a patchwork of tones

and colours — it is much more subtle than that. From a visual point of view, it is made up of overlapping veils of translucent colour. By using glazing, a natural transition from light to dark, from cool to warm, or vice versa, becomes technically possible.

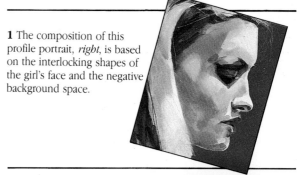

1 The composition of this profile portrait, *right*, is based on the interlocking shapes of the girl's face and the negative background space.

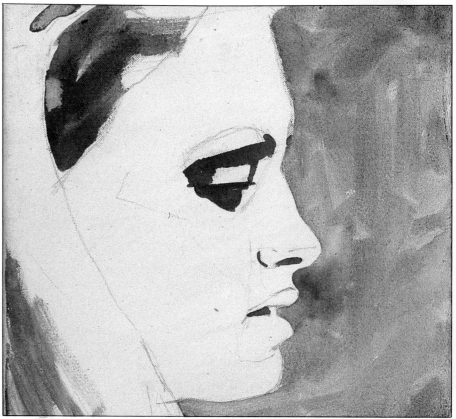

2 Using a thin wash of turpentine and burnt umber, the artist blocks in the shadow areas of the hair and face *right*. The larger background area is painted with a No. 4 flat bristle brush; the more intricate facial features are added with a No. 2 flat bristle brush. By establishing the main areas in the early stages, the artist is able to gradually introduce colour into the painting without worrying too much about tonal contrast and depth. The colour is applied thinly to allow transparent glazes of colour to be built up gradually.

3 Using a mixture of cadmium red, burnt umber and white, the artist loosely blocks in the warm facial tones with the No. 4 brush *left*. The light hair colour is yellow ochre and white.

4 The shadows around the eyes are painted with black, white and a touch of burnt umber *below*. The artist uses the No. 2 brush to obtain the tiny precise areas of varying tones.

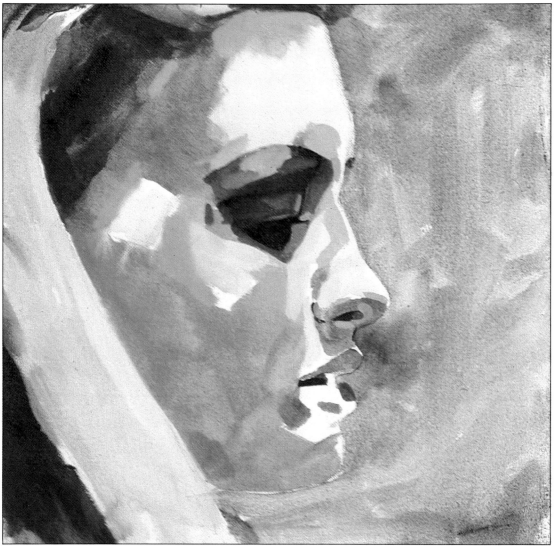

5 The artist works into the skin tones, developing the planes of light and shade *above*. Each small area of warm highlight and cool shadow is carefully applied in thin layers as the artist constantly refers to the subject.

6 Ultramarine and black are mixed together and applied to the background area. The artist uses a large brush to obtain a flat, even expanse of colour. Delicate strands of hair are added in yellow ochre and white *above*.

What the artist used

The painting was done on a fairly small scale — 30cm×37.5cm (12in×15in) — and the artist chose to work on a prepared canvas board. Flat bristle brushes, Nos. 2 and 4, were used to apply the oil paint. The palette consisted of eight colours: black, burnt sienna, burnt umber, cadmium red medium, scarlet lake, ultramarine, white, and yellow ochre. For mixing the thin glazes of colour, the artist used turpentine and linseed oil (too much turpentine can spoil a glaze, and the artist kept its use to a minimum).

GLAZING

Glazing is a method of building up colour in thin layers, or of applying a transparent layer over a solid one so that the colour of the first is slightly changed. The method produces a luminous finish which makes it particularly appropriate for painting the subtle, translucent tones of the skin, but it is a relatively slow process, because each layer must be allowed to dry.

When thinning oil paints for glazing, do not use turpentine alone as a thinner, and never use turpentine substitute. Turpentine is sometimes mixed with linseed oil, but linseed oil is not ideal for glazing because it tends to move after being laid. Ideally, a proper glazing medium should be used, such as the alkyd medium sold under the name of Liquin. When doing glazes in this way, increase the oil or glazing-medium content with each new layer of colour.

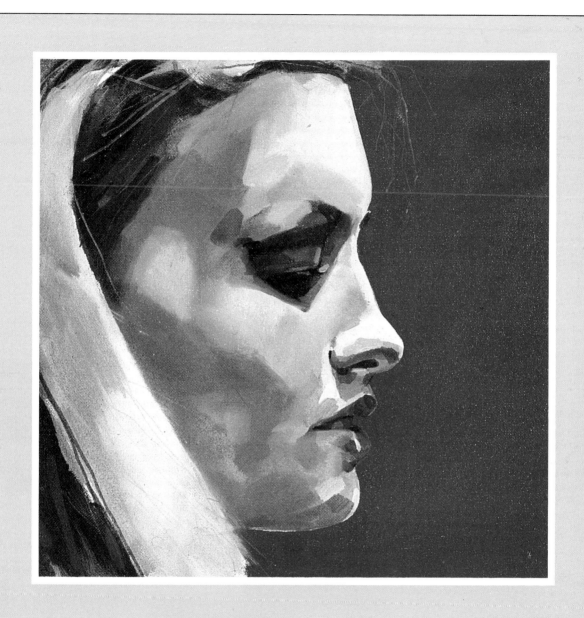

Girl in Profile

Woman Sleeping

In this close-up portrait of a woman sleeping the composition is particularly interesting and unusual. The woman's head slants diagonally across the picture, yet seems also to fill it, so that the diagonal does not intrude too much.

The artist has faced at least two main tasks, that of depicting the peaceful sleeping pose of the model reclining on a sofa, and that of capturing the tones and shadows of the skin.

The sleeping posture would have been easier to indicate by showing more of the model's body on the sofa; painting the head only made it more difficult. The use of the diagonal has helped to achieve the effect, as the head is placed across the picture in a way that naturally indicates a reclining position.

First, the artist sketched in the outline of the head with willow charcoal to establish the broad form. Charcoal is a good medium for this initial work, because it is rough and immediate, and thus prevents any over-attention to small detail, irrelevant in the early stages. She then quickly worked over the charcoal outline with a B pencil, developing the drawing and making a more specific outline, after which the surface was wiped to remove excess charcoal dust.

The artist blocked in the background around the head and the edge of the headscarf in a black-blue, taking the opportunity to re-define the contours of the head. She then turned her attention to what she noted to be an area of darker skin tone on and just below the uppermost eye. Many portrait painters put in skin tones across the whole face, moving from one area to the other, lightening and darkening certain areas, so that they come up, or tone down, in relation to each other. Here the approach was different: the artist

first developed the uppermost eye in some detail — an area which included some of the very lightest and very darkest tones. Taking these as a guide, she worked outwards from this point, relating each new area to those already established.

Throughout the painting the artist looked constantly at the subject, because not only did she have to pick out the tiny irregular planes of light and shade, but also had to consider the local colour. For instance, the cheeks have a naturally rosy hue, while the inside corners of the eye cavity have a cooler, darker local colour. She was careful, too, not to lose the internal contours — the outline of the nose, eyes and mouth, were developed in a linear way with a small paintbrush.

1 Although the artist works on such a small scale — this painting measures 20cm×20cm (8in×8in) — she prefers to use a large, stable easel *right*.

2 The head and features are sketched in charcoal *left*. The artist's prime interest is in the face and flesh tones, so the head is placed prominently, filling the whole picture area.

3 Any excess charcoal dust is wiped off the support *left*. Charcoal dust mixes with all types of paint, usually resulting in dirty, messy colours. Here the artist rubs away almost all the drawing, leaving only a faint outline to act as a guide for the painting.

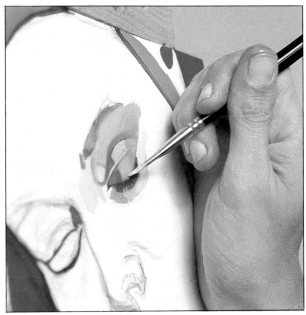

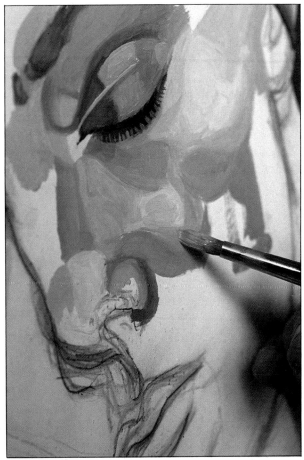

4 The dark blue background and the lighter toned headscarf are blocked in. The artist then begins to work on the face, starting at the eye and working outwards *above*.

5 Planes of light and shade are filled in piece by piece *right*. Each new patch of warm or cool tone is related to the adjoining area, and is painted as a flat plane of colour.

WARM/COOL SKIN TONES

The human skin is composed of many shades of varying warm and light tones. Generally, the shadows have overtones of blue, green or purple, while the lighter areas are mainly yellows, pinks and oranges. However, the division is not absolute. Often there are warmish tones in the shadow areas and comparatively cool tones in the lighter areas and highlights. Much depends on the subject's skin colour and the type of lighting.

A close-up view of this face shows how the artist has carefully observed the changing colour temperatures across the surface of the skin, portraying these in accurate and clearly defined planes.

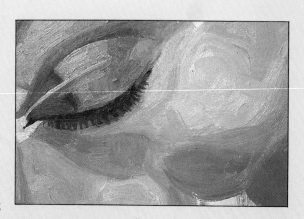

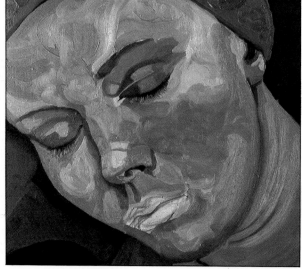

6 A No. 2 sable brush is used for the small shapes of flesh tone *above left*. The image emerges gradually as each patch is filled in.

8 The flesh tones are all mixed from yellow ochre, alizarin crimson, titanium white, cadmium red, violet, terre verte, ultramarine, cobalt blue, cerulean blue and Naples yellow *above*.

7 Shaded areas are mainly cool, light areas are mainly warm. Here the deep shadows around the nose are painted in a dark, cool purple *left*.

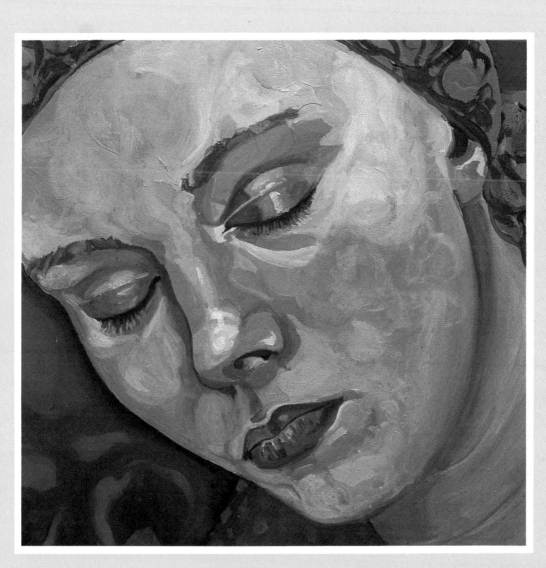

Woman Sleeping

What the artist used

Working on a piece of primed hardboard measuring 20cm×20cm (8in×8in), the artist started by drawing the subject with willow charcoal. She worked from a palette of titanium white, yellow ochre, alizarin, violet, terre verte, ultramarine blue, cobalt blue, cerulean blue, Naples yellow, Rowney rose, Rowney orange, Payne's grey, cadmium yellow and cadmium red. Colours were applied with a selection of round sable brushes, Nos. 2, 3, 4 and 5.

CHAPTER SEVEN

ACRYLIC

The advent of acrylic paints in the early part of this century was the most significant discovery in artists' materials for more than five hundred years. It offered many of the advantages of oil paints with the additional ones of being fast-drying and practically indestructible once applied to the support.

An extraordinarily versatile medium, acrylic is particularly helpful to portrait painters. The traditional technique of building up flesh tones in a series of transparent layers, or glazes, can be achieved in a matter of minutes, as thinned acrylic dries almost immediately, whereas with the slower-drying oil paint, glazing is a lengthy procedure because each layer must dry before the next is applied. Hence warm and cool tones can be applied on top of each other to create the 'living' tones of skin without the colour looking dead or muddy.

Its quick-drying capacity makes acrylic ideal for underpainting. Artists of the past frequently painted a monochrome version of their subject before introducing colour. Using acrylics, such an underpainting can be ready to work on within a few minutes of application. It is also possible to use oil paint over acrylic, and many artists who work mainly in oils find it useful to use acrylics for the initial blocking-in.

Acrylic can be applied thickly for rich impastos, or very diluted to obtain transparent washes. But although the results sometimes resemble oil or watercolour, it is a mistake to regard it as a substitute for either. Acrylic is a medium in its own right, very different from any other, and patience and practice are required to get the best results.

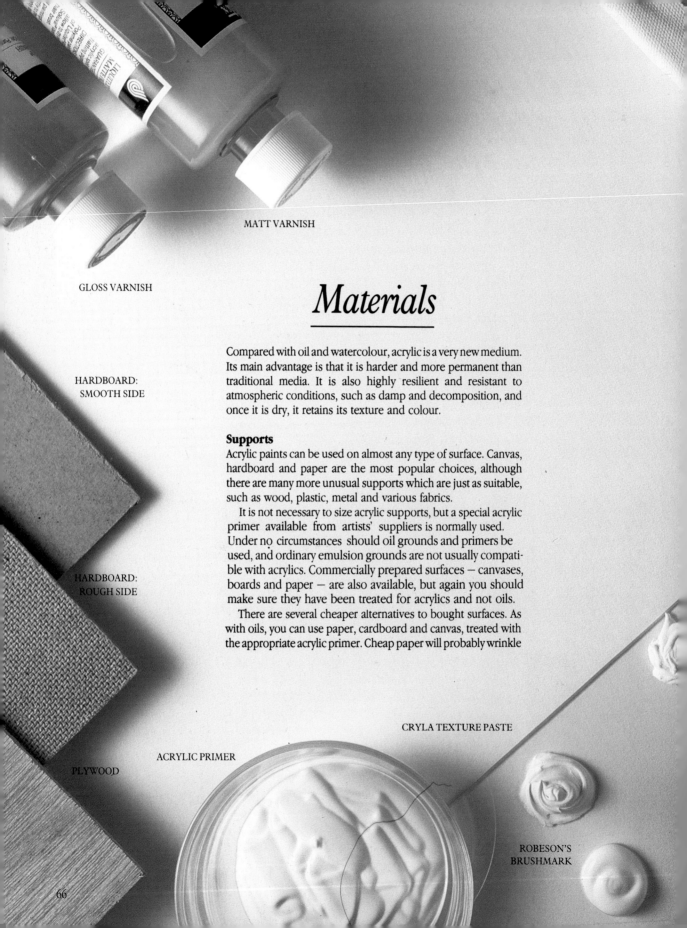

GLOSS VARNISH

MATT VARNISH

HARDBOARD:
SMOOTH SIDE

HARDBOARD:
ROUGH SIDE

PLYWOOD

ACRYLIC PRIMER

CRYLA TEXTURE PASTE

ROBESON'S
BRUSHMARK

Materials

Compared with oil and watercolour, acrylic is a very new medium. Its main advantage is that it is harder and more permanent than traditional media. It is also highly resilient and resistant to atmospheric conditions, such as damp and decomposition, and once it is dry, it retains its texture and colour.

Supports

Acrylic paints can be used on almost any type of surface. Canvas, hardboard and paper are the most popular choices, although there are many more unusual supports which are just as suitable, such as wood, plastic, metal and various fabrics.

It is not necessary to size acrylic supports, but a special acrylic primer available from artists' suppliers is normally used. Under no circumstances should oil grounds and primers be used, and ordinary emulsion grounds are not usually compatible with acrylics. Commercially prepared surfaces — canvases, boards and paper — are also available, but again you should make sure they have been treated for acrylics and not oils.

There are several cheaper alternatives to bought surfaces. As with oils, you can use paper, cardboard and canvas, treated with the appropriate acrylic primer. Cheap paper will probably wrinkle

STRETCHED CANVAS STRETCHERS

if you use the paint diluted, so use a good-quality thick one. You can also stretch your own canvas (see under Materials section in Chapter 6) and give it two or three coats of acrylic primer. Many artists use dilute acrylic directly on unprimed canvas to obtain the luminous, wash effect known as 'staining'.

Paints

Almost every manufacturer of artist's materials now produces its own brand of acrylic paint. These have impressive technical names like dioxazine purple and naphthol crimson — names which reflect their laboratory origins.

The thickness of the paint depends on the brand, but the consistency is generally similar to that of gouache or oils. Rowney make a slightly runnier version in their softly textured 'Flow Formula' series. PVA colours are cheaper then acrylics and are made with less costly pigments, although they share the hardwearing and quick-drying advantages. Cheap vinyl colours are sold in larger quantities especially for use on big areas. Alkyds are acrylic-based paints which are mixed with turpentine instead of water.

You are not confined to using acrylics on their own when working in this medium. Acrylics are particularly good mixers and can be combined effectively with other materials. They are popular for collage work, a method of creating images by sticking various materials on top of each other. One characteristic of acrylics, which makes it ideal for collages, is its adhesiveness —

LIQUITEX MODELLING PASTE

MATT MEDIUM

CANVAS BOARDS

LASCAUX THICKENER

67

LIQUITEX PAINT

PALETTE KNIVES

you can actually stick a shape or cut-out into wet paint or acrylic medium. It is also possible to achieve highly textured paint surfaces by mixing sand, sawdust and other suitable materials with the paint before applying it to the support.

Brushes

Brushes suitable for oil or watercolour are generally also suitable for acrylics, but you may develop a different way of working, which will call for different brushes. Concentrate on acquiring a workable selection of a few useful shapes and sizes, adding to these gradually as you discover what your specific needs are.

Oil painting brushes are normally made of bristle, whereas the best watercolour brushes are sable. Both types can be used for acrylics, but the bristle brushes, which are stiffer, are generally more appropriate when the paint is applied thickly in the manner normally associated with oil paint. Soft watercolour brushes are usually preferred for more translucent, diluted paint effects.

All brush types are now available in nylon. These are hardwearing, and many artists find the synthetic brushes particularly compatible with the synthetic acrylic paint. It is easier to remove acrylic paint from nylon brushes, but, like all brushes, they must be cleaned well and frequently, because acrylic paint dries so fast that they can become stiff and unusable very quickly. The large nylon brushes sold in hardware and decorator's shops are excellent for applying large areas of flat colour.

SYNTHETIC FAN-SHAPED
BLENDER NO.4

HOG HAIR FLAT NO.8

Media

Acrylics are not compatible with the media used for oil paint. You can buy various substances which can be mixed with the paint to achieve different effects and, of course, the paints can also be thinned with water. Gloss and matt media — as their names suggest — can be added to make the paint surface dull or shiny, and there is a particularly useful medium called retarder, made of glycerine, which slows down the drying of the paint.

For creating prominent, textured brushstrokes, use gel medium, which comes in a tube and is thicker than the paint itself. If you want to make your colours really thick, mix the paint with texture or modelling paste. This can be built up on the surface of the support to form a heavy impasto, and is particularly effective when applied with a palette or painting knife.

HOG HAIR ROUND NO.3

Other equipment

There is generally little difference between the equipment used with acrylic and that used with oil or watercolour. However, it is better to obtain a white, plastic palette instead of the usual wooden one, because it is easier to clean the hard acrylic paint from a plastic surface.

If you find the quick-drying colour hard to handle, there is a special palette which is designed to help, the Rowney 'Staywet' palette, which uses the principle of osmosis to keep colours wet for several days. You can also keep the paint wet on your palette by occasionally sprinkling or spraying it with water.

SYNTHETIC BRIGHT NO.6

SYNTHETIC ROUND NO.11

FLOW FORMULA ACRYLIC PAINT

SABLE ROUND NO.8

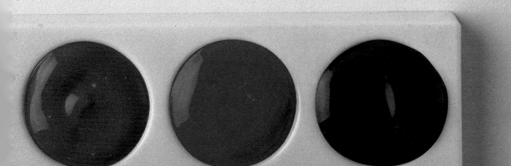

Melissa, from a Photograph

In this portrait of a little girl in a brightly coloured dress, done entirely from a photograph, the artist chose to tone down the background, painting it in neutral colours, although a scumbling of lighter colour was applied to the background surface to give an interesting texture. The texture became modified as the artist worked, but still retains a lively surface in the final picture.

The portrait is quite formally composed, the main task being to capture the lively personality of the girl in such a way as to counteract the symmetry and conventionality of the pose.

The artist used acrylic for the background, taking advantage of its quick-drying property, and also for the hair, the basic skin tones and the large blue expanses of the girl's dress. He then developed the more subtle skin tones, some parts of the face, such as the mouth, and the details of the dress, with the slower-drying and more malleable oil paint.

The artist worked from a fairly small-scale photograph, making the drawing stage important. This is the stage at which he interpreted and developed the rather blurred, indistinct tonal variation in the photograph. This was done very clearly, in a hard pencil, and the artist made a definite statement, taking firm decisions about the way the picture was to develop.

Skin tones were mixed on a large piece of white formica, enabling the artist to see clearly what he was using. A large white surface is useful because you can mix a complete set of tones, ranging from very light to very dark, and you can keep these separate, going back to the required colour as necessary. Not all artists work in this way. Some prefer to start off with a basic skin tone, modifying this by the addition of other colours to obtain tonal variation.

The crisp edge on the narrow band of brown which divides the background area was achieved with masking tape. The tape was pressed firmly onto the canvas along the straight edge of the strip, and fairly thick brown paint was used on top of it. (If paint is too thin, it will run under masking tape.)

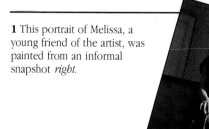

1 This portrait of Melissa, a young friend of the artist, was painted from an informal snapshot *right.*

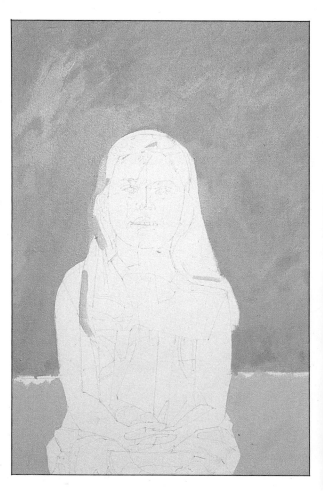

2 Working on pre-primed canvas, the artist first makes a detailed drawing of the subject using an F pencil. A careful outline is sketched in, and facial features and areas of light and shade are accurately indicated. The figure is placed in the lower half of the rectangular canvas to allow plenty of background space and to offset the rather conventional full-frontal pose. The lighter background area is painted with raw umber, titanium white and Payne's grey; small amounts of ivory black and burnt umber are added for the dark area *right.*

3 With a mixture of ivory black and burnt umber, the artist blocks in the dark areas of the girl's hair *right*.. The dark tones are predominantly black; the lighter areas contain more burnt umber. Two brushes are used here — a No. 2 bristle for the broader expanses of colour, and a No. 3 sable for the delicate outlines and complex edges. At this stage the lighter tones are left as patches of white canvas. These will be filled in later to tone with the rest of the image as it is developed.

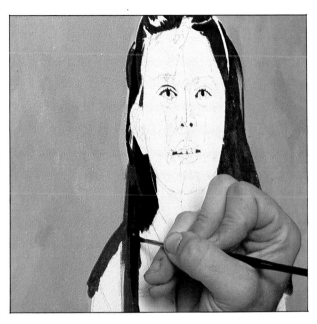

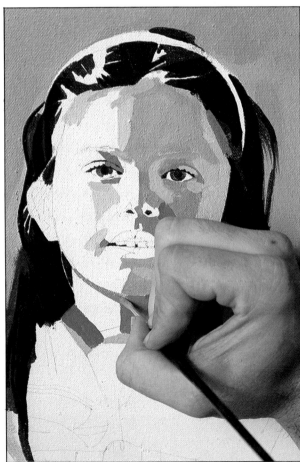

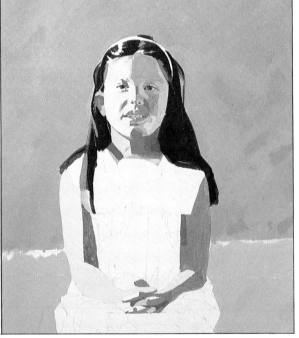

4 Here the artist paints dark and medium flesh tones mixed from varying quantities of cadmium red, yellow ochre, cadmium orange, titanium white and cobalt blue *left*.

5 The general skin tones of the face and arms are now established *above*. Areas of white canvas are left to represent highlights.

6 The basic colours and tones of the dress are painted in a mixture of turquoise, cerulean, Payne's grey and titanium white *right*. The light dress tone is achieved by adding extra white to the basic mixture.

7 The basic overall tones are established in a series of built up patches of flat acrylic colour *below,* and the artist is now ready to work into the image in the more malleable oil paint. Notice how the artist has not, so far, attempted to blend the tiny areas of acrylic colour. Instead, they are left to merge 'optically', in the viewer's eye.

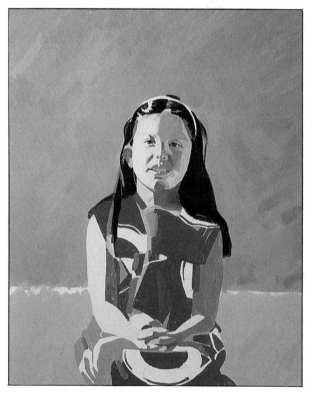

8 Working with a No. 2 sable brush, the artist builds up the facial details, *above*, referring continually to the photographic reference.

THE MOUTH

The mouth in this portrait is gradually built up from three basic skin tones – light, medium and dark. These are mixed from white, cadmium red, yellow ochre, cadmium orange and cobalt blue, the amount of white determining the actual tone. The artist starts by filling a middle tone, adding the highlights and, finally, the dark shadows.

This method of working depends on accurate drawing for its success. Another artist might take a completely different approach, possibly starting with the broad form of the mouth, and the developing this to create the lips, with the highlights being added last. The most important thing to remember is that the mouth is not a flat shape, and that the lips and the face around the mouth have distinct form and volume.

9 The artist uses masking tape to achieve the straight edges of the brown band along the seat. The tape is carefully removed to avoid smudging the paint *left*. The horizontal brown strip stands out from the pale background, strengthening the composition.

10 Moving from one area to another, the artist continues to develop the tone and detail, improving the form and adding increased depth to the image. Here, *right*, the artist strengthens and blends the contours of the face.

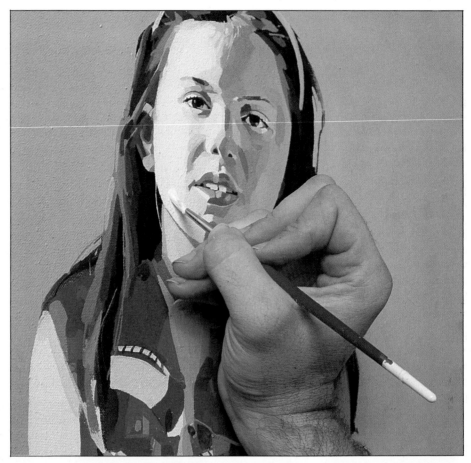

11 Using a No. 3 bristle brush, the artist adds white highlights to the dress *below*. The oil colour is brighter than the flat white of the canvas primer, the added contrast giving vibrancy and sparkle to the coloured dress. Because the acrylic underpainting is now quite dry, the artist is able to take the oil colour over the edge of the blue to make a crisp, clean shape.

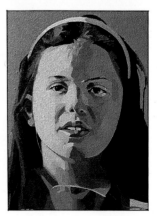

12 The close-up, *above*, shows how the skin tones benefit from a combination of flat, acrylic underpainting and final detail, added in oil.

What the artist used

The artist worked on pre-stretched Herston flax canvas, manufactured by Daler. This support measured approximately 56cm×46cm (22in×18in). For the acrylic blocking-in, he used a palette of black, titanium white, raw umber, Payne's grey, burnt umber, cadmium red, yellow ochre, cadmium orange, cobalt blue, turquoise and cerulean blue. Oil colours were titanium white, ivory black, raw umber, Payne's grey, cadmium red, burnt umber, yellow ochre, cadmium orange and cobalt blue. Brushes used were Nos. 2 and 3 bristle and a No. 2 sable. The preliminary drawing was done with an F pencil.

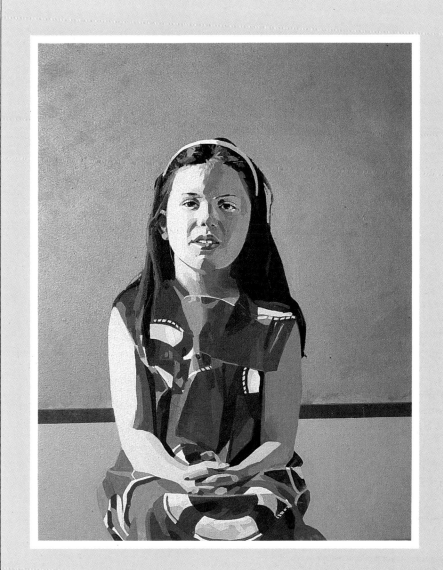

Melissa, from a Photograph

75

The Wedding Portrait

It is possible to paint creatively from photographs without slavishly reproducing their entire contents or being restricted by the unselective, uniform image usually produced by the camera. For instance, in this wedding photograph the artist has chosen to simplify the background, selecting only certain elements and making these more graphic than they appeared in the original snapshot. The result is a picture with striking formality and an unusual, almost surrealistic setting.

However, the photograph has been given a much more central role in the finished product than is usual for portrait painters. Many painters use photographs as reference only, as the equivalent of rough sketches or shorthand notes, from which to work when the subject is not present. In this case, one particular photograph has been chosen, and its main features have been retained and even built upon, though adapted to give the picture a more personal and permanent feel. The painting represents something consciously put together rather than a recording of a random moment in time.

Because acrylic dries so quickly it is possible to build layer upon layer of thin colour rapidly, without long waiting periods between the various stages. This is particularly useful to the portrait painter, who has to depict the subtle and varied tones of skin by building up layers to produce a translucent look.

The artist applied thin colour throughout all the early blocking-in stages of this picture, creating a basis to work into in the later stages. First, he established a dark neutral tone for the shadows around the features of the couple and for their hair. This was quickly followed by some approximate dark skin tones and the background. The only splashes of colour are the flowers and the bridegroom's tie, and the artist suggested the pinks and greens of the flowers quite early in the process, instead of adding them as a finishing touch. The pink therefore became an integrated tone in this early stage.

The finished picture looks realistic, but is in fact composed of fairly broad areas of tone. The painter cannot see and select detail which has been blurred or lost by the small scale of the photograph. He is faced with the problem of simplifying illegible detail into a flat area of colour which, when viewed from a certain distance, fits into the whole and becomes an integrated part of the image.

1 A postcard-sized photograph, *right*, was the artist's only reference when painting this souvenir wedding portrait as a present for the bride and groom.

2 The artist starts with an outline pencil drawing on Daler board, and then uses a No. 6 synthetic round brush to block in the darkest areas of the hair and face with a mixture of raw umber and Payne's grey *below left*.

3 Deeper skin tones are blocked in with a mixture of raw umber and burnt sienna. The background is loosely painted in Payne's grey and raw umber with a 2cm ($^3/_4$in) synthetic brush *below*.

4 Looking constantly at the photographic reference, the artist develops the skin tones. Because the photographic image is so small, it is not possible to make an exact copy of the image. Instead, the artist translates what is visible in the photograph into general terms rather than making a possibly inaccurate guess at what might be there. Here, *left,* the light flesh tones are blocked in with a mixture of white, raw umber, burnt sienna and cobalt blue.

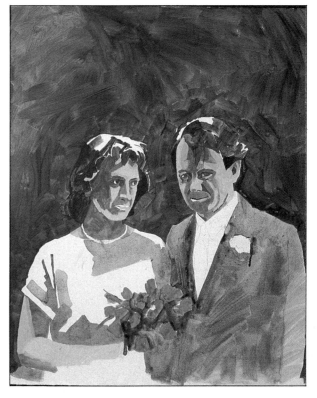

5 A touch of cadmium red is mixed with white for the flowers. The clothes are applied in broad terms with a large brush *above.* As the colour is applied, the artist uses a clean wet brush to alter the tones within the clothing by diluting the lighter areas.

6 The painting is taking shape, with the broad areas of colour and tone already established *right.* Because acrylic dries so quickly, this underpainting is ready to be developed, and the artist can start to add detail and make final adjustments immediately.

MASKING LINES

To paint the panes of the grey background window, the artist uses thin strips of masking tape. In order to obtain an even, mechanical line, it is essential that the width of the strip is consistent. The strips of tape are pressed firmly onto the support to stop the colour from seeping underneath. The area covered by the tape will be protected and therefore unaffected by any colour applied over it. When using masking tape, you should mix the paint to a thick, creamy consistency, because watery colour will run under it and spoil the clean edge.

7 *Left*, skin and hair are treated in approximate terms. Because the image is enlarged from a photograph, the planes of light and shade cannot be accurately blended, and the artist makes no attempt to obtain a tidy finish.

8 The artist develops the tonal depth across the whole painting *below left*. Flesh tones are strengthened, and dark grey shadows across the front of the groom lend a feeling of form and solidity to the subject. The groom's tie adds a dash of colour.

What the artist used

A palette of cobalt blue, Payne's grey, cadmium red medium, yellow ochre, burnt sienna, black, raw umber, titanium white and cadmium orange was chosen for this double portrait. The artist worked on Daler board, measuring 56×46cm (22in×18in), using a 2cm (¾in) brush for the large expanses of colour. Other brushes include sable rounds, Nos. 4 and 6; bristle flats, Nos. 4, 6 and 8; and a No. 6 round synthetic. An F pencil was used for the initial drawing.

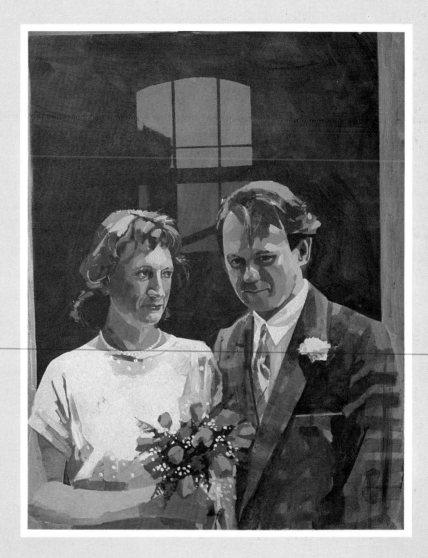

The Wedding Portrait

Pippa in a Pink Shirt

The texture of the paint is very much part of this portrait of a girl in a pink shirt. There was comparatively little drawing of detail before the application of the paint, which has been applied in thick strokes with brush and palette knife. The artist used the direction of the paintstrokes to describe the form and contours of the subject. The thick — or impastoed — surface gives a full and lively appearance.

Impasto done with oil paints has always suffered from the problem of being so slow-drying — exceptionally thick paint can take months to dry properly. Acrylic paint, on the other hand, is ideal for this type of painting and has become popular with modern painters who want to create impasto effects. It is best not to try to move or manipulate acrylic paint once it has been applied to the support. Impastoed acrylic has a crisp, fresh appearance which can be destroyed by attempting to move it while it is drying.

The artist began by doing a very quick drawing in charcoal, and then roughing in with a large brush those areas of background immediately surrounding the figure. This was done with broad, textural strokes of colour. The artist was then able to establish some initial tones on the figure — flesh, skin and shirt. The paintstrokes were left sketchy and unfinished, to maintain the fresh, spontaneous paint surface. The artist built up the flesh tones with a large brush in broad planes of cool mauves and warm pinks which picked up the colour of the shirt. Instead of mixing smooth blended colour, he often applied partially mixed, raw paint scraped from the palette with a knife, incorporating accidental streaks of colour to give a freshness to the whole.

By comparison, there is more detail in the facial features, which have been delineated with a small bristle brush. This brings the face into focus and provides a contrast with the sketchy treatment of the clothing and background.

1 To set off the bright pink shirt to advantage, our artist asked the model to sit in neutral coloured surroundings, against a white wall *right*.

2 Working onto primed hardboard, the artist starts by sketching in the basic composition with charcoal *below*. Mistakes are corrected by rubbing out the lines and redrawing.

3 Before embarking on the figure, the artist first establishes some of the background tones *above*. All other colours and tones can be related to these initial marks.

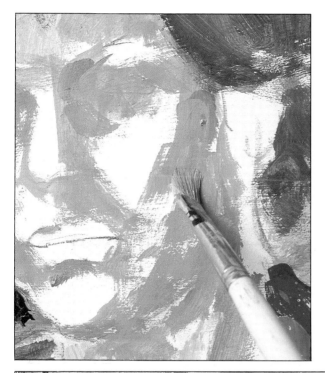

4 The cooler skin tones are blocked in with a No. 8 bristle brush *left*. These cool shadow tones are mixed from white, yellow ochre and crimson – the lighter highlights are predominantly white and yellow ochre with a touch of burnt sienna.

5 A soft sable brush is used to define the contours of the lips and inside edge of the mouth *below*. This artist applies colour in short, thick strokes, frequently defining the outline and linear features in a darker colour. Patches of white canvas primer are occasionally allowed to show through between the dense paint marks.

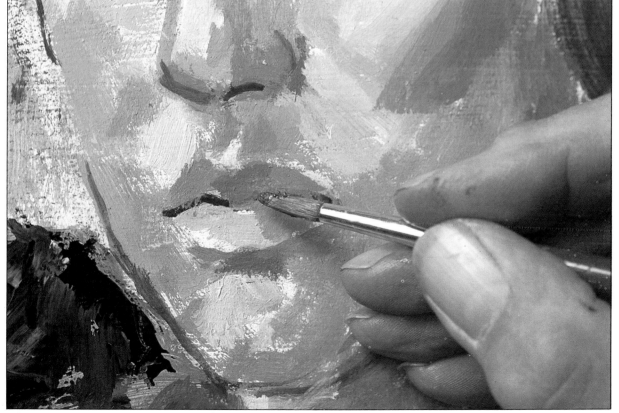

PAINTING WITH A KNIFE

Painting knives and palette knives are especially useful for applying thick, impastoed colour to create a lively and spontaneous paint surface. Here the artist uses a painting knife to lay in the pink blouse and background area. Acrylics lend themselves to this approach, being quick-drying and therefore ideal for direct, immediate colour application which requires no further blending or working on the canvas.

For an especially thick, textural effect, the acrylic paint can be mixed with texture or modelling paste. This is thicker than the actual paint and transforms the colour into a stiff substance which retains the shape of the knife.

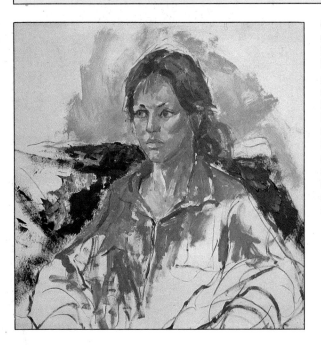

6 The artist works across the canvas, developing the background in relation to the bright pink of the girl's shirt *left*. The broad folds of fabric are applied with a painting knife, creating solid wedges of flat colour which help to create a richly varied surface texture. Painting knives are available in a range of sizes — some types are more flexible than others — and are invaluable when solid or smooth areas of colour are required.

What the artist used

The artist worked on the smooth side of hardboard, measuring 76cm×61cm (30in×24in) and primed with acrylic gesso. The acrylic colours — white, ultramarine, Hooker's green, burnt sienna, yellow ochre, raw sienna, black, crimson and permanent rose — were applied with flat bristle brushes, Nos. 6, 8 and 10, and a No. 4 sable round.

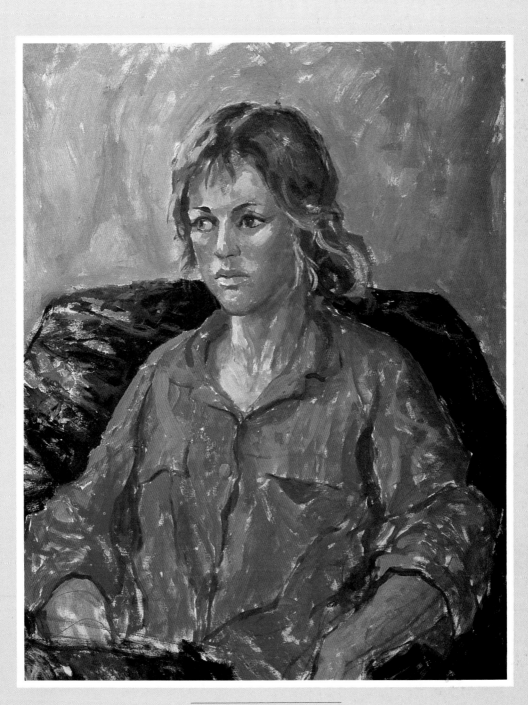

Pippa in a Pink Shirt

Pause from Work

In this portrait, a complete change from the formal type, the subject pauses for a break from work in her busy environment. The picture makes this immediately clear, in other words, the artist has set out to 'tell a story'. In doing this, he is following a well-established tradition of portrait painting. The Dutch Master, Jan Vermeer (1632-75), specialized in placing figures in everyday settings which instantly established their jobs and roles in life: some doing housework, some playing musical instruments and so on. One of the most famous of these genre paintings is *Maid Servant Pouring Milk*.

But, like most paintings, the picture here is not simply a narrative or a portrayal of the woman herself, it is a study in neutral colours. Greys and beiges run quietly and harmoniously through the background, and the fawn of the wall is echoed in the reflections in the glass and video screen. Moreover, the area around the typewriter and glass could be isolated as a tiny still life in its own right — just as in some of the Dutch Masters' works, objects such as food, jugs and kitchen utensils could form miniature still lifes within a bigger picture.

Because this is a picture of an interior as well as a portrait, the setting is important. The background does not exist simply as a backdrop — its detail is a crucial part of the whole. The artist has avoided treating the figure differently from the rest of the composition. The flesh colours of the face and arms are simplified to a very limited range of tones so that the figure does not stand out too much from everything else.

Graphic devices have been used to a considerable extent here. The artist has used flat areas and planes of tone to suggest rounded form, rather than building up a gradual blend — the forearm is divided into three distinct tones of light, medium and dark. In another graphic formula, the artist has used the direction of the red lines on the check shirt to describe the three-dimensional volume of the body underneath. He simply painted an area of pale grey shadow on the space occupied by the shirt, and then relied almost entirely on the red lines.

1 This informal portrait of the young woman pausing from work in her busy environment was painted from the photograph *right*.

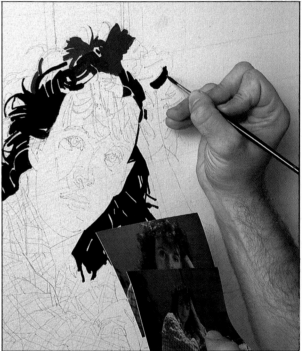

2 *Left*, a pre-drawn tracing paper grid, available from graphic supply shops, is used to ensure an accurately transferred image. The artist lays the grid on the photograph, then draws a corresponding number of squares onto the support. The image is transferred square by square.

3 When the detailed drawing is complete, the artist starts to block in colour. Dark hair tones are painted in black, raw umber, burnt sienna, titanium white and cobalt blue *above*. The artist works accurately with a No. 4 flat bristle brush and a No. 6 synthetic round brush.

4 When the lighter hair tone is established, the artist blocks in the background colour *right*. This is done to eliminate the distracting whiteness of the primer. The overwhelming expanse of bright white makes it difficult to assess the real value of new tones and colours as they are applied, and the artist is anxious to establish an accurate mid-tone.

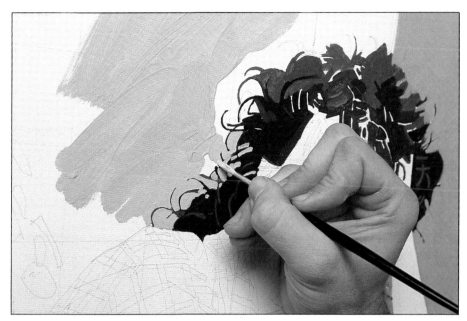

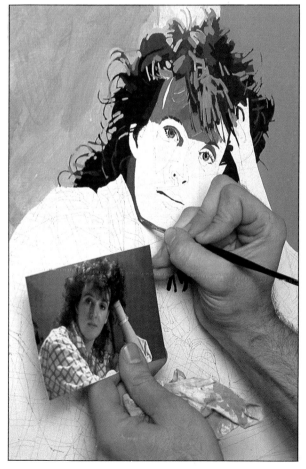

5 The light hair tones are elaborated to reflect some of the surrounding background colour. With a mixture of Hooker's green, ivory black and raw umber, the artist carefully paints in the shape of the climbing plant *above*. Traces of the background colour are introduced into the leaves.

6 Chrome orange, yellow ochre, cadmium red and cobalt blue make the basic skin tone *right*. Working closely from the photograph, the artist blocks in the shaded side of the face. The success of the portrait depends on absolute accuracy when picking out the shapes of the various planes.

MASKING SHAPES

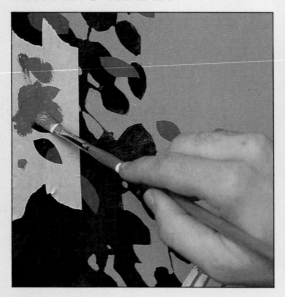

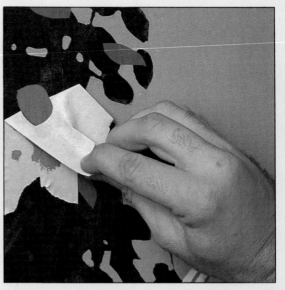

For foliage and other complicated and repeated shapes, crisply defined edges can be effective. Here the artist has selected a few leaves, giving them a clean, cut-out edge which 'lifts' the otherwise flat mass of foliage, creating the illusion that all the leaves are more finished than they actually are.

Wide masking tape is used for this, and the leaf shapes are cut out with a sharp scalpel. The tape is pressed firmly into position and the thickish light green paint applied with a bristle brush. The tape is removed when the paint is dry.

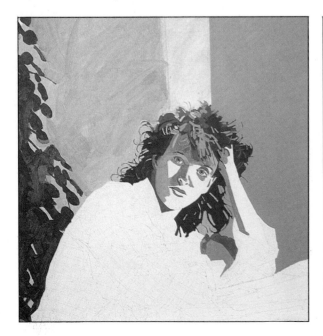

7 A lighter, 'middle' skin tone is mixed by adding white to the basic colour. This is established in relation to the dark shadow area *left*.

8 The finished face is made up of just three basic tones — light, medium and dark — carefully rendered to describe the facial form *above*.

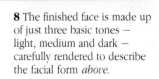

9 Grey wash is applied to the shadow areas of the shirt. The colour is thin enough to allow the drawn stripes to show through (this drawing acts as a guide to the painted red stripes). Using thin, flowing lines the artist paints in the checked pattern in cadmium red with a No. 3 sable brush *below*. The direction of the stripes is important because it describes the underlying form.

10 The figure and most of the background is now complete *below*. The bright red check becomes a focal point of the painting, drawing the viewer's eye towards the young woman, the subject of the portrait.

11 In muted, neutral colours, the artist starts to block in the objects on the desk *bottom*. The colours reflect the surrounding wall colour and some of the neutral tones in the composition.

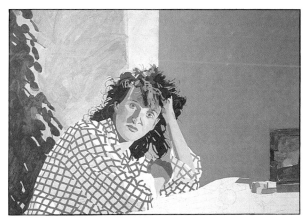

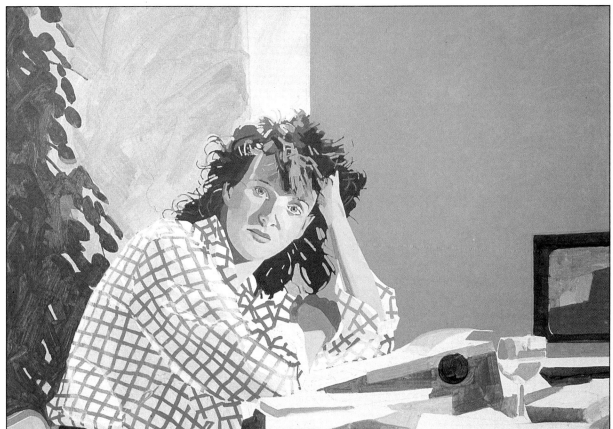

12 The collection of objects on the young woman's desk form a tonal composition, a miniature still-life within the main painting *right*. This arrangement adds an unusual touch without drawing attention from the subject. Notice how the colourless nature of the wine glass is suggested by the use of distorted shapes of various background colours; the rounded shape of the glass is indicated by the use of well-observed shapes of flat tone.

13 Using a plastic ruler, the artist carefully paints five lines on the blind *above*. To paint continuous, even lines in this way, it is necessary to mix the paint to a thin, runny consistency. Here the artist uses a No. 6 synthetic brush, holding the ruler off the surface of the painting. If the loaded brush comes into contact with the edge of the ruler while the ruler is resting on the support, the paint will form blobs and run underneath.

14 A close-up of the woman's face shows how the form is systematically built up from flat patches of colour *below*. By making a detailed and accurate drawing of the subject in the early stages, the artist was free to manipulate the limited range of tones in order to create a solid, convincing form. Strong, directional light illuminates one side of the face, emphasizing the contrast between the light and dark tones.

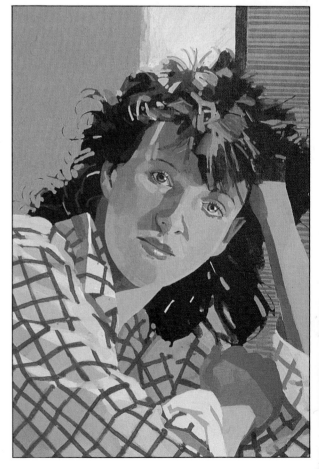

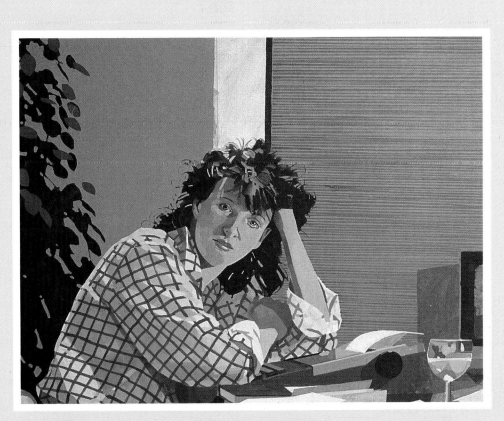

Pause from Work

What the artist used

For this portrait the artist worked on Daler board measuring 64cm×76cm (25in×30in). The board was primed for use with either oil or acrylic paints. This was supported on a 'Gallery' studio easel for the duration of the painting. An initial pencil drawing was made with a F graphite pencil. The artist worked from a palette of ivory black, raw umber, burnt sienna, titanium white, cobalt blue, Payne's grey, Hooker's green, chrome orange, yellow ochre, cadmium red and cadmium yellow. He used a selection of brushes, the main ones being a No. 4 flat bristle, and a No. 6 synthetic round. Most of the details and linear work, such as the precise leaf shapes, were painted with a No. 2 sable brush.

Family Group

The picture shown here is in fact a preliminary sketch, painted in acrylic, which will be used later as the basis for a commissioned painting. Acrylic is ideal for this type of sketch, because its quick-drying quality allows colour and tone to be changed readily.

'Note-taking' is how the artist refers to this form of sketching with acrylic. The sketch has been put together from rough pencil drawings and a selection of photographs. The artist has experimented with these elements to see how they work together, in an attempt to arrive at a satisfactory composition. The sketch also provides an opportunity to try out colours and tones at this stage.

A sketch of this sort is a useful way of approaching a larger portrait, especially a commissioned one in which it is risky to leave too much to chance. However, the artist will have to overcome the problem of transforming the sketch into a larger painting. He himself has pointed out that 'what works on a small scale does not always work on a large one'. For instance, the faces of the subjects have been reduced to the barest essentials. The artist will have to return to detailed photographs to develop the features and character of the individuals.

The members of this family particularly wanted to be portrayed in front of their home. The artist has treated the house in such a way that it dominates the background. It is built up with big geometric shapes of starkly contrasting tone. He has offset these shapes with the bright blue reflections of the window panes, which pick out the blues that appear in the clothes of three of the subjects.

The grouping plays an important part in this picture. The artist has avoided a 'snapshot' type of informality, in order to produce a more considered, permanent-looking product. He has placed the group formally, with one exception — a deliberate means of providing a diversion. The figure on the right, instead of sitting next to the others on the seat, is perched casually on the arm of the bench with the direction of the arms and legs pointing downwards towards the corner of the composition. The spiral staircase and the wrought-iron window balconies provide a delicate, linear relief which contrasts with the solid areas of tone making up the rest of the picture.

1 The family, *right,* asked our artist to paint their portrait. This painting is a preliminary colour sketch for the main commission.

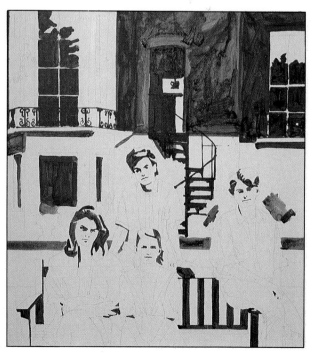

2 Combining information from two photographs — one of the family, one of their home — the artist puts together a composition with the members of the family sitting in front of the house. He makes a detailed line drawing directly onto the support, and starts to block in the dark tones with a thin mixture of ivory black and raw umber *right.*

SIMPLIFYING THE FACE

For quick colour sketches, or paintings in which the figure is small and relatively unimportant, it is sometimes useful to try and see, and then paint the face, in the simplest possible terms without losing its identity or form.

If we follow the progress of one of the faces in this group portrait, we see how the artist tackled this problem. The shadow areas are established first in a thin mixture of raw umber and ivory black. Light and medium flesh tones are then added to this, each area of tone being represented by one or two simple brushstrokes.

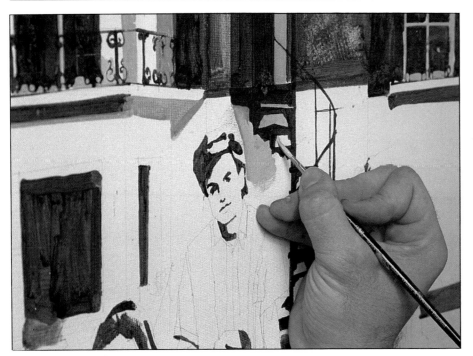

3 Starting with the background, the artist continues to fill in small areas of tone and colour *left*. The main house tones are Payne's grey, raw umber, white and yellow ochre. Window reflections are cerulean blue, Payne's grey and white. A No. 2 brush is used for fine details. Larger areas are painted with a No. 3 flat bristle. Linear details, such as the spiral staircase and wrought-iron balcony, are important to the composition, and painted with care and precision.

4 The artist starts to block in the flesh tones and shadow areas of clothing *right*. Flesh is mixed from white, chrome orange, yellow ochre, cadmium red and cobalt blue.

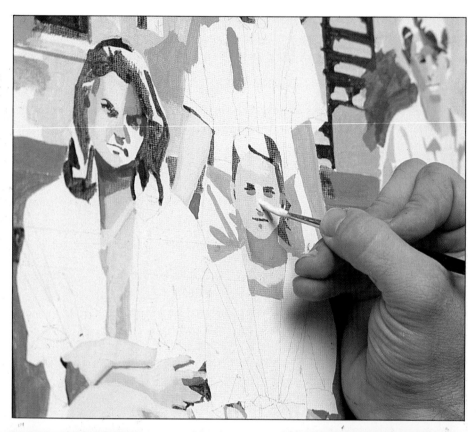

5 *Below left*, remaining areas are blocked in, each one carefully related to the rest of the painting. The major areas are now established, and the picture is ready to receive some finishing touches and final details.

6 A No. 2 sable brush is used to refine the tonal planes of the faces. For a preliminary sketch, such as this, the general distribution of tone is more important than exact detail *below right*.

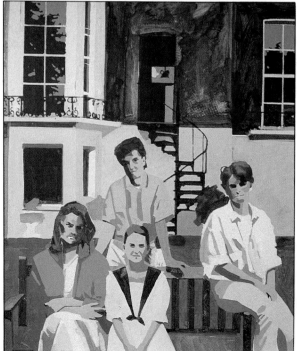

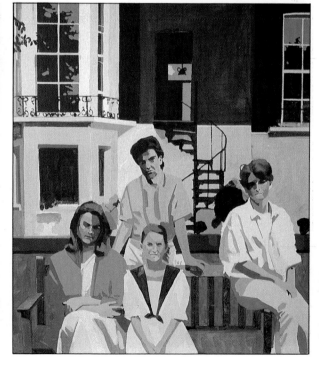

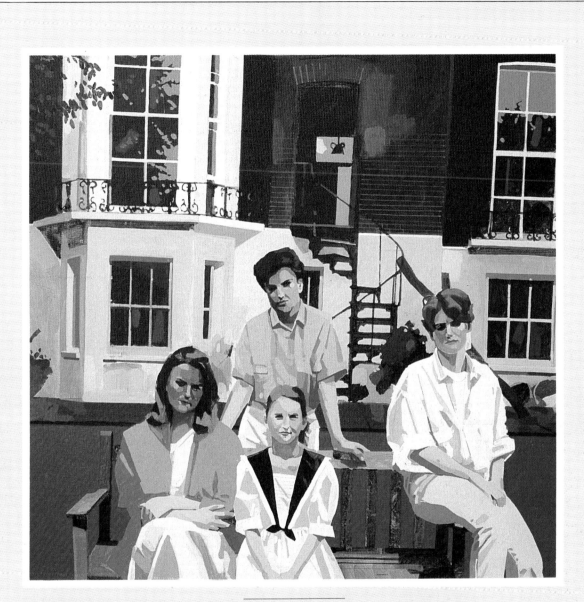

Family Group

What the artist used

A Daler board, cut down to 51cm square (20in square) was the support. Ivory black, raw umber, Payne's grey, titanium white, yellow ochre, cerulean blue, permanent green bright, chrome orange, cadmium red and cobalt blue were applied with sable brushes Nos. 2, 4 and 6; and flat bristle brushes, Nos. 4, 6, 8.

CHAPTER EIGHT

WATERCOLOUR
AND
GOUACHE

Watercolour is a unique and somewhat unpredictable medium which has always held a special fascination for artists. The element of uncertainty and the accidental effects often achieved with watercolour paints make them exciting to use, and watercolour paintings have a beautiful translucence impossible to achieve in any other medium. Many of the Old Masters used watercolour to make preliminary sketches before embarking on larger oil paintings, but others painted in watercolour alone, using it as a medium in its own right.

There are two types of watercolour, both of which are soluble and bound with gum arabic. Pure watercolour is transparent, and is applied in thin layers of colour, usually on white paper. Gouache, or body colour, contains chalk, which makes it opaque. Many artists have successfully combined the two.

A comparison between the portrait of the child on page 103 and that of the young man on page 123 provides an example. The former is worked mainly in pure watercolour, the artist building up the image in thin washes of paint and using the light tones of the paper as a basis for the shirt and the highlights on the face and hair. She worked in the traditional watercolour manner, from light to dark, to produce a delicate portrait from transparent layers of colour. The second portrait was painted in gouache, and the difference between the two paintings is immediately apparent. Here the colour is opaque, and the artist has used light tones over dark ones to establish the form of the subject, painting pale highlights onto the darker red of the shirt, and using solid blocks of opaque colour for the skin tones.

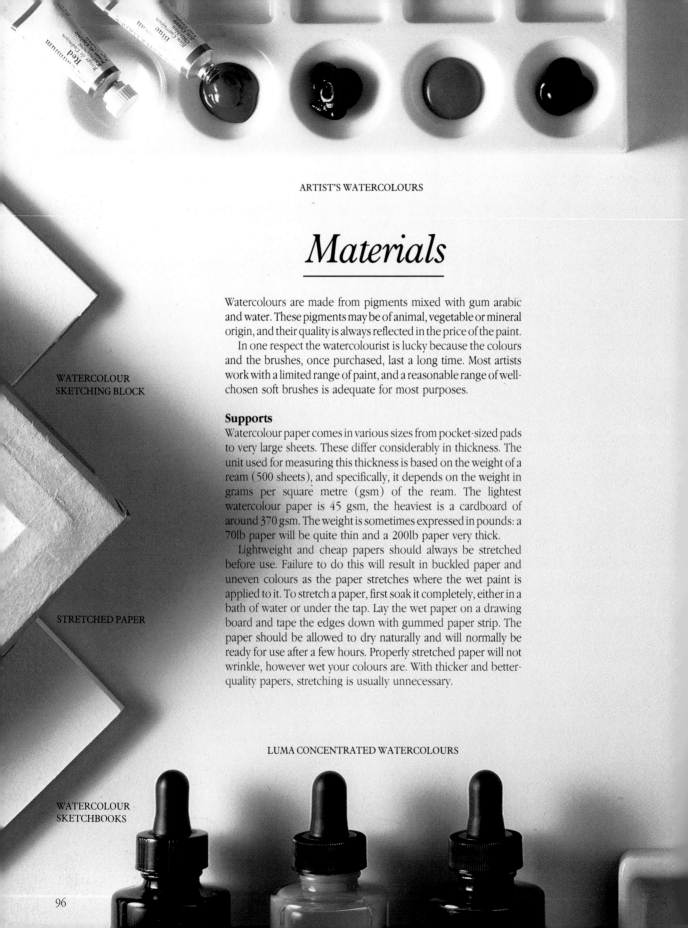

Materials

Watercolours are made from pigments mixed with gum arabic and water. These pigments may be of animal, vegetable or mineral origin, and their quality is always reflected in the price of the paint.

In one respect the watercolourist is lucky because the colours and the brushes, once purchased, last a long time. Most artists work with a limited range of paint, and a reasonable range of well-chosen soft brushes is adequate for most purposes.

Supports

Watercolour paper comes in various sizes from pocket-sized pads to very large sheets. These differ considerably in thickness. The unit used for measuring this thickness is based on the weight of a ream (500 sheets), and specifically, it depends on the weight in grams per square metre (gsm) of the ream. The lightest watercolour paper is 45 gsm, the heaviest is a cardboard of around 370 gsm. The weight is sometimes expressed in pounds: a 70lb paper will be quite thin and a 200lb paper very thick.

Lightweight and cheap papers should always be stretched before use. Failure to do this will result in buckled paper and uneven colours as the paper stretches where the wet paint is applied to it. To stretch a paper, first soak it completely, either in a bath of water or under the tap. Lay the wet paper on a drawing board and tape the edges down with gummed paper strip. The paper should be allowed to dry naturally and will normally be ready for use after a few hours. Properly stretched paper will not wrinkle, however wet your colours are. With thicker and better-quality papers, stretching is usually unnecessary.

WATERCOLOUR
SKETCHING BLOCK

STRETCHED PAPER

LUMA CONCENTRATED WATERCOLOURS

WATERCOLOUR
SKETCHBOOKS

The texture of watercolour papers, which varies widely, is important. Some are very rough, with an irregular, 'pitted' surface which is favoured by many painters. Others are completely smooth, and are generally preferred by graphic artists.

Handmade papers, usually identifiable by their irregular edges, are superior to those manufactured on a machine, and are, of course, much more expensive. They are often made of rag and are free from many of the impurities contained in factory produced paper. To find out which is the right side — the side which has been sized — hold the sheet up to the light and look for the watermark, which should read the right way round.

Machine-made papers are usually cheaper, and the better quality ones are very good indeed. They are available in three main categories — Hot-Pressed, Cold-Pressed (also called Not), and Rough. The Hot-Pressed type tends to be very smooth, and is only suitable when a particularly flat finish is required. The most popular is Cold-Pressed, and the majority of watercolour papers fall into this category. Rough paper, as the name suggests, has a very irregular surface and is used when a particularly rugged effect is required.

Watercolour papers are traditionally white or off-white. Coloured or tinted paper is sometimes used for gouache and other opaque paints.

Paints

Genuine watercolour contains no chalk or other opaque ingredient which would threaten its pure, transparent quality. It is sold in four forms: pans or half-pans of moist colour, cakes of dry colour, tubes, and bottles of liquid colour.

Dry cakes are the least expensive, but are usually inferior and require much 'working' with water before yielding a strong

WATERCOLOUR
PAPERS

HOT-PRESSED

NOT

ROUGH

CONCENTRATED WATERCOLOUR

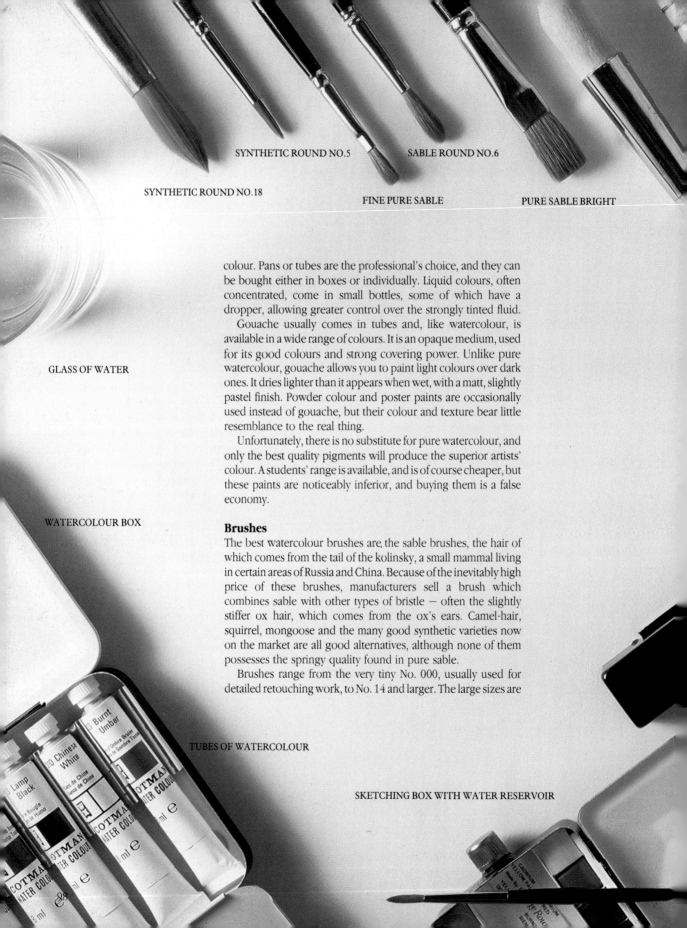

SYNTHETIC ROUND NO.5 SABLE ROUND NO.6

SYNTHETIC ROUND NO.18

FINE PURE SABLE

PURE SABLE BRIGHT

GLASS OF WATER

WATERCOLOUR BOX

TUBES OF WATERCOLOUR

SKETCHING BOX WITH WATER RESERVOIR

colour. Pans or tubes are the professional's choice, and they can be bought either in boxes or individually. Liquid colours, often concentrated, come in small bottles, some of which have a dropper, allowing greater control over the strongly tinted fluid.

Gouache usually comes in tubes and, like watercolour, is available in a wide range of colours. It is an opaque medium, used for its good colours and strong covering power. Unlike pure watercolour, gouache allows you to paint light colours over dark ones. It dries lighter than it appears when wet, with a matt, slightly pastel finish. Powder colour and poster paints are occasionally used instead of gouache, but their colour and texture bear little resemblance to the real thing.

Unfortunately, there is no substitute for pure watercolour, and only the best quality pigments will produce the superior artists' colour. A students' range is available, and is of course cheaper, but these paints are noticeably inferior, and buying them is a false economy.

Brushes

The best watercolour brushes are the sable brushes, the hair of which comes from the tail of the kolinsky, a small mammal living in certain areas of Russia and China. Because of the inevitably high price of these brushes, manufacturers sell a brush which combines sable with other types of bristle — often the slightly stiffer ox hair, which comes from the ox's ears. Camel-hair, squirrel, mongoose and the many good synthetic varieties now on the market are all good alternatives, although none of them possesses the springy quality found in pure sable.

Brushes range from the very tiny No. 000, usually used for detailed retouching work, to No. 14 and larger. The large sizes are

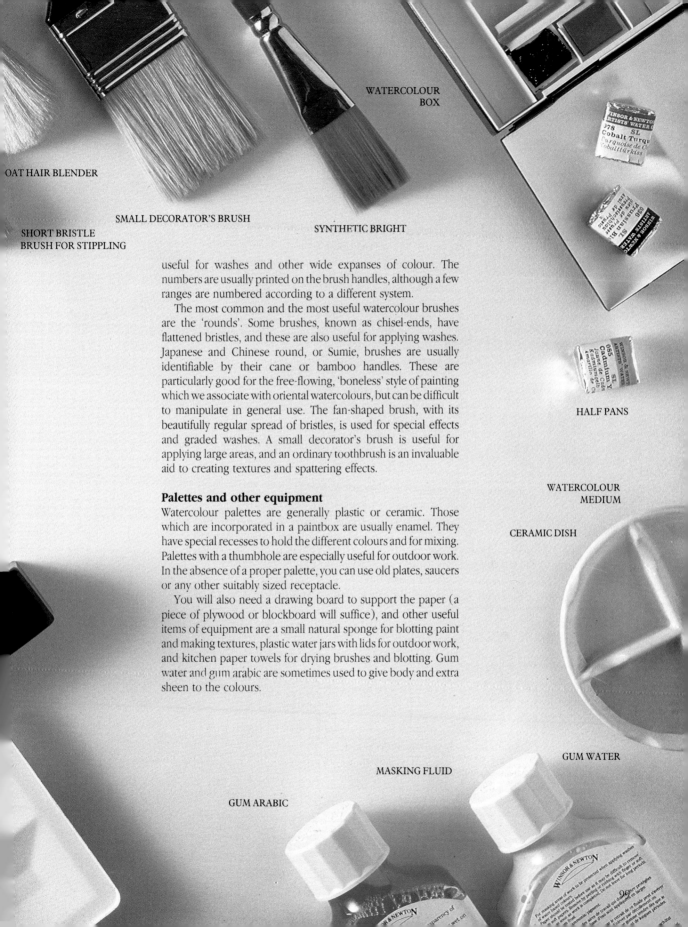

OAT HAIR BLENDER

SMALL DECORATOR'S BRUSH

SHORT BRISTLE
BRUSH FOR STIPPLING

WATERCOLOUR
BOX

SYNTHETIC BRIGHT

HALF PANS

useful for washes and other wide expanses of colour. The numbers are usually printed on the brush handles, although a few ranges are numbered according to a different system.

The most common and the most useful watercolour brushes are the 'rounds'. Some brushes, known as chisel-ends, have flattened bristles, and these are also useful for applying washes. Japanese and Chinese round, or Sumie, brushes are usually identifiable by their cane or bamboo handles. These are particularly good for the free-flowing, 'boneless' style of painting which we associate with oriental watercolours, but can be difficult to manipulate in general use. The fan-shaped brush, with its beautifully regular spread of bristles, is used for special effects and graded washes. A small decorator's brush is useful for applying large areas, and an ordinary toothbrush is an invaluable aid to creating textures and spattering effects.

Palettes and other equipment

Watercolour palettes are generally plastic or ceramic. Those which are incorporated in a paintbox are usually enamel. They have special recesses to hold the different colours and for mixing. Palettes with a thumbhole are especially useful for outdoor work. In the absence of a proper palette, you can use old plates, saucers or any other suitably sized receptacle.

You will also need a drawing board to support the paper (a piece of plywood or blockboard will suffice), and other useful items of equipment are a small natural sponge for blotting paint and making textures, plastic water jars with lids for outdoor work, and kitchen paper towels for drying brushes and blotting. Gum water and gum arabic are sometimes used to give body and extra sheen to the colours.

WATERCOLOUR
MEDIUM

CERAMIC DISH

GUM WATER

MASKING FLUID

GUM ARABIC

Blowing Bubbles

This portrait, in which the artist has transformed a small snapshot into a finished watercolour, relies heavily on skilled use of certain specific techniques.

The photograph was of the whole figure of the child blowing bubbles, and of the background houses and climbing frame, but the artist used only the upper lefthand corner containing the top part of the child's figure. She overlaid the photograph with a tracing paper grid in order to transfer the image on to a larger scale drawing on another piece of tracing paper. The grid divided the smaller image into 16 squares, and the artist then drew a larger version of each square, thus enlarging the whole scale. Taking the new drawing on tracing paper as a basis, the artist developed and corrected the image, using shading and detail where this was needed to establish the accuracy of the outline.

Now it was time to transfer the drawing to white watercolour board. If she had done this in the usual way, by scribbling over the back of the tracing paper and then going over the outline of the impression with a pencil, she would have ended up with a grey outline and possibly smudges on the paper from the graphite pencil. She avoided this by using iron-oxide paper, which is rather like office carbon paper but produces red-brown outlines. She placed this face downwards on the support with the tracing paper drawing on top, and then carefully traced the outline with a clutch pencil (a special pencil into which a range of leads can be fitted, giving a fine, even line). This gave a faint image on the board.

The artist began the final painting by laying in a very diluted wash over the background and shadows of the face, hair and clothing. This was almost the same colour, with very little variation between the skin tones and the background. She gradually introduced local colour when building up with thin washes from light to dark in traditional watercolour manner. For this she used surgical brushes — brushes once used for examining people's eyes. These have the same adaptability and quality as small Chinese paint brushes.

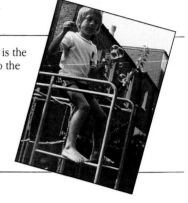

1 A small snapshot, *right*, is the only reference available to the artist for this watercolour portrait of a small child blowing bubbles.

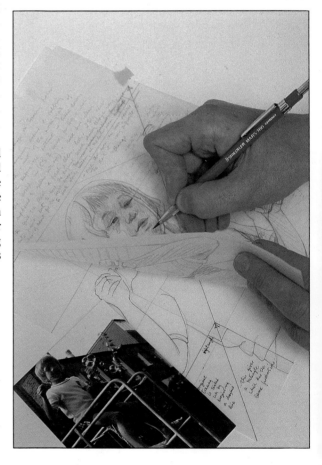

2 Iron oxide paper is used to enlarge the photographic image to the required size *right*. It is important to start with an absolutely accurate outline, and the artist takes particular care at this stage to obtain a clear, precise image.

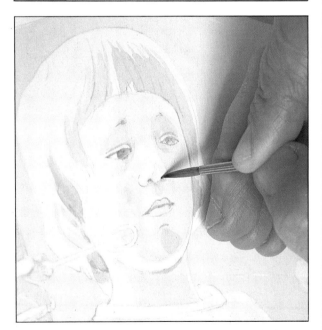

ENLARGING THE IMAGE

The basis for this watercolour portrait is a coloured photograph. The artist first constructs a grid on a piece of tracing paper, to cover the relevant area of the photograph. A similar grid, the same size as the proposed painting, is then drawn onto a second piece of tracing paper and the image enlarged square by square on to this. Any details to be included in the painting are also included in this enlarged drawing. A sheet of tracing-down paper, sometimes called iron-oxide paper, is placed face down on the support. The enlarged drawing is laid on top of this and the artist carefully follows the lines of the drawing. The tracing-down paper acts like carbon paper, producing a light brownish image which is ready for painting.

3 Working onto smooth watercolour board, the artist applies a wash of violet, Indian red and yellow ochre to the background *top*. This will be strengthened later.

4 *Above*, the facial shadows are laid in a combination of the background colours. These are slightly darker than the background tone, and will provide depth to subsequent washes.

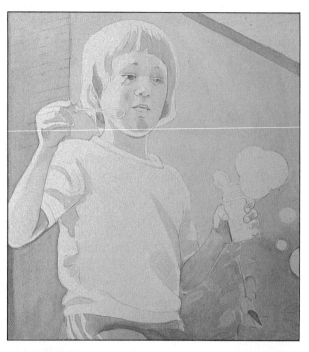

5 This initial wash, *left*, can be applied with a fine sable brush, although our artist actually used a surgical brush, the type once used for examining eyes. This provides the artist with a quality and adaptability similar to that of small Chinese brushes.

6 *Below left*, shadows are touched in with the point of a No. 2 sable brush, in the traditional watercolour manner of dark over light. The artist moves across the image strengthening the tones — here the shadow between the hair and face is being darkened.

What the artist used

The artist used Rowney Artist's watercolours, working mainly with yellow ochre, violet and Indian red. Other colours were cadmium red, alizarin, ultramarine, Payne's grey and sap green. The support was CS2 watercolour board — the portrait was approximately 20cm square (8in square). Brushes were sable rounds, Nos. 1, 2 and 4, and a surgical brush. Other materials were iron oxide paper and a propelling pencil.

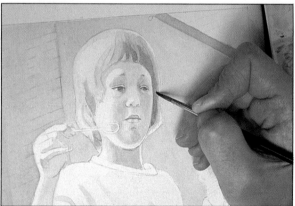

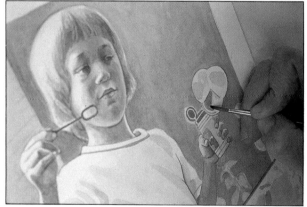

7 When painting details, the artist frequently finds it difficult to see enough information in the small photograph. The eye is touched in with the point of the No. 2 sable brush, but the artist feels the result is too dark, finding it necessary to strengthen some of the surrounding tones to compensate for this *left*.

8 Most of the painting is built up from the three original colours — violet, yellow ochre and Indian red — although small areas, such as the tin of bubbles and the child's jeans, are added in the appropriate local colour *above*. To retain the harmony of the composition, the artist develops and strengthens the tones surrounding these brighter colours.

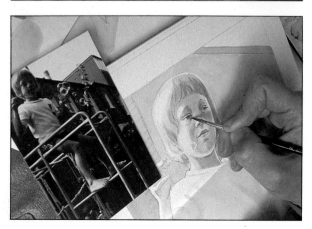

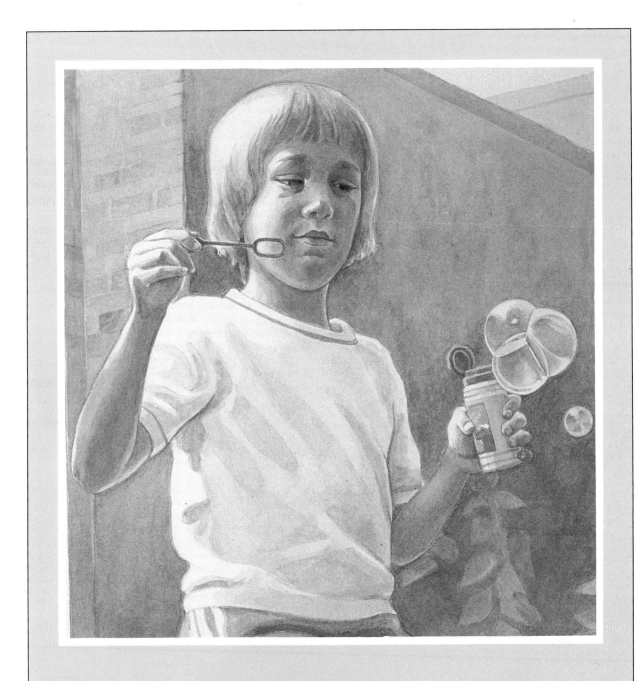

Blowing Bubbles

Against a Striped Blanket

The artist worked from a live model to produce a watercolour in which the colours of the striped blanket in the background play a prominent role. The painting was done deliberately in a low colour key, with the image built from loose washes across the paper surface. The brights have therefore been modified into softer pastel tones, yet work in relationship to each other. The charm of the portrait lies in these delicate differences between the overlapping areas of wash.

One of the main considerations in this work was to keep the model in an exact position, because the subtle light and shade tones on the face had to be stable in order for the slight differences to be seen. The model therefore had to be comfortable. She is sitting on a sofa, and the positions of her arms and feet — although not visible in the painting — were chalked so that she could resume the pose after rests. She was also given a fixed point to look at.

The artist worked on a fairly large scale, almost life-size, which involved blocking in large areas on the paper. The character of the picture is very light, with even the striped blanket interpreted in subtle tones, and the bright blue shirt reduced to the palest shadows.

The first stage was a line drawing, but a minimal one consisting of the merest outline done with a clutch pencil to act as a guide. A very pale graded background wash was applied, starting with yellow and adding small quantities of cobalt blue as the artist moved from left to right. This gave a dimension to the background, so that it did not remain as a flat colour but provided a spatial setting for the subject.

Hair often presents a problem to artists. It is difficult to decide whether to treat it as a mass — as one complete form — or to build it up as separate hairs, giving it an overall texture and trying to work in the many shapes within the main form. Here, the artist treated the tresses as separate forms, blocking in the shadow areas and highlights with fairly substantial wedges of colour.

1 The artist draped a cheerful coloured blanket over the back of the model's chair to brighten this portrait composition *right*.

2 A lightly drawn sketch of the head, shoulders and background is made on stretched Bockingford watercolour paper *left*. The artist reworks the image, using a putty rubber where necessary, in order to get a good likeness of the model at this early stage. When the drawing is complete, the artist rubs out any dark lines, leaving an image which is clear enough to guide the painting, but which will not interfere with the delicate effects of subsequent watercolour washes.

THE EYES

The artist uses a clutch pencil to draw the outline of the eyes. This is done carefully, with special attention to the structure of the eye and the underlying eyeball. Working from light to dark, the artist uses a fine brush to paint the narrow shadow thrown by the eyelid across the eyeball.

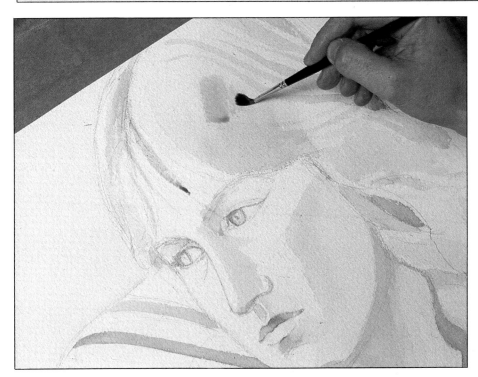

3 When the drawing is complete, a highly diluted background wash is applied in order to eliminate some of the bright white expanse of paper. The artist begins with pale yellow on one side of the picture, adding small amounts of cobalt blue as she moves across the painting. A No. 2 sable brush is used to block in some of the darker areas of the face with a mixture of Indian red, yellow ochre and cobalt blue. The hair is mainly yellow ochre with touches of violet, Indian red and cobalt *left*.

4 The stripes of the blanket are painted in slightly bolder colours *right*. This provides the artist with a guide to the strength of tones to be used elsewhere in the portrait. The artist uses a No. 2 sable brush throughout the work, painting lines and tiny details with the tip of the bristles. Most of the colour is applied 'dry-into-dry', with each layer of wash being allowed to dry before more colour is laid on.

5 Using a mixture of violet, Payne's grey and a touch of Indian red, the artist picks out the darkest shadows of the hair *below*. These are a similar colour to the cool shaded area of the face and blouse.

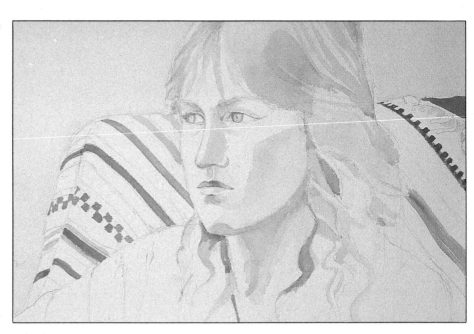

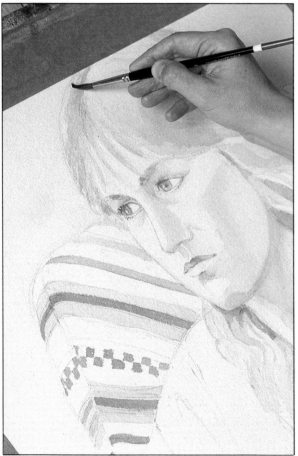

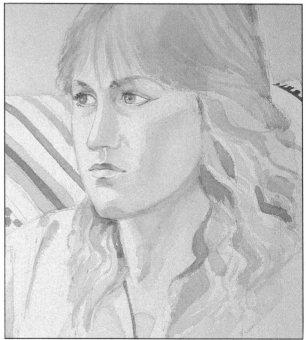

6 The main areas of colour and tone are now complete *above*. The artist feels the image is rather weak, lacking solidity and tonal interest. To complete the painting, she strengthens the flesh tones and darkens the clothing. The hair is worked into with a wider range of cool and warm colours, defining the curls and bringing out the texture of the hair.

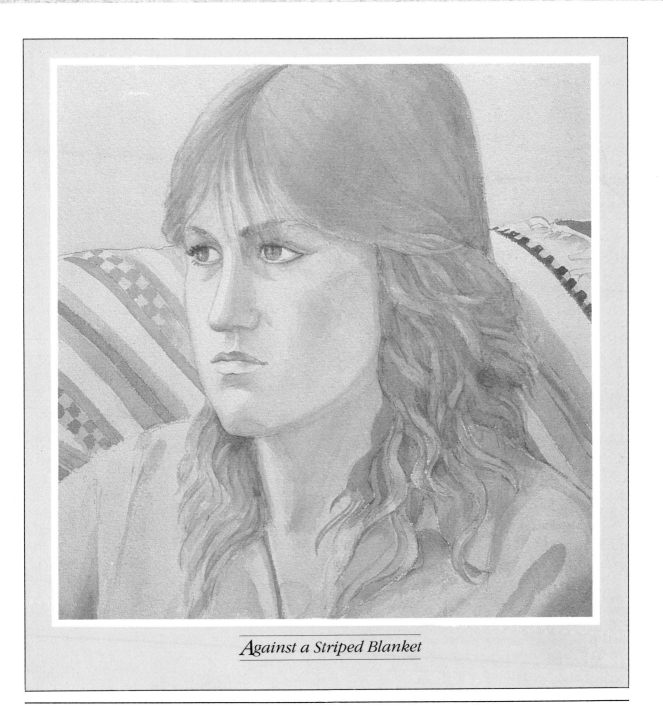

Against a Striped Blanket

What the artist used

The artist worked on stretched Bockingford watercolour paper 46cm×40cm (18in×16in). From a box of watercolour paints, she used Indian red, cadmium red, ultramarine yellow ochre, violet, Payne's grey, cobalt blue, alizarin, and sap green. She used a clutch pencil, a No. 2 sable brush and a putty rubber.

Sitting Cross-legged

'Wet-into-dry' is the term used for the technique employed in this portrayal of a young person sitting cross-legged on a kitchen chair. It describes the process of applying a colour wash over a dry colour, as opposed to 'wet-into-wet', when the colours are allowed to bleed into each other. Because the artist was painting with a lot of wet colour, he used a hair drier in between stages to speed up the process.

The artist began with a pencil drawing which indicated the outlines and tonal areas of the subject. He worked into the drawing with the pale flesh tones of the face and hands, using pale washes in a base colour of orange, alizarin, burnt umber and yellow ochre. When these were dry the darker tones of the T-shirt were added, followed by the mid-tones of the hair in a darker version of the flesh colour. As the shadows built up in an increasing variety of tones, the image began to emerge as a solid, recognizable form.

In a slightly unusual approach, the artist filled in the background after the subject was complete. He used the dark colour of the background to define and develop the contours of the figure. For instance, a small sable brush was used to pick out the spiky form of the hair and fringe, leaving narrow slivers of white paper as the highlights on the hair. In this way, the darkness of the background was actually used as a definitive outline for the central image.

The lettering on the shirt is important in this portrait because it describes the folds and creases and helps to give an impression of the form beneath. Here the artist worked directly by eye, in paint, using his experience to obtain an accurate rendering. Generally it would be necessary to draw the letters in pencil first before committing them to paint.

1 The strong directional light on the seated child, *right*, provides the artist with ample opportunity to use the classical watercolour technique of allowing the white paper to represent highlights.

2 The artist makes a light pencil drawing and starts to apply pale washes of colour *right*. Flesh tones are mixed from cadmium orange, alizarin crimson, burnt umber and yellow ochre; shadows on the clothing are blocked in with cobalt blue, Payne's grey and ivory black.

3 *Opposite*, a darker flesh colour is used for the middle tones of the hair. Shadows are added in raw umber and Payne's grey. Here the artist touches in the lettering on the T-shirt in pure black mixed with gum water.

4 *Far right*, the artist works across the image, strengthening the tones to develop the form. A mixture of black and Payne's grey is used to darken the clothing tones on the shaded side of the subject.

USING THE BACKGROUND TO DEFINE SHAPES

The 'negative space' of the background often provides the artist with a good opportunity to re-draw and re-define the shape of the subject. Here the artist uses a small brush to take the background colour up to the edge of the subject, at the same time tightening up and improving the contours of the boy's face and the line of the leg. Although this method is useful for making small alterations, it is a mistake to attempt any significant changes at this stage.

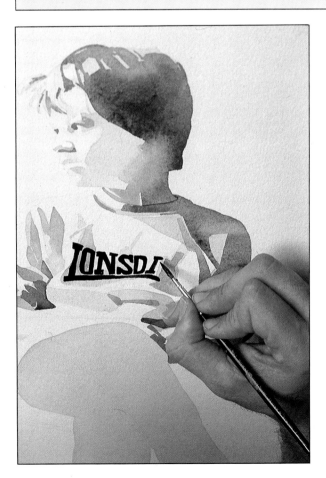

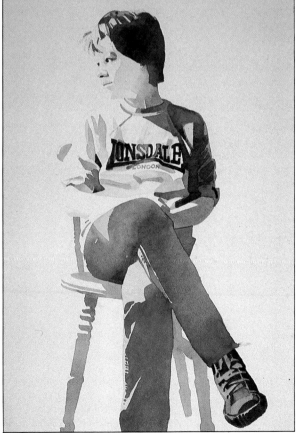

5 When the basic tones have been established, the background is blocked in with Payne's grey mixed with a little black *below*. Using a No. 2 sable brush to take the paint up to the subject, the artist takes this opportunity to redefine and sharpen the outline of the figure.

6 *Right*, the imposition of the strong, dark background causes some of the figure tones to look weak and faded in comparison. To remedy this, the artist strengthens certain of the darkest shadows. For example, the eye and nostril have been picked out with a dense mixture of ivory black and burnt sienna.

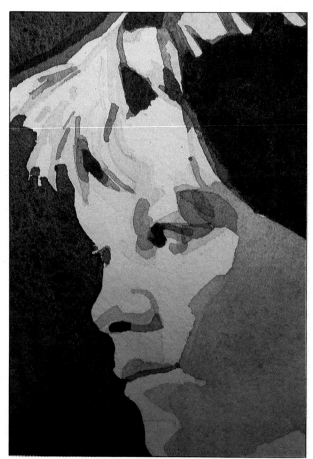

7 Lettering on the T-shirt is painted accurately, the shape of the words being dictated by the folds and creases in the fabric *right*. Gum water is mixed with the black paint to create a rich, dense tone — it also causes the paint to dry with a slight sheen. Both gum water and the thicker gum arabic can be used to enliven the normally matt finish of watercolour.

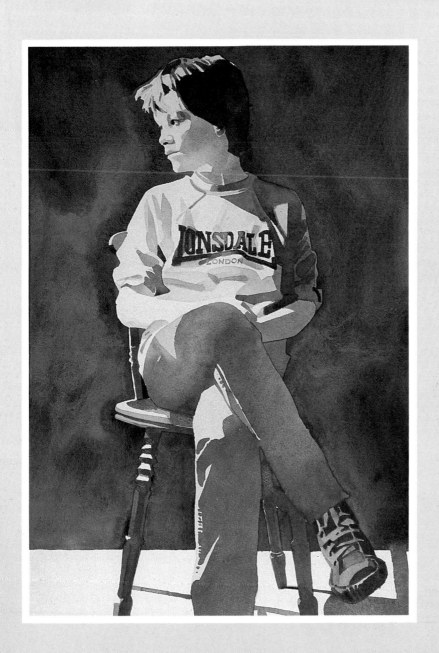

Sitting Cross-legged

What the artist used

A sheet of stretched Bockingford watercolour paper was the support for this young boy's portrait. Standard sizes were unsuitable because the artist needed to work on a slightly narrower rectangle to accommodate the seated figure. He therefore cut the paper to meet his own requirements, approximately 65cm×45cm (25½×17½in). Most of the portrait was painted with a No. 2 round sable brush, although the artist used smaller sizes, Nos. 0 and 1, for the lettering and some of the finer areas of colour. Colours were ivory black, Payne's grey, cadmium orange, alizarin crimson, burnt umber, yellow ochre, raw umber, burnt sienna and cobalt blue. The lettering on the T-shirt and some of the deep clothing shadows were strengthened with the addition of gum water. A preliminary drawing was made with an F pencil, and the artist used a hairdrier to speed up the drying process between stages.

Portrait of Paul

A quill pen, made from a goose feather, was used to make the initial drawing for this portrait. Quills are often used when a natural, undulating line is required, because by turning the quill it is possible to vary the width of the line, achieving a swelling and diminishing effect. Paint, watered down to a very thin consistency, was used with the quill in this case.

The quill drawing was done quickly, exploring spontaneous effects without much thought for form, and looking deeply into the face in a linear way, seeking the most interesting contours. Using a Chinese brush, the artist then applied thin washes of colour across the image, supplementing the quill by softening the drawing in places with a little clean water.

This artist likes to work close to the subject, because this enables her to observe contours and lines within the main outline. She is less interested in light and shade and the tonal representation of form. Character portrayed through line is one of her objectives, and if a line is wrong she can draw over it repeatedly until a contour emerges, increasing the strength of the line so that the darker ones dominate. It is almost the opposite of the technique used by some other painters illustrated in this book; for instance, the previous painting, on page 111, begins with a precise single outline which is systematically worked into with areas of controlled colour.

The artist here has suggested form in several places by using the lines drawn by the quill. She has used short, broad strokes to describe the shape and texture of the subject's hair, thus avoiding a formal or analytic approach, yet giving depth and a sense of volume to an almost wholly linear image.

1 This artist is concerned with the contours within the subject's face, and prefers the simple front view, *right*, to a more elaborate pose.

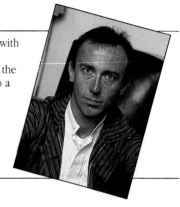

3 Colour is drawn directly onto the paper without any preliminary pencil drawing.

The loose lines of the quill pen describe the internal contours of the face *below*.

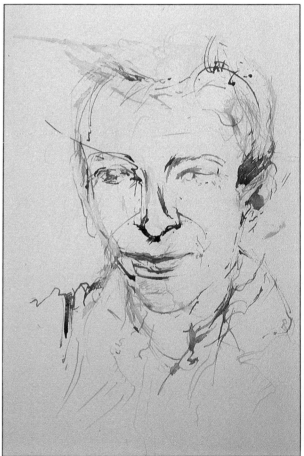

2 *Above*, the artist works from three diluted watercolour mixtures: raw sienna and cobalt blue; Prussian blue and cadmium red; cadmium yellow and yellow ochre.

4 Mistakes are difficult to remove, but wrong lines can be softened with water. Here, *right*, the artist uses a Rowney No. 9 (series 40) brush to lighten an incorrect line before redrawing.

5 Selected areas of local colour are applied with a Chinese brush. The colour is not literal, but is a spontaneous reaction to what the artist sees. *Below*, she applies a warm orange to the neck.

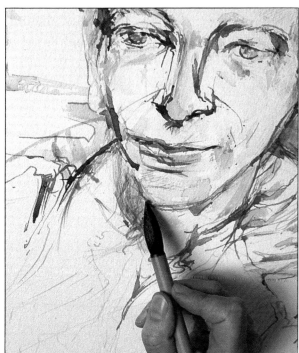

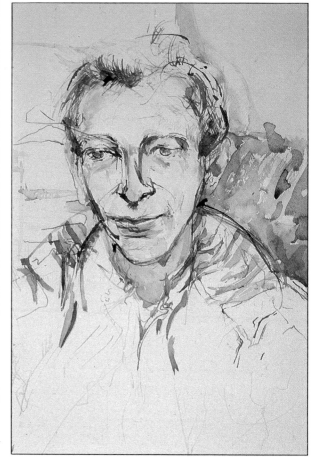

6 The background is worked with a Chinese brush and a No. 9 sable round *right*. No attempt is made to create flat, even colour. Instead, the artist exploits the textural brushmarks.

DRAWING WITH A QUILL

A bought quill was used for the initial outlines of this watercolour sketch. Quills are usually made from goose or swan feathers – you can make your own by cutting a diagonal tip with a sharp blade or scalpel. They are particularly effective for drawing on rough or heavily textured paper and, unlike the pen, do not catch on the fibres but glide smoothly across the surface to produce an irregular but flowing line.

Here the artist is using the quill for the fine, sketchy outline and for adding broader areas of dark texture to the hair.

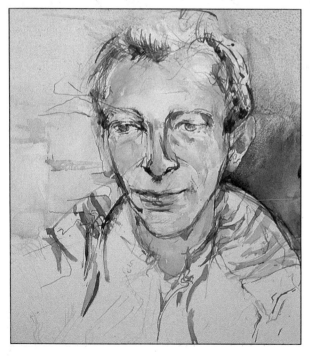

7 Light and tone are not important aspects of this portrait. The painting so far reflects the artist's prime interest in the linear qualities of the face *left*.

8 A Chinese brush is used to apply colour to the jacket *above*. Again, the emphasis is on the linear and directional rather than a literal representation of the local colour.

What the artist used

For this watercolour portrait, the artist chose to work on Langton watercolour paper, measuring approximately 30cm×25cm (12in×10in). On this occasion she worked with a bought quill pen, although she often makes her own from a goose or swan's feather, cutting this diagonally near the tip with a sharp blade. Brushes used were a Rowney No. 9 sable (series 40) and a Chinese brush. Colours were watercolour tubes – raw sienna, cobalt blue, Prussian blue, cadmium red, cadmium yellow and yellow ochre. These were mixed in separate ceramic dishes.

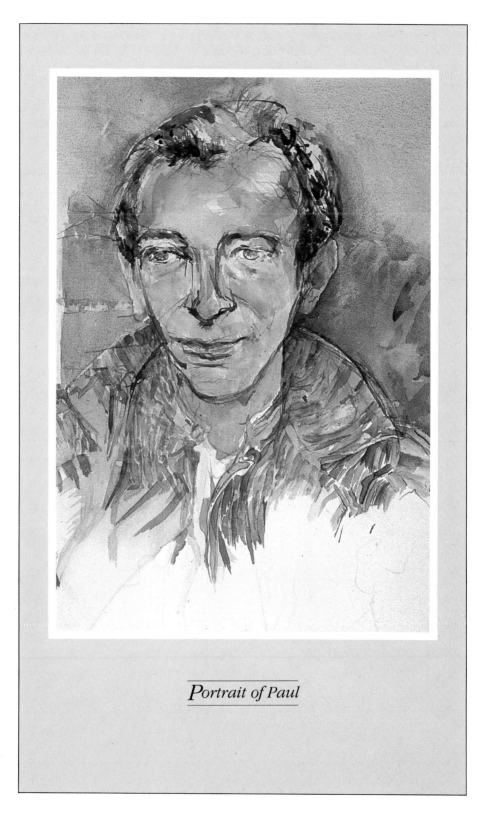

Portrait of Paul

Girl with a Pony-tail

The girl is painted in straight profile, with a background of plain white, but the artist has taken two steps to improve the background. She has cropped the composition very closely so that the top of the head and the back of the girl's hair touch the sides, breaking the background into four definite shapes. She has also included a dark, textural background, in which she has introduced a pattern of black, white and grey in the bottom section of the composition.

The painting is a small one, enabling the artist to see the image as a whole at a glance and to work tightly, producing controlled shapes and lines.

Although the artist has worked in a traditional watercolour manner, building up tone and colour from light to dark, she has broken the rules in one respect. Occasionally she introduced opaque white to represent tiny highlights and to correct mistakes. For this she used a special 'bleed-proof' white, which stops the colours beneath from showing through and running into it, as they will with gouache or poster-colour white. For instance, the fine white highlight along the girl's collar has been added later with a fine brush because the artist neglected to leave a margin of white paper showing through the colour. This type of white is extremely useful when correcting mistakes, but it should be used only in small quantities and only when absolutely necessary, as it tends to destroy the transparent quality of the medium.

An initial fine-line drawing was done for this portrait, using a sharp clutch pencil. Because the portrait is a small one, the drawing had to be quite precise, containing enough detail to allow the artist to concentrate on the build-up of tone and colour that followed.

1 The model was sitting against a plain white wall *right*, although the artist subsequently decided to create a more substantial background.

2 A clutch pencil is used to make an initial drawing *right*. This pencil has a fairly hard adjustable lead, making a light, precise line which is particularly suitable for watercolour work. The support is pure white watercolour board (CS2) measuring just 15cm×15cm (6in×6in), which does not yellow with age. At this stage the artist decides the composition needs some added background and suggests this with light lines.

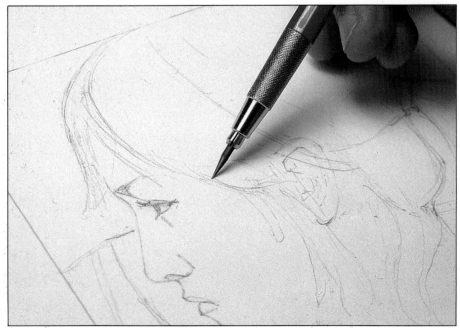

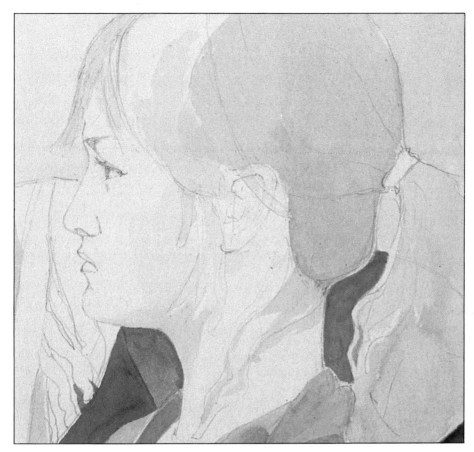

3 The profile head fills the rectangular picture are. This forms a series of abstract shapes around the subject, creating a tightly arranged composition with a deliberate lack of empty space around the head. By taking the subject out of the picture area on three sides, the remaing 'negative' shapes become almost as important to the final composition as the actual face. The artist starts to apply colour in this wash *left*. Hair tones are mixed from violet, yellow ochre and Payne's grey; the blouse is rose madder, cadmium red and a touch of Payne's grey.

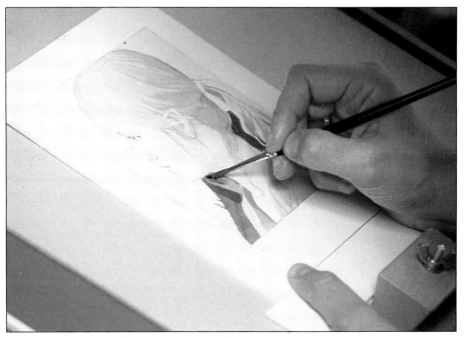

4 Using a No. 2 sable brush the artist washes in the flesh colour in yellow ochre, Payne's grey and rose madder. The shadow tones are painted in precise areas, emphasizing the light highlights of the face and describing the form and underlying structure. The background tones are developed to create a sense of space in the painting *left*. Notice how the colour is applied gradually, the initial light washes being built up layer by layer until the correct tone is established.

DARK OVER LIGHT

Because watercolour is transparent it is difficult or impossible to paint a light colour over a darker one successfully. Here a very dilute wash, representing the light areas of hair and the highlights, has been laid over the entire hair area and allowed to dry – in the picture the artist is using the traditional 'dark over light' watercolour technique to add shadow areas to the hair.

5 Opaque white is used for tiny highlights. *Above*, the artist uses 'bleed-proof' paint for the narrow edge of light on the collar.

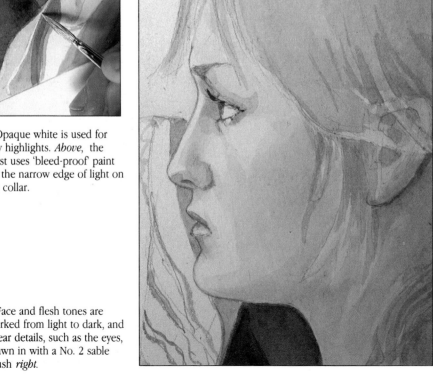

6 Face and flesh tones are worked from light to dark, and linear details, such as the eyes, drawn in with a No. 2 sable brush *right*.

What the artist used

The artist used a sheet of CS2 smooth white watercolour board which is made especially for line and watercolour work. The board retains its colour and does not yellow with age. Watercolours were rose madder, cadmium red, violet, Payne's grey, yellow ochre, raw umber and burnt sienna. Opaque 'bleed-proof' white paint was used for some of the smaller highlights (these were kept to a minimum to preserve the transparent quality of the overall image). The artist worked with a No. 2 round sable brush, using the tip of this for linear details and especially tiny areas. A preliminary line drawing was done with clutch pencil.

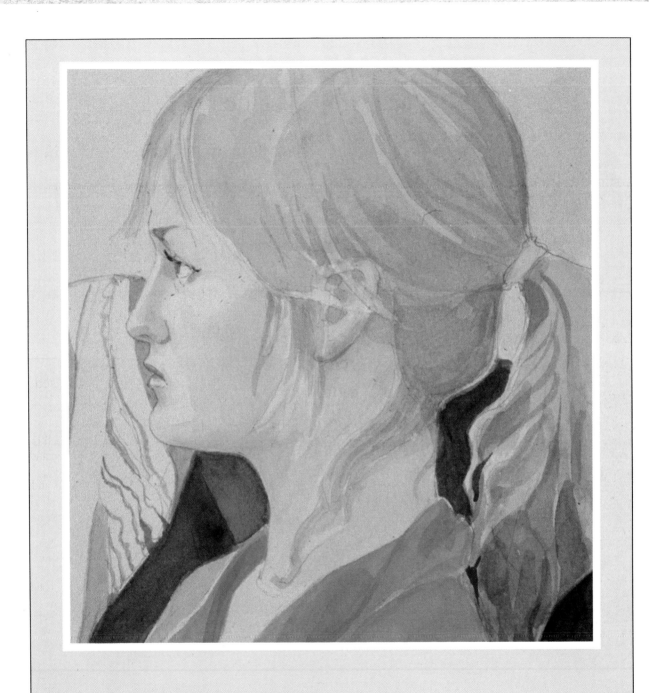

Girl with a Pony-tail

In a Red T-shirt

This portrait is painted in gouache, an opaque form of watercolour, which enables the artist to paint light colours over darker ones in a way which cannot be done with pure watercolour. The gouache gives a more solid effect, and a slightly chalky finish particularly on the face tones, which have been blocked in with patches of thick opaque colour instead of the watercolour technique of overlaid washes.

Gouache needs care. It is always water-soluble, even when dry, so when painting one colour on top of another there is always a risk of disturbing and mixing with the preceding colour. For this reason the medium is better suited to quick colour sketches than to finished paintings. Notice here how the artist has not attempted to blend in or tidy up the planes of colour, but has left them as a patchwork of broad, gesturing strokes which work optically as an overall image.

In this portrait the face contains more detail than the rest of the picture, making it the focal point. The background has been left deliberately unfinished, suggesting a hazy though real interior. The artist worked from natural light coming from a window to the right of the model, which helped describe the volume of the figure and the forms within the face.

The artist began by making a drawing with a brush, instead of a preliminary pencil sketch, and the painting grew from this drawing rather than being treated as a separate stage. Thin washes of colour were used in conjunction with bold brushed outlines, causing the image to emerge gradually. The artist used a bristle brush for most of the work, removing the temptation to become lost in particular details to the detriment of the overall composition.

The model was posed in a relaxed position, elbows resting on the arms of a chair. The artist placed the head slightly to the left of the composition to balance the elements in the picture.

Throughout, the work was kept as fluid and free as possible, allowing the artist to make constant adjustments with the opaque colour.

1 The model is turned slightly, presenting a three-quarters view to the artist *right.*

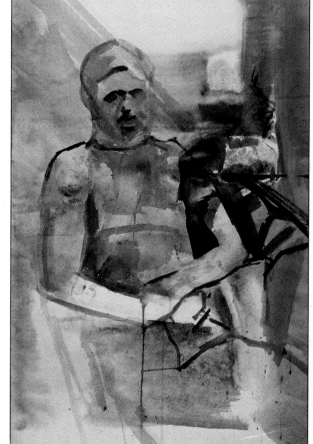

2 Instead of starting with a preliminary pencil drawing, the artist begins by drawing directly onto the canvas with brush and paint *right.*

3 The artist blocks in basic tones and colours, keeping the image fluid, and constantly changing and readjusting the main elements in this early stage. Here the trousers are established as a solid, dark shape with a No. 6 flat bristle brush *right*.

4 This direct approach gives the artist freedom to develop the face as a series of tones. These tonal planes can be changed and moved around on the paper until the form and likeness of the face emerge from the arrangement of lights and darks. Here, *below*, the artist works out the structure and position of the eye.

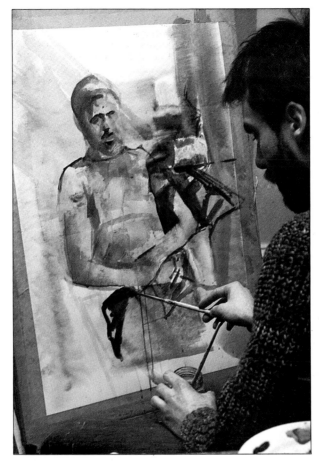

5 The paint is kept as fluid as possible. As the painting grows out of the initial 'drawing', the artist continually returns to the drawing, strengthening the outlines to ensure that the structure and form of the figure are not weakened or lost as the tone and colour are developed. Because gouache is opaque, it is possible to paint a light tone over a darker one. The artist takes advantage of this quality by working the red tones of the shirt from dark to light. He first establishes the local colour in cadmium red, yellow and raw umber, then adds white to this basic mixture in order to paint the highlights *below*. Too much water reduces the covering power of gouache and the artist takes care to keep the paint at a thick, creamy consistency for maximum opacity.

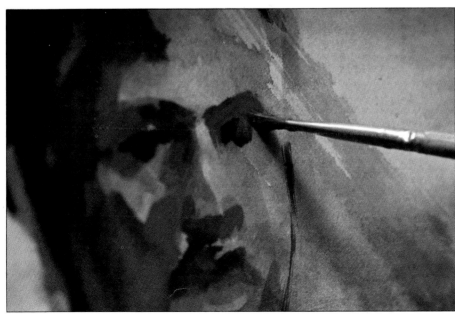

LIGHT OVER DARK

Gouache contains a lot of chalk, or body colour. This makes it opaque, unlike pure watercolour which is transparent. With gouache it is possible to paint extremely light colours, or even white, over a dark base, providing the paint is not diluted too much. In this portrait the artist takes advantage of the opacity to add highlights to the face and arms, and to lay in the light areas of the shirt and trousers.

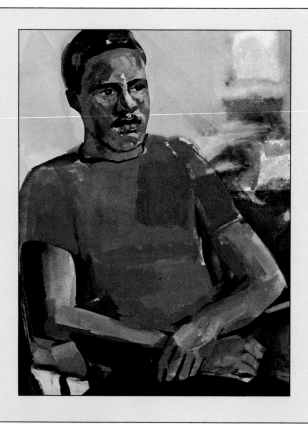

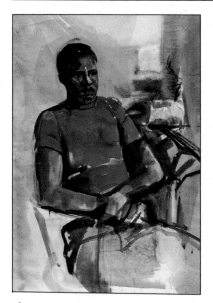

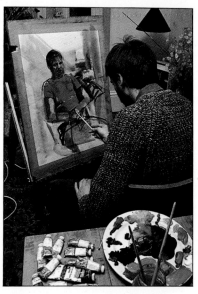

6 Dried gouache remains soluble. Wet paint may disturb the colour underneath, although in this painting *above* the loose style makes this unimportant.

7 The composition is considered for its abstract qualities as well as for its more obvious representational function *above*.

What the artist used

This gouache portrait was painted onto a sheet of stretched Bockingford watercolour paper measuring approximately 61cm×50cm (24in×20in). The artist chose a palette of cadmium red, cadmium orange, alizarin crimson, white, burnt sienna, cadmium yellow, yellow ochre, raw umber, ivory black and Payne's grey. Colour was applied with flat bristle brushes, Nos. 2, 4 and 6. The artist used a white dinner plate as a palette.

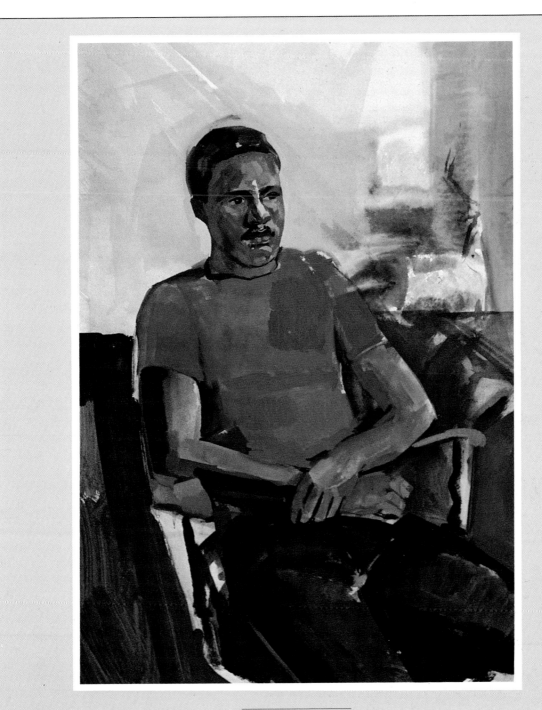

In a Red T-shirt

CHAPTER NINE

Pastel

Pastels are perfect for rapid, on-the-spot sketching, because they have a spontaneity that makes them difficult to rival for a quick colour rendering. There are basically two types — the traditional soft pastels which crumble and smudge easily and must be sprayed with fixative, and the more recent oil pastels which are more stable but can be difficult to blend.

Pastel work is sometimes referred to as 'drawing', sometimes as 'painting'. In fact, it falls somewhere between the two. The softest pastels produce an effect which is very similar to that of painting, with the entire surface being covered with solid pigment. Slightly grittier 'soft' pastels are also available, and the effect of these is more like that of drawing.

Although pastels have been popular since they first came into general use more than two hundred years ago, they were particularly important to the Impressionists who saw the possibilities of the brilliant, broken colour areas that could be created with them. The works of Edgar Degas (1834-1917) gave the relatively unexploited medium a new importance. He used pastels in bold superimposed layers, developing an ideal combination of line and colour. He also devised a technique of steaming the pastel surface to dissolve the pigment into films of colour which he then worked with a stiff brush or with his fingers.

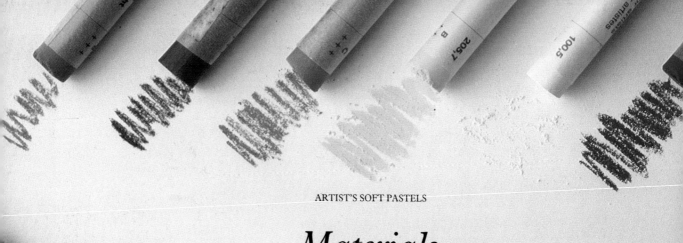

Materials

INGRES PAPER

Pastels are a medium that lies halfway between painting and drawing. The traditional pastels are soft and chalky, requiring care both during the execution of the work and afterwards, when it is all too easy to smudge the colours. They have qualities in common with chalk and conté crayon, which are sometimes included in the same general category.

Supports

The most important consideration when choosing paper for pastels is the texture. This must be rough enough to provide a 'key' or 'tooth' for the fine pastel dust to adhere to, otherwise the colour literally drops off the paper. Your support should also be a good-quality one, otherwise it will tear and buckle as you work.

PUTTY RUBBER

Papers which are specially made for pastels have a velvety or sandpaper-like surface. This is ideal, allowing a substantial amount of colour to be built up within a single image. Good quality drawing or watercolour paper is perfectly adequate, providing it is coarse enough to take the pastel. Very smooth surfaces are almost always unsuitable because the pastel slips around the surface and very little actual colour will adhere to it.

Tinted papers are excellent for use with pastels. Warm, cool, bright or subtle shades can be exploited to advantage. The tinted paper is allowed to show through between the pastel marks, integrating the composition and contributing to the work in a positive and effective way. Some artists prefer to tint their own paper for pastel work. This can be done by dipping a dampened

ARTIST'S SOFT PASTELS

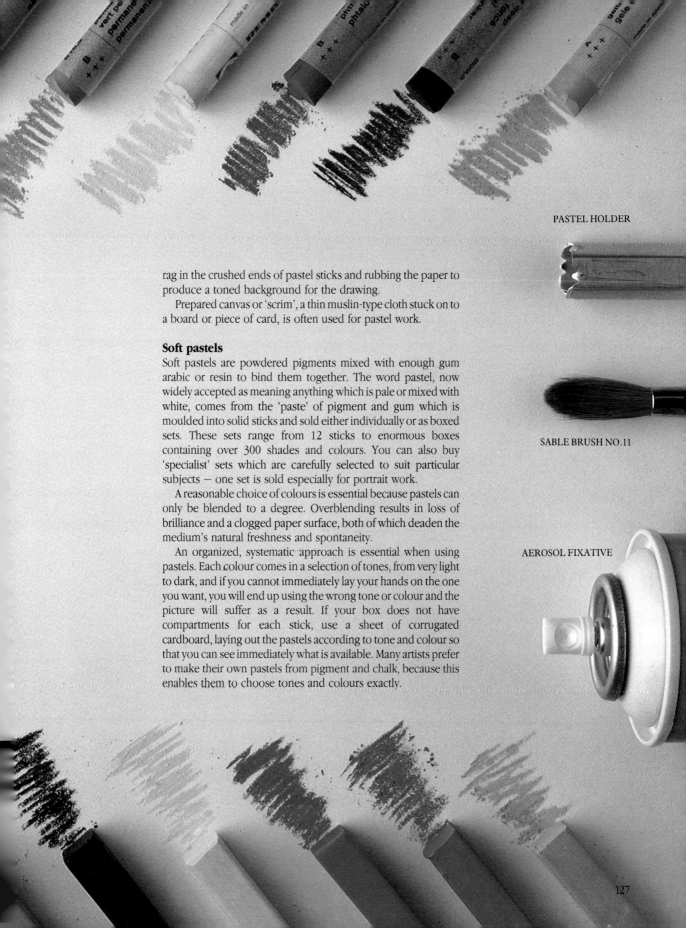

PASTEL HOLDER

SABLE BRUSH NO.11

AEROSOL FIXATIVE

rag in the crushed ends of pastel sticks and rubbing the paper to produce a toned background for the drawing.

Prepared canvas or 'scrim', a thin muslin-type cloth stuck on to a board or piece of card, is often used for pastel work.

Soft pastels

Soft pastels are powdered pigments mixed with enough gum arabic or resin to bind them together. The word pastel, now widely accepted as meaning anything which is pale or mixed with white, comes from the 'paste' of pigment and gum which is moulded into solid sticks and sold either individually or as boxed sets. These sets range from 12 sticks to enormous boxes containing over 300 shades and colours. You can also buy 'specialist' sets which are carefully selected to suit particular subjects — one set is sold especially for portrait work.

A reasonable choice of colours is essential because pastels can only be blended to a degree. Overblending results in loss of brilliance and a clogged paper surface, both of which deaden the medium's natural freshness and spontaneity.

An organized, systematic approach is essential when using pastels. Each colour comes in a selection of tones, from very light to dark, and if you cannot immediately lay your hands on the one you want, you will end up using the wrong tone or colour and the picture will suffer as a result. If your box does not have compartments for each stick, use a sheet of corrugated cardboard, laying out the pastels according to tone and colour so that you can see immediately what is available. Many artists prefer to make their own pastels from pigment and chalk, because this enables them to choose tones and colours exactly.

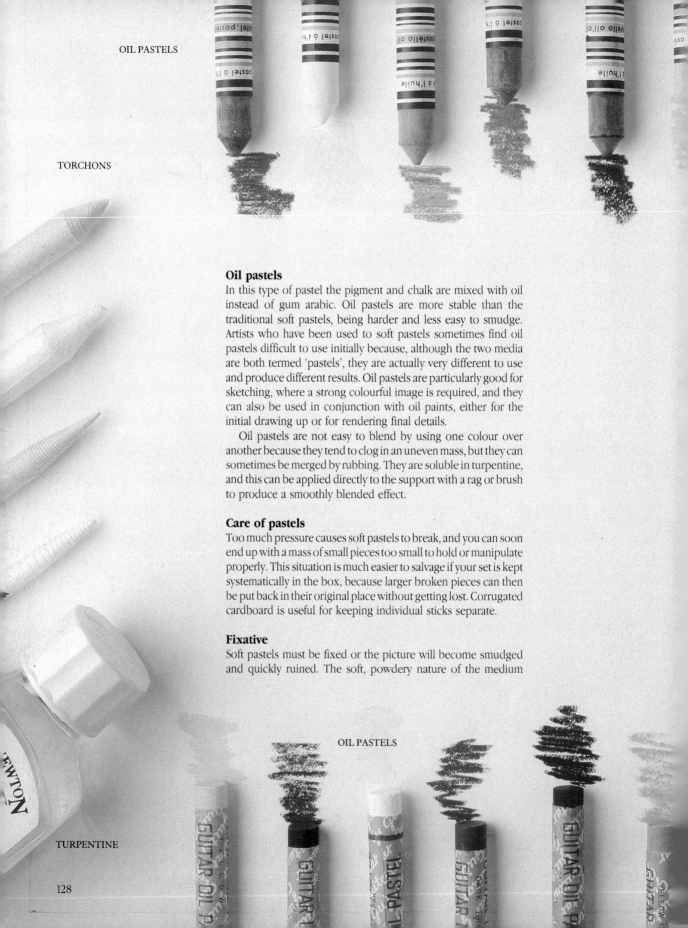

TORCHONS

Oil pastels

In this type of pastel the pigment and chalk are mixed with oil instead of gum arabic. Oil pastels are more stable than the traditional soft pastels, being harder and less easy to smudge. Artists who have been used to soft pastels sometimes find oil pastels difficult to use initially because, although the two media are both termed 'pastels', they are actually very different to use and produce different results. Oil pastels are particularly good for sketching, where a strong colourful image is required, and they can also be used in conjunction with oil paints, either for the initial drawing up or for rendering final details.

Oil pastels are not easy to blend by using one colour over another because they tend to clog in an uneven mass, but they can sometimes be merged by rubbing. They are soluble in turpentine, and this can be applied directly to the support with a rag or brush to produce a smoothly blended effect.

Care of pastels

Too much pressure causes soft pastels to break, and you can soon end up with a mass of small pieces too small to hold or manipulate properly. This situation is much easier to salvage if your set is kept systematically in the box, because larger broken pieces can then be put back in their original place without getting lost. Corrugated cardboard is useful for keeping individual sticks separate.

Fixative

Soft pastels must be fixed or the picture will become smudged and quickly ruined. The soft, powdery nature of the medium

OIL PASTELS

TURPENTINE

makes it particularly vulnerable, and even pastel drawings framed under glass will disintegrate to some degree without prior fixing. The fixative is sprayed onto the finished work and binds the loose particles of pigment to the ground.

Various adhesive materials have been used as a fixative – in emergencies some artists have used hair spray. The choice depends on the nature of the ground and which medium is being used. Fixative can be bought ready-made in convenient aerosol cans, or it can be bought in bottles, in which case you will need a mouth spray, or atomizer, to apply it.

Fix the work by holding the spray about 30cm/12 in away from the drawing, which must be held vertically. Apply the fixative lightly from side to side across the entire surface. Several light coats are better than one heavy one because a soaking may cause colours to run and affect the crispness of the image. Pastels can be fixed from the back as well as the front, depending on the amount of pigment on the surface. You can also use fixative lightly after each stage, although too much will cause the surface to become shiny and unreceptive to further pigment.

Other equipment

A chamois stick and a torchon (a pencil-shaped stump usually made from tightly rolled paper) are useful for blending and rubbing out fine areas of colour. Pastel holders, available from artist's suppliers, can be helpful for holding short sticks and for keeping your hands clean. For sharpening pastel sticks, use sandpaper or glasspaper, and for erasing lightly worked areas, use a kneadable putty rubber.

Jane

Pastels can be used either in a linear way as a drawing medium or in a more 'painterly' way to obtain areas of solid colour. The artist here has combined both these approaches, using line to establish the pose and to draw the main characteristics, and then developing selected areas in blocks.

Dark, rich brown paper was chosen for this portrait. This enabled the artist to lay in light skin tones and the highlights of the hair with maximum effect, allowing the tinted paper to show through and suggest shadows and recesses. Choice of paper is particularly important with pastels – darker and tinted papers are often used, because they provide a ready-made middle tone against which the other colours can be set. When using white papers it must be remembered that whatever colour goes on them will show up darker than the paper background, and the flat plane of white paper has to be counteracted with the pastel. Areas of white showing between pastel strokes tend to 'fight with' a solid form; the viewer will always be subconsciously reminded of the white paper and thus will be distracted from taking in the complete image.

Jane sits in an armchair, in pensive pose, looking directly out of the picture. The strongest light comes from behind her left shoulder, emphasizing the shape of the back of the neck and the jawline. The background was complex, almost cluttered, but the artist has chosen to ignore this completely, concentrating only on the powerful expression and mood of the pose.

Because pastel comes in chunky sticks it is often assumed that the medium is best suited to broad strokes and general impressions, but in fact it is possible to render quite delicate and precise details with it, especially when the sticks are sharpened. The hand presented a particular problem in this portrait, as it is a central part of the whole pose and could easily have looked unnatural and awkward. The artist has treated the hand in the context of the face, giving both the same defined planes and highlights, so that the hand guides the viewer's eye round into the enclosed, vignetted composition.

1 The model sits in an informal, though upright, position *right*. She is almost in profile, but a small part of the other side of her face is visible.

2 When working on a medium toned paper like the one used in this portrait, it is possible to relate all marks to this already established 'middle' tone. The artist is therefore able to use white to establish the position of face and hands *right*. This light tone will eventually be integrated into the light flesh tones.

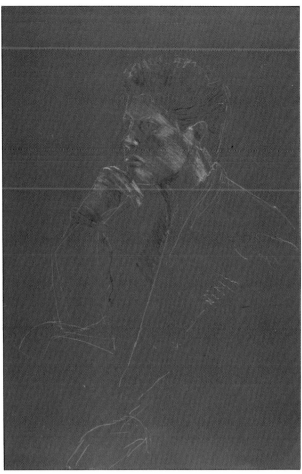

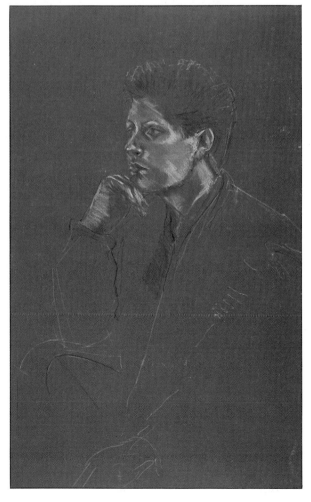

3 Regular diagonal shading from left to right emphasizes the form of the head *above*. At this stage the shading is applied lightly, the artist working across the whole image, marking in key areas of light and shade.

4 For finer areas, such as the shadows under the eyes and around the mouth, the artist changes to coloured pencil *top right*. Instead of using neutral tones, the artist chooses cool blues and greens to contrast with the warmly tinted paper.

5 As the drawing nears completion, greater emphasis is put on the face and hand *right*. The flesh tones become more substantial and the artist introduces a range of strong orange-pinks and blue-greens to depict the warm highlights and cool shaded areas of the face.

SOLID TONE WITH PASTEL

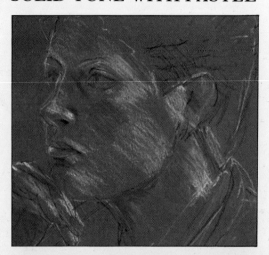

The solid areas of tone and colour in this picture are built up with short, closely packed pastel strokes. This is especially necessary when using such darkly tinted paper, because it prevents the paper colour showing through the lighter tones and breaking up and weakening the image. The artist uses the pastels in even, diagonally parallel strokes, allowing greater control over the density of tone and colour.

6 *Top*, the artist begins to block in the shoulders and upper part of the jacket. Local colour and highlights are filled in with blue; the tinted paper shows through to indicate shadow areas.

7 The flexibility of pastel allows it to be used to depict both line and tone. This close-up, *above*, shows how the artist combines the two techniques.

Jane

What the artist used

Toned paper measuring 36cm×51cm (14in×20in) was used for this pastel portrait. The artist chose the warm, deep brown because it provided maximum contrast with the cold blue of the model's jacket. The dark tint also allowed the artist to apply the flesh tones as solid areas of light colour. Tinted papers are ideal for use with pastels. They provide an instant 'middle' tone, allowing the artist to begin work with a complete tonal range, including white and black. Most pastel artists avoid working on white or off-white paper because it is usually necessary to break down the paper surface into workable tones before the image can be established. With pastels, this is a messy job, often making it difficult to keep subsequent colours clear and bright. Soft pastels were from a boxed set of 72 assorted colours manufactured by Rowney. Blue, green, grey and purple coloured pencils were used for smaller areas of flesh shadows.

John 1 and 2

Pastels do not restrict the artist's scale, as these very large portraits illustrate. If you look at the size of the artist's hand compared with the emerging facial features, you will see how the pastels can be used on a grand scale, producing in this case a dramatic effect.

Both these portraits were done on large sheets of primed cardboard. The first was given a thin coat of white oil paint and the second was primed with dark oil paint. In both cases, instead of beginning with an outline that would establish the rough areas of the composition, the artist started from the inside of the features and worked outwards. She blocked in the areas of the nose and central face, using the side of the pastel to obtain a broad area of broken colour to work into.

The final effect was made even more dramatic by the fact that the subject's face fills the entire picture area, especially in the first picture. Because the area is so large, the artist is unable to see the whole image while she is working, so she moves across the entire picture, placing marks to denote the related positions of the features and contours within the face. The marks were strokes of bold colour — each one denoting just a portion of a particular feature — which were related together as the picture developed.

In both pictures the colour is intuitive. The artist has exaggerated the reflected tones and colours visible on the actual subject, interpreting these in bright and vibrant terms. She has built up hue upon hue as the lines have become more intense and closely packed, so that in places the lines gradually merge into solid areas of tone.

In the first portrait the various bright colours of the built-up lines mix optically to produce a shimmering and delicate interpretation of the skin tones. Orange and yellow, for instance, are overlaid to create a vibrant orange. Because of the way the drawing has been built up, the artist has avoided the clogged, overworked paper surface which all too often is the result of enthusiastic but inexperienced work with pastels.

The use of colour in the second portrait is equally personal and idiosyncratic, but here the dark-toned background has enabled the artist to use a lot of white with the bright pastel colours. The result is a luminous, slightly unearthly portrait.

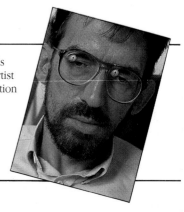

1 A close-up view of John's face, *right*, provided the artist with enough visual inspiration to produce two large and colourful pastel portraits.

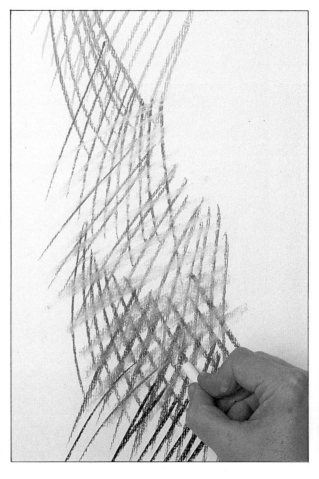

2 Working directly onto the large sheet of cardboard treated with white oil primer, the artist starts by boldly cross-hatching areas of bright colour *right*. There is no preliminary drawing.

OPTICAL COLOUR BLENDING

Pastel colours can be blended by rubbing them together, usually with cloth, tissue or the fingers. Or — as the artist has done in this portrait — they can be blended optically, to mix in the eye of the viewer rather than being actually blended together on the support. Here the artist has relied heavily on drawing, on the linear marks made by the pastels, to build up the structure of the subject's face. She mixes colours by laying thin meshes of pure pastel, one on top of the other, to create new and brilliant hues. For example, the rich greens in the beard and moustache are the result of dense layers of blue and yellow lines; many of the mauve and purple tones come from blue and pink; and the vivid oranges of the lips and skin tones are 'mixed' from primary red and yellow.

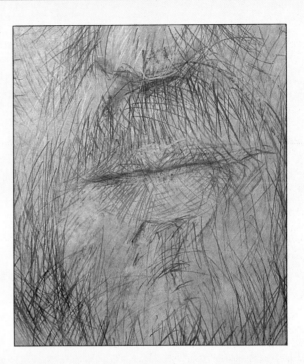

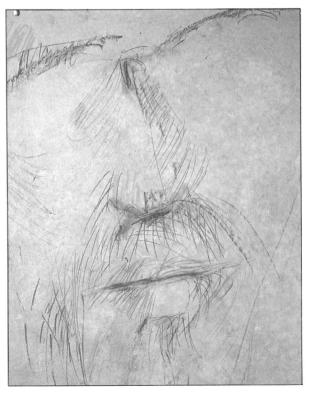

3 Colour is intuitive. The artist is not interested in representing the actual flesh tones, but works from a personal selection of vivid colours *above*.

4 The image emerges from the mass of sketchy lines, *right*, and the artist frequently stands back from the work in order to get an overall view of the large-scale portrait.

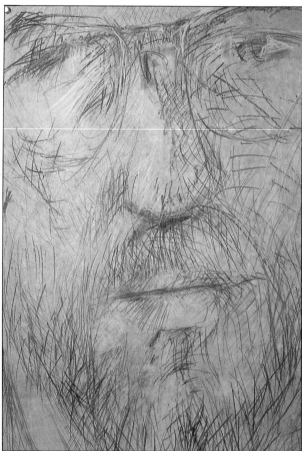

5 Colours are often mixed 'optically'. For instance, yellow is worked over red to create a bright orange *above left*. This method produces exceptionally vibrant and luminous colours.

6 *Above,* working on such a large scale helps the artist to maintain a loose, spontaneous approach. The artist continues to build up the image, creating form by intensifying the cross-hatched areas of colour.

7 White chalk emphasizes the eye *left.* The chalk is brighter than the dullish white of the primed hardboard, and stands out strikingly from the surrounding colours.

What the artist used

The artist worked from a boxed set of 24 soft pastels, working mainly in bright reds, orange, green, violet, blue and yellow. White chalk was used for the eyes and occasional highlights. The artist worked on a sheet of primed cardboard measuring 92cm×61cm (36in×24in). Primed cardboard is an unusual support for pastel work, but in this case the artist was more interested in creating a lively, textural interpretation of the subject than an exact representation of the subject, and therefore chose this slightly coarse surface. The work was supported on a Rowney's Norwich easel, which enabled the artist to stand back frequently from her work.

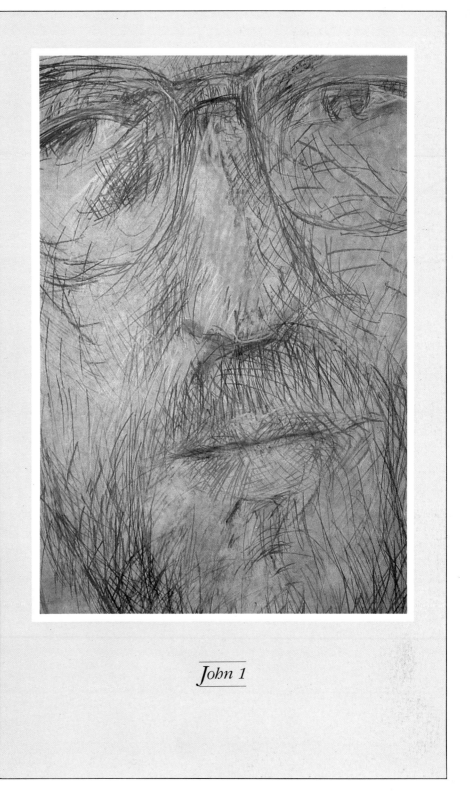

John 1

BLENDING LARGE AREAS OF COLOUR

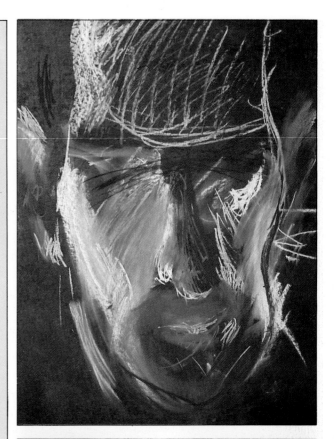

In this large pastel portrait the artist has used her hand and fingers to blend colours in the face, background and clothing. Care was taken not to overdo these smooth areas, because too much blending can make the image blurred and soggy, tending to destroy the structure of the drawing. In this case enough of the coarse pastel strokes are left showing through to preserve the form and structure of the subject, as well as providing textural contrast. The drawing was sprayed lightly with fixative between stages to prevent the bright colour and pure white from smudging as the artist worked. It was then re-fixed on completion to protect it.

1 The artist embarks on a second pastel portrait, working on the same large scale as before *top*. For this painting she chooses a dark support — pieces of cardboard treated with a coat of deep blue oil primer.

2 Using broad strokes of pastel, the artist begins by establishing the main facial tones *above*. There is a predominance of white and pastel tones here, contrasting with the dark blue of the support.

3 Using black chalk, the artist draws in the facial features. This drawn linear detail, superimposed on the blended areas of light tone and colour, brings the entire image into sharp focus *left*. The technique illustrates the flexibility of pastels, which can be used to produce either linear effects (as the artist demonstrates in the preceding pastel portrait) or to establish extensive blocks of solid colour and tone. Although it is generally assumed that pastel is best suited to fairly broad treatment, considerable linear details can be obtained by sharpening the pastels or by using the sharp edge of the pastel. Most pastels are too soft to be sharpened with a knife or blade, but can be rubbed carefully on a piece of sandpaper to create a point (sandpaper blocks are manufactured specially for this purpose and are available in art shops). When sharp lines and details are important, it is a good ideal to give the work an occasional light spray of fixative in between stages to prevent the image from getting smudged.

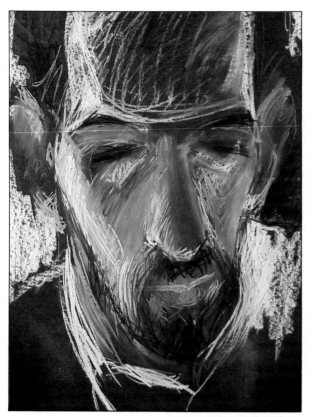

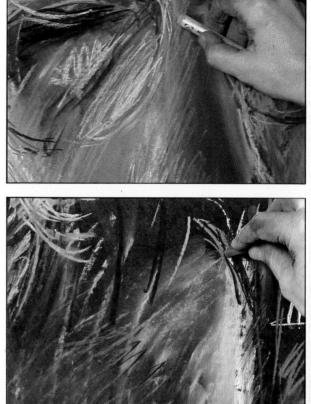

4 The pale tones are applied lightly over dark blue, and the cool underpainting shows through to create a luminous and slightly unreal image *above*. Vivid strokes of colour are mixed with the whites, their direction suggesting the form of the face and features.

5 Strong diagonal hatching over smooth, blended areas produces solid areas of colour. Here the artist uses the dense strokes of flesh-coloured pastel over a dark red base *top right*.

6 The approach throughout this painting is free and uninhibited. By holding the pastel loosely and working with a broad sweeping movement of the arm, the artist produces lively strokes of broken colour *right*.

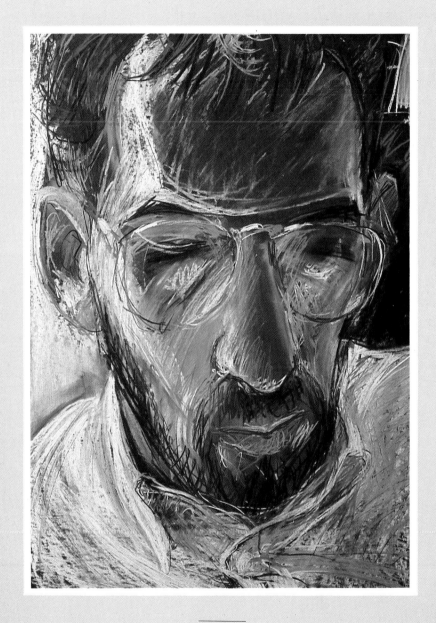

John 2

What the artist used

As with the previous portrait, the artist worked from a boxed set of 24 pastels. The principal colours were white, black, violet, reds, pinks, blue, orange and flesh colour. The artist worked on a sheet of primed cardboard measuring 92cm×61cm (36in×24in). A deep blue prime was chosen because the artist wanted to experiment with whites and light tones over a dark base. The work was supported on a Rowney Norwich easel, which allowed the artist to stand back from the work easily at frequent intervals. Spray fixative was used on the finished portrait.

Helen

Character and expression are important in this portrait, and the artist has relied on a quick colour sketch to capture the spontaneity of the subject's smile and casual pose. The bright, warm pastel colours were used in a quick, vigorous manner to develop the texture and main features of the portrait, rather than using the more intricate methods of some other media. For this picture, there was no preliminary bold outline, with proportions worked in later. Instead, the artist began with a light outline in burnt sienna, and the backwards and forwards action of the pastel quickly established the main areas, bringing the image up almost as though it were emerging through a mist, as a whole entity. Pastels can often have this rapid and direct effect if used with confidence.

Blue-grey pastel paper, which has a greenish hue in the final result, has been used as the support, giving an immediate fullness to the background, but the tint has not been allowed to overwhelm it and make it appear flat and dull. The composition of the portrait has been worked out with much more care than its spontaneous appearance indicates. Firstly, the subject was deliberately posed to one side, avoiding a rigid symmetry and adding to the seeming casualness by the slightly leaning posture. Secondly, the artist has blocked in an area of blue background in one corner, offsetting the tint and complementing the blue of the subject's clothing.

After establishing a quick outline the artist worked into the face with bright orange, ultramarine and pink and then stroked in light tones of white and yellow to firm up the main parts. In some areas the artist laid in thin strokes and then blended them by rubbing gently with a finger, a technique often used to soften the strokes of pastels. As the picture began to develop, the artist used multi-directional strokes, reinforcing the fleeting, 'quick frozen' effect of the whole picture, and the face was highlighted with warm and bright tones.

SOLID AREAS OF PASTEL STROKES

Pure dense colour can be built up by using tightly packed, regular strokes of pastel. Here the artist develops the face with strong warm tones, keeping the strokes close and parallel to produce an area of solid colour. Notice how the tinted paper has been virtually obliterated by the close and overlapping marks. The strokes of pure colour are not blended, so that each new colour stands separately from those already applied. For every strong, dense colour, such as the highlights on the hair and face, the artist applies considerable pressure while drawing.

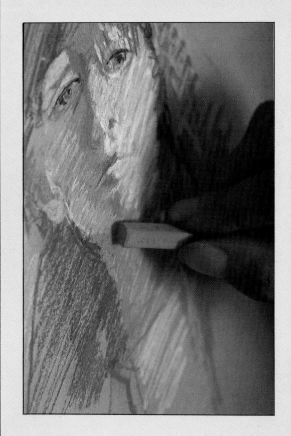

1 A quick sketch is often more successful than a carefully worked, laboured drawing. This lively portrait sketch, *right*, was completed in one short sitting.

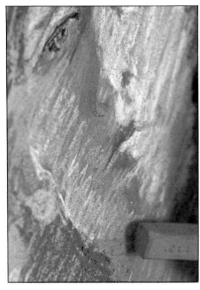

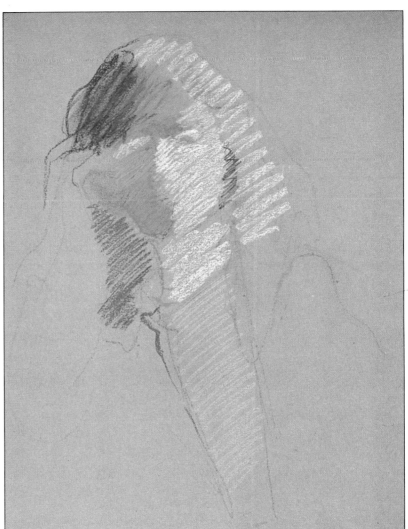

2 The outline of the head and figure are drawn in burnt sienna. The artist starts to lay in very thin strokes of warm and cool colours, blending these with the finger *top*.

3 Using the pastel lightly, the artist worked into the face with lines of bright orange, pink and ultramarine. The hair is established with loose strokes of raw umber *above*.

4 *Above*, a regular zig-zag stroke establishes the light side of the face in white and yellow. Blue and orange are worked into the shaded areas of the face, and the artist marks in a small amount of blue background tone.

5 Fine black lines and patches of strong colour accentuate the shapes in the face. Outlines are redrawn in darker tones, and the flesh colours are heightened with light pink and mauve against dark red shadows *right*.

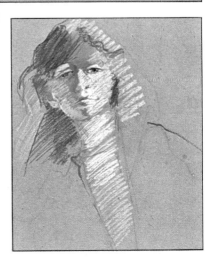

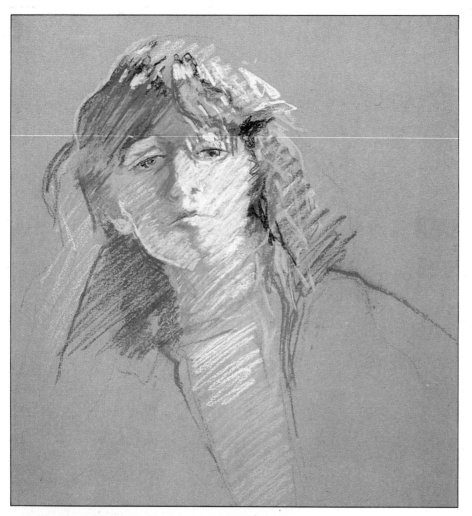

What the artist used

The artist worked on a piece of blue-grey pastel paper measuring 27.5cm×37.5cm (11in×15in). This allowed the warm, light tones of the flesh and hair to be established against the tinted paper, the cool paper colour to be used to represent shadows. The artist restricted the number of pastels to 11 basic colours — black, burnt sienna, mauve, orange, pink, ultramarine blue, light blue, white, yellow, red and raw umber. A light coat of fixative was applied to the finished portrait to prevent the colours from smudging.

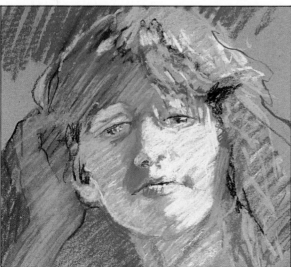

6 The artist looks closely at the subject, defining the darkest shadows with short, specific strokes of black. Dense white is built up on the illuminated side of the face, and the hair is developed with loose, textural strokes of black, orange, yellow, and red *above*.

7 The hand and arm are drawn with a fine black line, and then established in solid areas of pink, red, mauve and yellow. Heavy strokes of dark blue are laid across the top of the paper to establish the background tone and to indicate space behind the subject *left*.

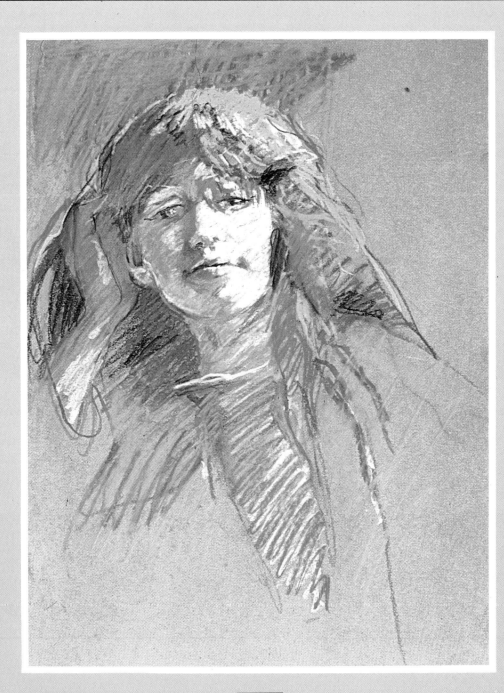

Helen

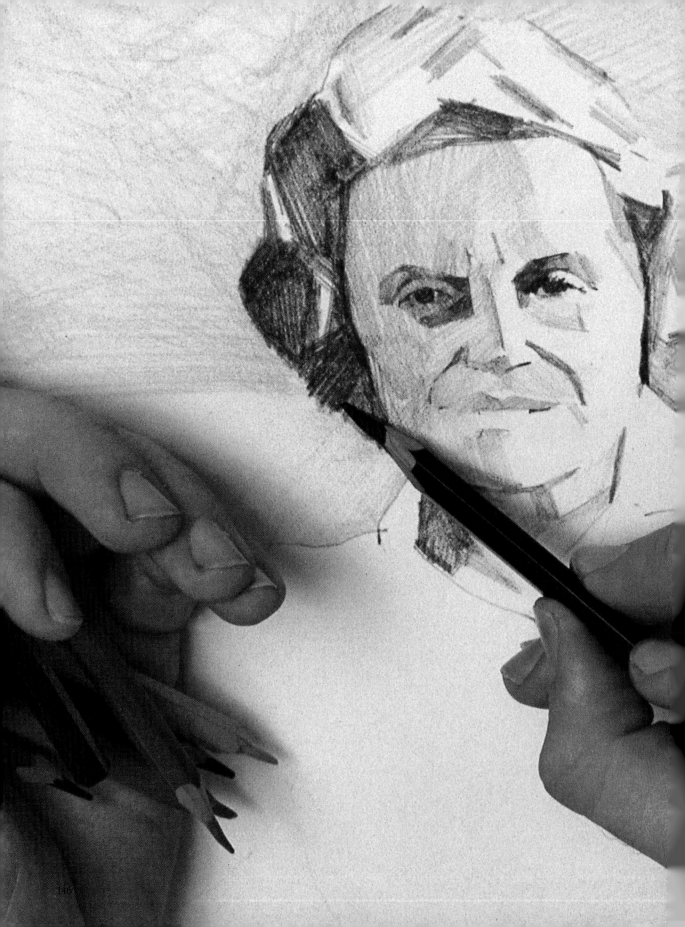

CHAPTER TEN

DRAWING MEDIA

Drawing with lines is the most basic means of making a picture. The term drawing covers a wide range, from rough sketches and notes to analytical studies and finished, detailed portraits. Sometimes a drawing is intended as a complete statement in its own right, and sometimes it is an early stage in a larger project, a preparation for a painting. The quality of a drawing cannot be judged by the amount of work and time involved. Indeed, a rapidly drawn impression often has a liveliness and spontaneity that is lacking in a lengthy study, which can look quite dead.

One of the major problems of drawing is knowing how to put down what is in front of you, or how much of it to put down. Learning to draw is rather like developing a personal shorthand system, and this must become almost automatic if it is to be really successful. The actual drawing technique you evolve is irrelevant — the most important thing is that it fulfils the function for which it is required. Just as an architect's plan includes the information necessary to build or restore a house, so an artist's drawing should contain relevant visual information about a particular subject — whether as a complete work or as a reference for use in a future painting.

There is an enormous range of drawing materials now available. Alongside the traditional media, such as graphite pencil, charcoal and ink, is a vast selection of new items. In this chapter we have introduced a few of these. The Rapidograph pen, normally associated with technical work and design, is used for the portrait drawing on page 157 while coloured pencils, at one time the sole preserve of children, were the artist's choice for the drawings on pages 168 and 171. Your own selection of materials will depend to a large extent on which medium you feel comfortable with, how you work, and the reason for your drawing.

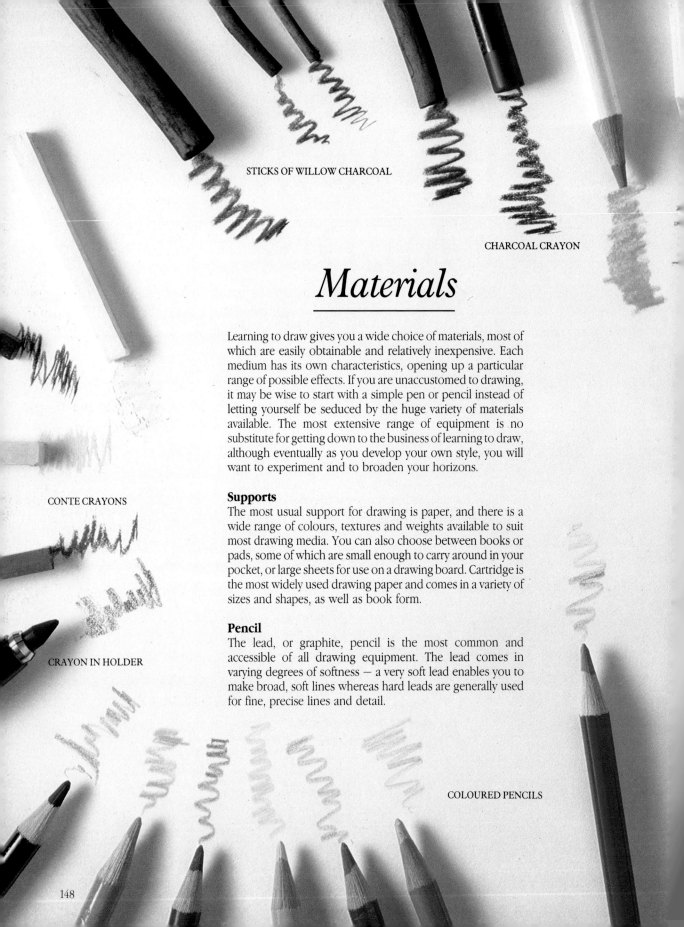

STICKS OF WILLOW CHARCOAL

CHARCOAL CRAYON

Materials

Learning to draw gives you a wide choice of materials, most of which are easily obtainable and relatively inexpensive. Each medium has its own characteristics, opening up a particular range of possible effects. If you are unaccustomed to drawing, it may be wise to start with a simple pen or pencil instead of letting yourself be seduced by the huge variety of materials available. The most extensive range of equipment is no substitute for getting down to the business of learning to draw, although eventually as you develop your own style, you will want to experiment and to broaden your horizons.

Supports

The most usual support for drawing is paper, and there is a wide range of colours, textures and weights available to suit most drawing media. You can also choose between books or pads, some of which are small enough to carry around in your pocket, or large sheets for use on a drawing board. Cartridge is the most widely used drawing paper and comes in a variety of sizes and shapes, as well as book form.

Pencil

The lead, or graphite, pencil is the most common and accessible of all drawing equipment. The lead comes in varying degrees of softness — a very soft lead enables you to make broad, soft lines whereas hard leads are generally used for fine, precise lines and detail.

CONTE CRAYONS

CRAYON IN HOLDER

COLOURED PENCILS

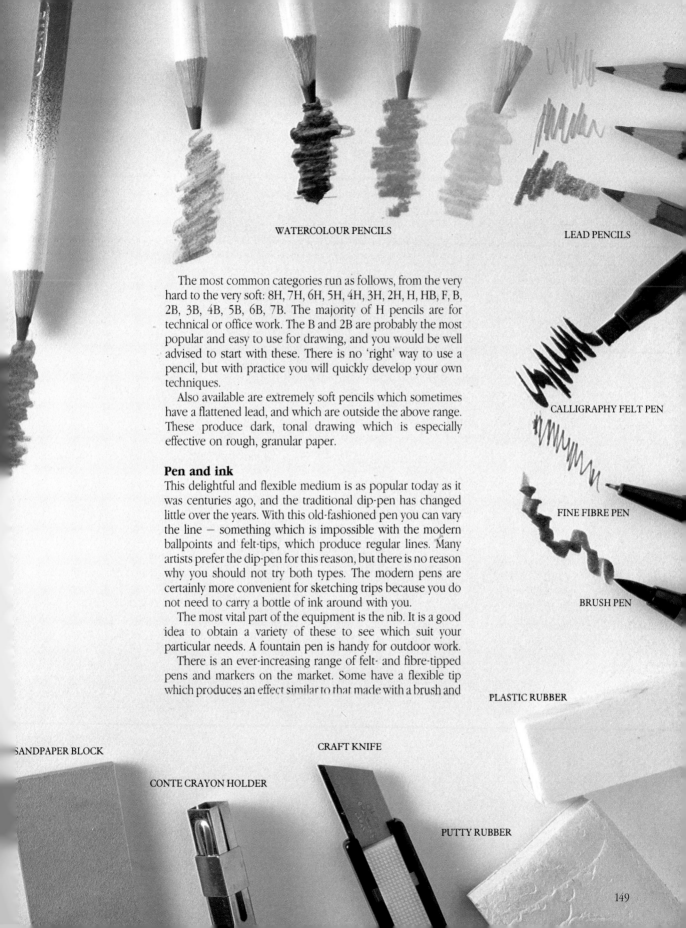

WATERCOLOUR PENCILS

LEAD PENCILS

The most common categories run as follows, from the very hard to the very soft: 8H, 7H, 6H, 5H, 4H, 3H, 2H, H, HB, F, B, 2B, 3B, 4B, 5B, 6B, 7B. The majority of H pencils are for technical or office work. The B and 2B are probably the most popular and easy to use for drawing, and you would be well advised to start with these. There is no 'right' way to use a pencil, but with practice you will quickly develop your own techniques.

Also available are extremely soft pencils which sometimes have a flattened lead, and which are outside the above range. These produce dark, tonal drawing which is especially effective on rough, granular paper.

Pen and ink

This delightful and flexible medium is as popular today as it was centuries ago, and the traditional dip-pen has changed little over the years. With this old-fashioned pen you can vary the line — something which is impossible with the modern ballpoints and felt-tips, which produce regular lines. Many artists prefer the dip-pen for this reason, but there is no reason why you should not try both types. The modern pens are certainly more convenient for sketching trips because you do not need to carry a bottle of ink around with you.

The most vital part of the equipment is the nib. It is a good idea to obtain a variety of these to see which suit your particular needs. A fountain pen is handy for outdoor work.

There is an ever-increasing range of felt- and fibre-tipped pens and markers on the market. Some have a flexible tip which produces an effect similar to that made with a brush and

CALLIGRAPHY FELT PEN

FINE FIBRE PEN

BRUSH PEN

PLASTIC RUBBER

SANDPAPER BLOCK

CRAFT KNIFE

CONTE CRAYON HOLDER

PUTTY RUBBER

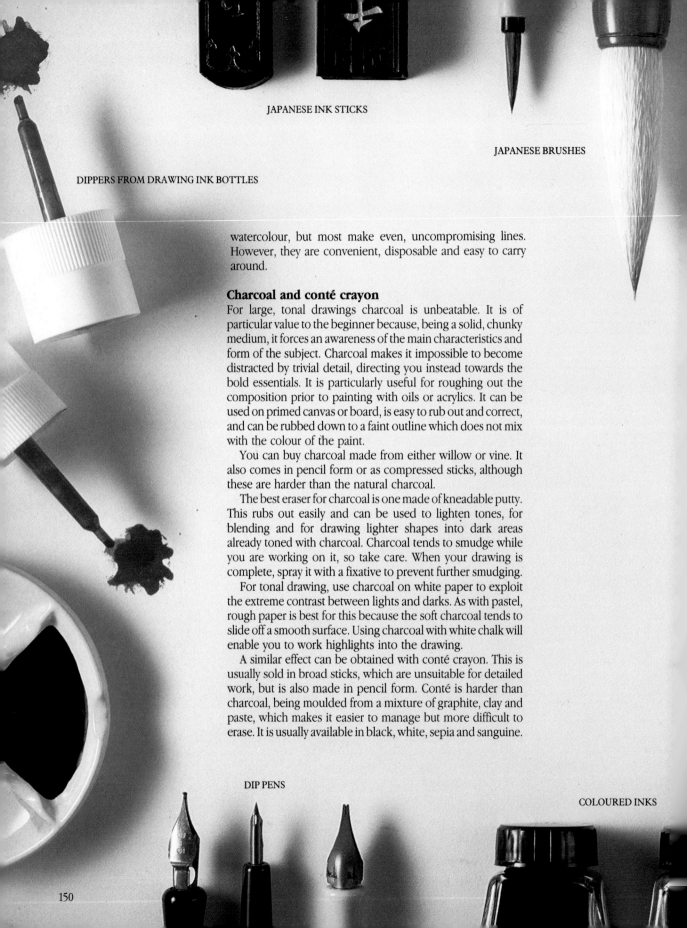

watercolour, but most make even, uncompromising lines. However, they are convenient, disposable and easy to carry around.

Charcoal and conté crayon

For large, tonal drawings charcoal is unbeatable. It is of particular value to the beginner because, being a solid, chunky medium, it forces an awareness of the main characteristics and form of the subject. Charcoal makes it impossible to become distracted by trivial detail, directing you instead towards the bold essentials. It is particularly useful for roughing out the composition prior to painting with oils or acrylics. It can be used on primed canvas or board, is easy to rub out and correct, and can be rubbed down to a faint outline which does not mix with the colour of the paint.

You can buy charcoal made from either willow or vine. It also comes in pencil form or as compressed sticks, although these are harder than the natural charcoal.

The best eraser for charcoal is one made of kneadable putty. This rubs out easily and can be used to lighten tones, for blending and for drawing lighter shapes into dark areas already toned with charcoal. Charcoal tends to smudge while you are working on it, so take care. When your drawing is complete, spray it with a fixative to prevent further smudging.

For tonal drawing, use charcoal on white paper to exploit the extreme contrast between lights and darks. As with pastel, rough paper is best for this because the soft charcoal tends to slide off a smooth surface. Using charcoal with white chalk will enable you to work highlights into the drawing.

A similar effect can be obtained with conté crayon. This is usually sold in broad sticks, which are unsuitable for detailed work, but is also made in pencil form. Conté is harder than charcoal, being moulded from a mixture of graphite, clay and paste, which makes it easier to manage but more difficult to erase. It is usually available in black, white, sepia and sanguine.

NIB UNITS FROM
ROTRING RAPIDOGRAPHS

SMALL SYNTHETIC ROUND

COLOURED PAPERS

SYNTHETIC FLAT

Coloured pencils

Coloured pencils are a very useful sketching and drawing tool, producing a compromise between a lead line-drawing and a painted image. Although their range is more limited than oil, acrylic or watercolour, new sets are coming on to the market all the time, and they are now an established artists' material.

Coloured pencils are softer than lead pencils, but are more difficult to rub out. Mistakes usually have to be scraped off the paper with a sharp blade. Colours cannot be pre-mixed as with paints, but you can mix them 'optically' on the paper by lightly overlaying different colours to obtain a rich range of combined colours and hues.

Watercolour pencils

Watercolour pencils are a comparatively new medium which is available in an increasingly wide range. These are a cross between coloured pencils and watercolour paints. Apply them in the normal way, then use a fine sable brush dipped in clean water to blend the colours together, thus creating the effect of watercolour. This is a surprisingly flexible medium, allowing you to produce tightly controlled work with well-sharpened pencils and a fine sable brush or, alternatively, to create textural areas of spontaneous pencil marks and loose washes.

Rapidographs

Rapidographs have a tubular nib and are specially designed for creating lines of an even thickness. They are particularly good for drawing which involves shading with hatching and cross-hatching. Many artists feel that this is a rather unsympathetic medium, but the success of Rapidograph drawing depends very much on the style and attitude of the artist using it.

WATERCOLOUR
PAPERS

SKETCHING NIBS FROM FOUNTAING PENS

CARTRIDGE PAPER

A White-haired Gentleman

This drawing of a man with a crisp, executive look has been done in coloured and ordinary graphite pencils. The artist worked from a small photograph, beginning with a light preliminary sketch in which he mapped out some outlines of the major tonal areas.

The artist moved straight to the flesh tones of the face, first blocking in the shaded side with brown. Then he worked slowly across the features, developing each one in some detail and working back to blend each new colour into some of those already established. The image was allowed to grow without too much planning or thought, this artist being very experienced in the highly graphic, instant approach. Many artists would find it quite difficult to work across an image in this way, and the less experienced would be advised to pay more attention to the overall related tones in the initial stages, possibly switching from one area to another, bringing the tones up together in relation to each other, and adjusting as the work progressed.

However, if you wish to preserve the crisp clarity of coloured pencils, it is necessary to know when to stop. Two or three layers of lightly hatched colour will blend happily to produce a new colour; but the result can look grey, shiny and clogged if this is overdone. In this portrait, the artist solved this problem by developing each area separately, returning only for very minor adjustments.

The subject's white hair was established by leaving the surface of the white paper to show through. Its shape was defined by the pale blue-grey background which was more densely cross hatched around the outline of the hair. The same cross-hatched background was used to define the sharp edge of the white shirt and the light side of the man's face.

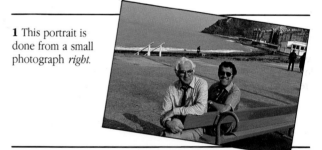

1 This portrait is done from a small photograph *right*.

2 The artist starts by making a very light preliminary sketch, establishing outlines as well as defining major tonal areas. Because the reference is tiny, the artist occasionally finds it necessary to draw from experience and memory in order to make the drawing as tight as possible. When the drawing is complete, colour is added an area at a time *right*. Yellow, brown, red and black are used for the initial flesh tones around the eye.

3 Cool hair shadows are added in blue *above*. The artist uses a well-sharpened pencil, working in regular hatched strokes to create darker tones.

4 Overlaid patches of blue are laid to build up the dense, dark colour of the man's tie *right*. Shadows on the neck and around the eyes are darkened to accommodate this.

OVERLAYING COLOUR

You can obtain any colour you need with coloured pencils by blending two or more colours together. Apply the first colour in light regular strokes, keeping the colour as even as possible — if the pencil is used too heavily other colours cannot be laid on top. Lay the second colour in the same way, taking the pencil strokes in the opposite direction. If you use too many colours, the translucent quality of the blended colour will be spoilt. The top colour will usually be the dominant one. For instance, if you lay red over blue, the result will be a reddish purple or maroon, whereas blue on top of red will produce a blue-purple.

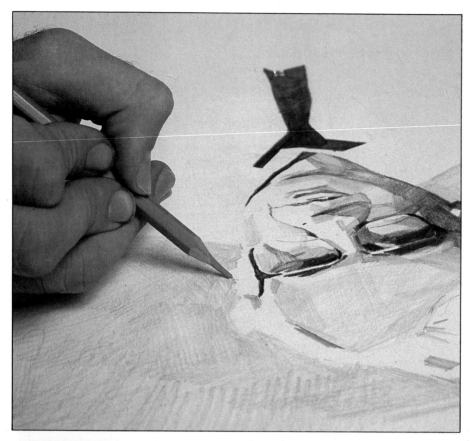

5 The artist blocks in the background with light grey, applying colour in a series of cross-hatched areas of irregular tone *left*. The artist does not create deeper tones by pressing harder — instead he uses a light, even stroke, darkening the colour by building up extra layers of hatching and cross-hatching.

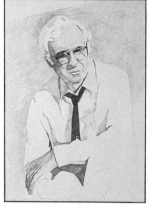

6 White areas are represented by the whiteness of the paper. Here, the artist has taken the grey background up the edge of the white hair and shirt, carefully preserving the outlines and defining them as negative shapes *above*.

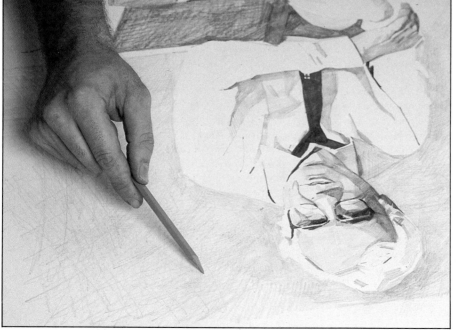

7 The artist develops the background, adding blue to pick out the blue tones in the figure *left*. The side of the pencil is used here to soften the cross-hatching and to cover the area more quickly.

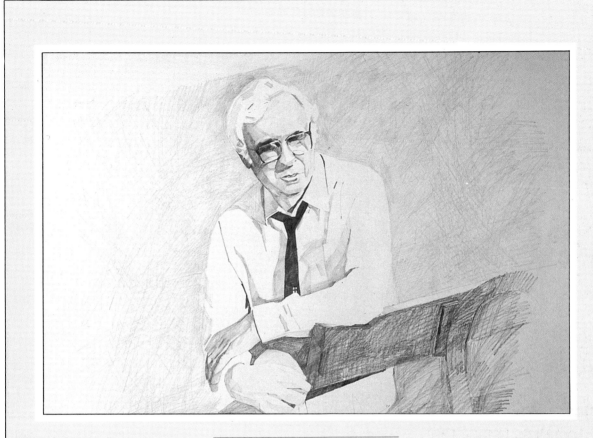

A White-haired Gentleman

What the artist used

For this coloured pencil drawing, the artist worked on a sheet of cartridge paper measuring 76.5cm×51cm (30in×20in). The colours selected were brown, red, yellow, black, dark blue, light blue and light grey. Other colours were mixed 'optically' from this basic set by careful overlaying (for example, red and brown are combined in some of the facial shadows to produce a warm mahogany tone). A scalpel was kept to hand, and the pencils were frequently sharpened throughout to maintain the fine cross-hatching and delicate lines.

Maurice

Rapidograph, which has been used for this portrait, can be a very unrelenting medium. The line produced is of a consistent, even thickness; it is impossible to achieve the natural undulating movement of a brush or pen-and-ink line. However, here the artist has used Rapidograph in conjunction with the more sympathetic effect of a soft Chinese brush. The advantages of the Rapidograph are that you do not have to keep stopping to refill it, there is a wide choice of nibs, and once mastered, it is more flexible than it immediately appears. The artist sketched out the basic outline with the Rapidograph's even line, but then varied this by keeping the drawing loose and by working over areas to produce different textures and a sense of liveliness. The drawing has been kept very rounded and flowing.

The artist did not just draw the outline and then change to the brush, but used the two tools alternately, blending some areas of the drawing with water and thin colour as the work progressed. Ordinary sepia fountain-pen ink was used for this. In some cases, lines were altered after being placed on the paper — a technique which many people do not realize is possible when using pens. There are two kinds of ink — waterproof and water-soluble — and the artist used the soluble kind, which meant that lines could be practically rubbed out with water after being applied, and even after they dried. This gave a flexibility to the process. In cases where lines did not totally disappear, as on Maurice's corrected collar, the presence of a new, redrawn line knocked the original line back sufficiently for it not to be noticed. At one stage, the artist changed the position of the eyebrow by dissolving the original line with water applied with the brush.

Although this artist used ordinary ink, this is not generally advisable when working with Rapidographs. Specially prepared inks can be obtained for the fine tubular nibs. These inks contain a solvent which prevents the ink from drying and clogging the tube, sometimes rendering the Rapidograph impossible to clean.

2 To soften the effect of the regular Rapidograph line, the artist works on slightly damp paper *above*. This causes the ink to bleed slightly, producing a runny, irregular line.

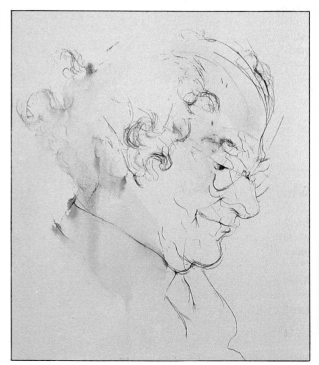

1 The amiable expression on the man's face, *right*, was captured in a quick sepia ink sketch using a Chinese brush and Rapidograph pen.

CHINESE BRUSHES

Chinese brushes are softer than ordinary watercolour brushes. They have fine hairs and are useful for soft, irregular washes and creating delicate flecks of colour. Here the artist uses the brush with water to soften the hard Rapidograph lines and to create a wash with the released sepia colour.

3 The artist drags a wet Chinese brush across the neck and hair lines, *left*, blurring the outline, and causing those areas to recede. This emphasizes the sharpness of the facial features, and creates a sense of form and depth in the drawing.

4 As the drawing develops, the artist strives to maintain a balance between the crisp precision of the Rapidograph drawing and the soft wash effects of the brushwork *left*.

What the artist used

For this portrait the artist worked on cartridge paper measuring 46cm×32cm (18in×13in) with a Rapidograph pen and sepia ink. She used a Chinese brush to soften the lines.

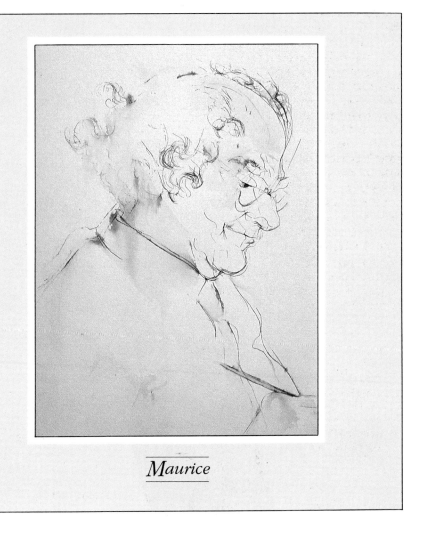

Maurice

John in Black and White

When working in black and white it is often helpful to choose a medium-coloured support. This enables you to start working in both black and white from the start, as both will register equally clearly against the middle tone. This portrait has been done in black and white chalk. The artist, who usually works in watercolour on a small scale, enjoyed this opportunity to experiment in a bold way in a different medium.

She worked very quickly, straight on the paper, chalking loosely and trying to familiarize herself with the appearance of the model. Straight away she began to block in the large contrasting areas of tone, starting with a very broad white approximation of the position of the model's face, and building on the image in both black and white, creating space and a three-dimensional form. She took advantage of the dense opaque quality which chalk has when used boldly, laying in large areas without worrying about whether she was making mistakes, but going ahead and adjusting as she worked.

The tonal planes of the face are rubbed together to blend the contrasting blacks and whites into the soft, rounded contours of the human features. Because she was working on a large scale she found it necessary to use her whole hand to blend the areas to obtain this softer grey, medium tone.

One advantage of working with chalks is that lines and tones can be easily changed as you work, so the artist was able to let herself go, confident that no statement was irreversible. She was able to work instinctively, but once the very loose basics were established her drawing became more disciplined and controlled. Details of the face were applied using a combination of finer lines and broad strokes.

Chalk drawings must be fixed, because the loose powder is easily rubbed off the surface of the paper, blurring the image. In this picture the artist not only fixed the final image, she also used a light spray of fixative over the earlier stages of the work, preparing it for finishing touches. If you do use fixative in this way, before the work is finished, it must be extra light — fixative is actually a varnish and the chalk will slide over a very hard surface.

2 Working on a large sheet of blue tinted paper, the artist immediately starts to block in some of the main areas of dark and light *above*.

1 There is no significant colour in the subject *right*. For the artist, the interest lies in the tones — the arrangement of lights and darks.

3 The edge of the chalk is used to block in large areas quickly *right*. Bold wedges of black and white are quickly established in this way.

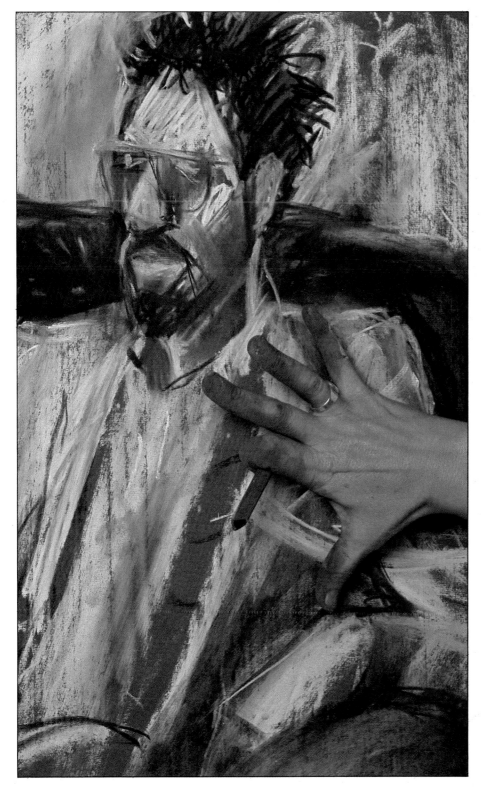

4 The artist uses her hands to blend large areas as she works *left*. Blending is used to strengthen the image and to obliterate some of the blue paper which shows through and weakens the image. The portrait is essentially sketchy and spontaneous, and no attempt is made to refine or change the character of the strong textural chalk marks.

BLENDING

Like pastel, chalk and charcoal can be blended by rubbing the two together or by laying one over the other. Here the artist uses the side of the stick to apply black over white to create a broad area of middle tone. In the second picture she uses her fingers to blend the black and white into a smooth grey. A soft putty rubber can also be used to rub back areas of chalk or charcoal to reveal the support colour underneath.

5 Although small areas of blue paper can be seen, the drawing is emphatically black and white. The artist used the tone of the paper as a starting point only, relating the initial strokes of light and dark to this convenient middle tone. In the picture so far, *right*, we see how these sharply contrasting tones have taken over. The direction of the chalk strokes on the solid tonal blocks describes the form of the figure; graphic black and white shapes dominate the composition.

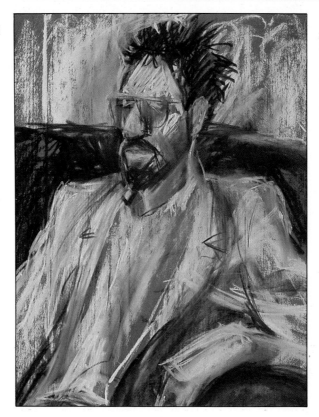

6 To preserve the sharp tonal contrasts and to prevent smudging the artist sprays the finished drawing with fixative *above*. Holding the can about 30cm (a foot) away from the paper, she sprays from side to side, gradually moving downwards, until the whole support is covered.

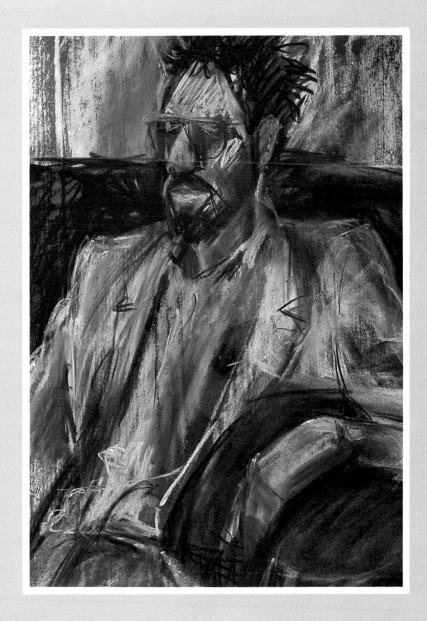

John in Black and White

What the artist used

The artist used black and white chalk on a sheet of blue Ingres paper measuring 61cm×46cm (24in×18in). By using tinted paper the artist was able to use black and white immediately to establish the light and dark tones of the portrait. She used a drawing board supported on a Rowney Norwich easel. The completed drawing was given a coat of spray fixative.

Woman in Red and White Chair

The artist has drawn surrounding elements into this picture, making the portrait an elegant and individual interpretation of the subject. The wrought-iron table with its distinctive twining shapes adds a formality to this coloured-pencil portrait, as well as breaking major rules about composition and getting away with it. For instance, the composition is divided vertically into two equal halves by the background division. It is also split horizontally by the line of the table top. However, within this unlikely symmetrical system, a harmonious composition has been created. The flowing lines and curves of the subject and the chair are so dominant and so very different from the uncompromising composition grid that they offset any uncomfortable rigidity. Colour also plays a role in the composition. The red chair and the red clothing are the only strong colours in the picture, and this focuses the eye on the soft, easy contours of both the figure and the chair.

A very simple light pencil drawing acted as a minimal guide for colour and stronger contrasting tones. This artist often starts with the head when working in portraiture, because this is the main feature and he prefers to establish this early on in the process. He developed a considerable amount of detail in the head and hands by laying one colour over another. He applied a main colour and then modified this by a light top layer of a second tone. On the face, for instance, he laid down a local colour of flesh pink, working a thin layer of brown over this to produce a deeper tone of the local colour. In this way he achieved something of the transparency of the glazing process used in oils or acrylic.

The artist drew in the red skirt using loose strokes, building up the darker shadow areas by overlaying the same colour to obtain a denser tone. Again, brown pencil was used to create the darkest tones of the folds. The stripes on the chair were drawn freely, their position judged by eye, carefully following the form of the chair, rather than by any method of mechanical measurement.

1 The artist liked this arrangement of the woman sitting in the striped chair at the table, *right*.

2 Working on white cartridge paper, the artist starts by making a light line drawing with an F pencil (this preliminary drawing is very accurate, leaving the artist free to concentrate on colour and tone). The hair is blocked in with black, the denseness of the cross-hatching determining the depth of tone and helping to establish form. Black and brown are combined to establish the shadows around the eyes *right*.

3 Flesh tones are built up from brown, yellow ochre and grey. The artist blends pencil colours by carefully cross-hatching one colour over another. At this stage, the background is blocked in with pale grey *left*. This is done with a combination of tight cross-hatching and loose scribbling, giving textural variation to the large background expanse.

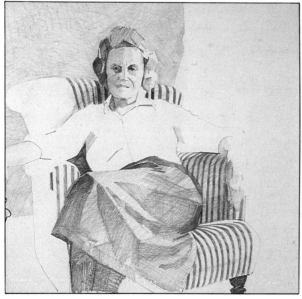

4 The artist puts in the red skirt, building up layers of cross-hatching to create the dense colour of the shadows and folds in the material. Very dark shadows are overhatched with brown *above*.

5 Here, *right*, the artist draws the red stripes of the chair in crimson red. The stripes, filled in with neat directional pencil strokes, describe the curved form of the chair. Highlights are indicated by lighter colour.

HATCHING AND CROSS-HATCHING

Depth and areas of dark tone can be created by hatching and cross-hatching. Apply the pencil in neat, directional strokes (hatching), and build up the tone with strokes overlaid in the opposite direction (cross-hatching). Here the artist is using several layers of black to build up the deep shadows and the irregular, recessed shapes of the subject's hair.

Keep the pencils well sharpened and apply each layer systematically to give yourself maximum control over the texture and depth of tone.

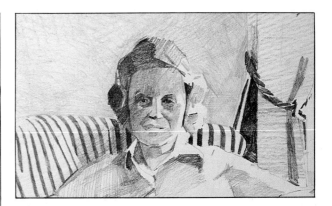

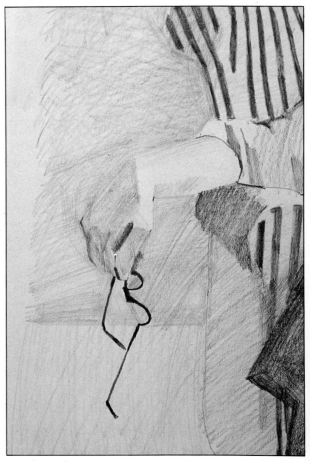

6 Background details are added with as much precision as the main subject. The warm red tones of the face and lips are emphasized by the strong red stripes of the same colour *top*.

7 The artist uses the direction of the pencil strokes to describe form. Notice how the strokes on the arm, hand and chair follow the contours *above*.

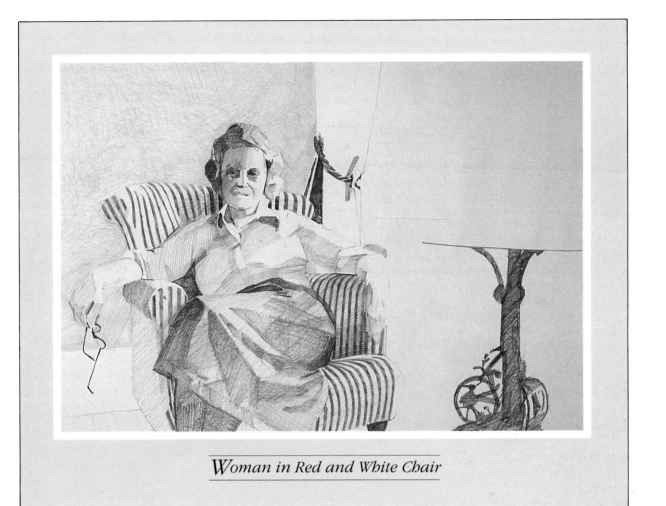

Woman in Red and White Chair

What the artist used

The support for this portrait drawing was a sheet of white cartridge paper measuring approximately 56cm×46cm (22in×18in). White paper was chosen because the artist wanted to use this to regulate the tones of the drawing — for instance, to create pink, it is possible to hatch well-spaced red lines, with the width of the white spaces between them determining the tone of the final colour. He also used the white paper to represent highlights. The basic colours were black, grey, red, crimson, yellow, burnt sienna and brown. A preliminary drawing was done with an F pencil, and the coloured pencils were sharpened with a scalpel.

Sunlit Face

The face basks in sunlight, and the artist has set out to capture it – both in mood and in visual tones of light – in a pen and-ink portrait. The direct playing of the light on the face gives the artist the opportunity to indicate this by means of strongly contrasting areas of light and shade.

The support for this portrait was white cartridge paper, and therefore light could be depicted in 'negative' fashion, by leaving areas of the white paper untouched. The artist in fact was observing light by drawing shade, an ideal task for pen and ink. But this is not so simple as it may sound, for the areas of shade vary delicately from light to dark, established in this case by grading the density of the inked lines and dots.

Working directly on an expanse of white can seem daunting, but the artist here used a light pencil outline as a guide, concentrating on the profile of the head. This outline was to be used only as a reference, showing where shadow and highlighted areas were to be developed.

The artist moved the pen vigorously, producing lively strokes and avoiding the stiffness which can sometimes result from pen and ink. Making initial use of the pencil guide, the artist hatched a dark tone on one side of the head to throw the profile into relief. Notice that the artist resisted the temptation to mark out the complete profile, leaving blank space between the bottom of the nose and the mouth, and the chin below the mouth. These features were to be brought clearly into silhouette later by hatching in background areas of shadow. Next the artist created an immediate feeling of mood by some touches of the pen which established the relaxed positions of the eye and mouth. Again, more detail was to be worked into these parts later.

Using fine parallel lines slanted across the paper, the artist next developed shadows inside the shape of the head and then worked outwards into the background in the same way. Some areas were cross-hatched to darken them, and gradually the image spread across the whole paper.

Stippling with the nib of the pen was used in the final stages to add detail to the texture and shadow in the face. The effect of strong sunlight was maintained by developing a high contrast of light and dark down the face and body. It was important to keep this in mind from the start, and to avoid overdoing the pen-work which would otherwise have produced a greyer effect and the 'sunlit' look would have been lost.

1 A well-lit profile, *right*, can capture characteristics as successfully as the more traditional full-faced and three-quarters portrait angles.

STIPPLING

Fine shadows and texture can be created by stippling with pen and ink. Here the artist develops the facial shading with a series of tiny dots, varying the density of these to create lighter or darker shadows. The dots are used to complement the more formal cross-hatched shading, creating a marked difference between the soft, irregular texture and contours of the face and the larger, angular tonal areas elsewhere in the composition.

 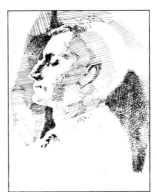 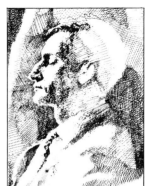

Above, left to right. A dark tone is hatched down the side of the head, throwing the profile into relief. Then the facial shadows and background are developed with fine diagonal lines – white paper is left to represent the bright highlights. In the next picture, working across the whole drawing, the artist works into the shadows, developing these in relation to each other. Finally, the background tones are expanded to cover more of the paper. Head and clothes are developed with small, detailed patterns.

What the artist used

A dip pen with a medium nib was used for this pen and ink portrait. The artist worked on white cartridge paper measuring 25cm×29cm (10in×11¹/₂in) with black waterproof Indian ink.

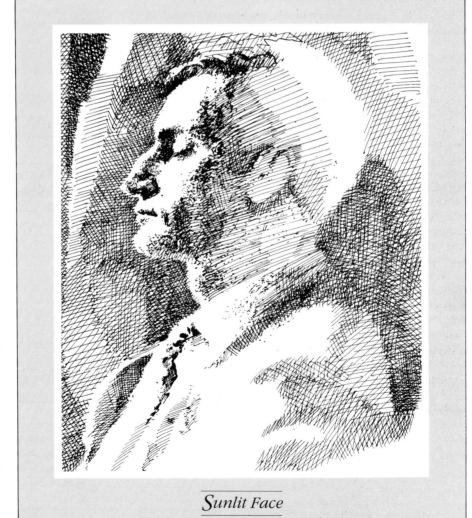

Sunlit Face

The Chinese Gown

This portrait is almost a monochrome study in black and white, except for the Naples yellow of the skin and background, yet its most immediate impact on the viewer is made by the colourful pattern of the Chinese gown. This has been established by working in comparatively small blocks of local colour. The starkness of the basic colour scheme gives the picture a stylized look, almost like a printed illustration which has been reproduced in a restricted number of colours. It is not unlike a fashion illustration. This feeling is strengthend by the background, which consists of a stylish vase of flowers which the artist has included in a very basic, almost symbolic form.

The skin tones here have been unusually observed, and local colour is important. The shadows are predominantly in grey and black with the highlights in pure white.

The drawing was done quickly. Time was limited, and the artist had to make rapid decisions about what information to record and what to discard. Colour is used simply and graphically in bold pure areas.

It is the black shape of the hair and gown which holds this composition together. These are established with confidence, the pencil strokes alone indicating the direction of the form. The hair, for instance, is built up by overlapping a mass of dark strokes and allowing the white paper to show through in areas affected by the light. Facial tones are described in more detail but still in the same emphatic directional strokes.

The artist began by making a basic drawing, using a dark-brown coloured pencil. This linear drawing was developed as the blocking-in progressed, and each area was quite firmly indicated in the early stages. Although the drawing is minimal, the line has a tautness and discipline which is the result of careful observation and accurate work.

The difference in surface textures of the drawing is suggested by a varied and creative use of hatching and cross-hatching. The background, for example, is established as an area of black cross-hatching over an undercolour of yellow. This light evenness contrasts with both the lively scribbled fabric of the gown and the smoothly rendered flesh tones.

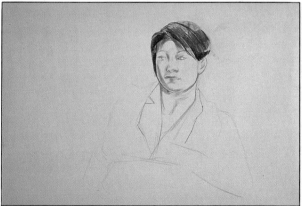

1 The model, leaning against the arm of a sofa, *right*, looks directly at the artist as she sketches her portrait.

2 Using a dark brown pencil, the artist starts by sketching in the composition and the position of the figure. Here, *top*, she draws in the head.

3 The face and features are established in light strokes of brown. Hair tones are blocked in with black *above*.

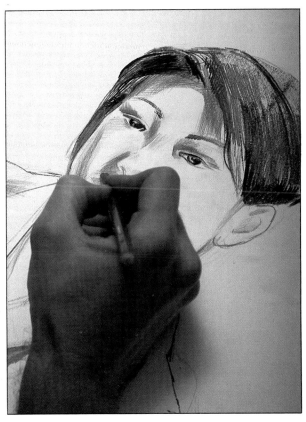

4 Hair is built up with overlapping masses of dark strokes, allowing white paper to show through in areas affected by light *left*. The artist works quickly and accurately, attempting to draw each line as a final statement, instead of anticipating subsequent change.

5 The smooth cartridge paper allows the pencil to glide smoothly over the surface *below*. Lack of texture on the paper surface is compensated for by the strong directional pencil strokes which the artist uses to block in areas of colour and tone.

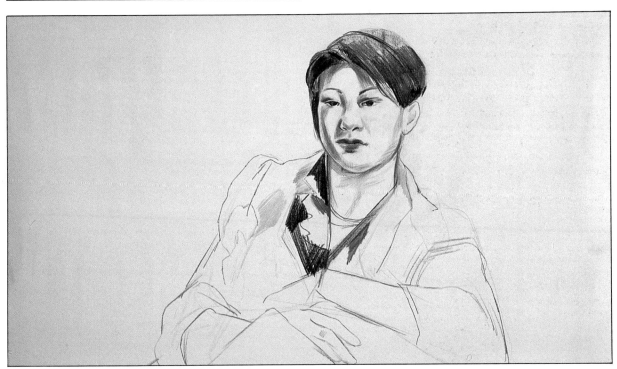

DIRECTIONAL PENCIL STROKES

The direction of the pencil strokes can play an important part in describing form. Because pencil is essentially a linear medium it can be difficult and time-consuming to suggest large forms through light and shade. Here the artist has carefully used the direction of the strokes to help indicate such form. The material on the gown is sketchily treated, but the loose drawing follows the direction of the folds of the garment to show the underlying forms of the subject's arms, shoulders and chest. The hair is not treated as a solid shape, but is built up from lines of colour which follow the fall of the strands of hair.

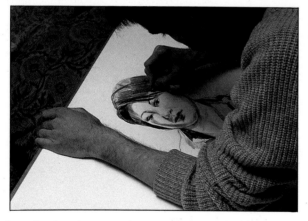

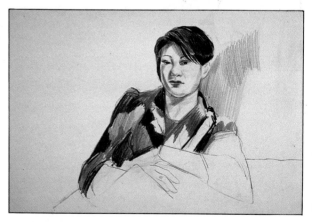

6 Fine hatching brings out the modelling on the face *above*. Apart from the local flesh tint there is no actual colour in the face. Shading is restricted to grey and black; highlights are represented by white paper.

7 The patterned dressing gown is heavily blocked in with bold colours *above*. In order to cover this comparatively large area, the artist works quickly with broad directional pencil strokes.

The Chinese Gown

What the artist used

This rapid coloured pencil portrait was sketched on a sheet of white cartridge paper measuring 38cm×51cm (15in×20in). The artist used a selection of colours, including black, dark grey, yellow, red, dark blue, light blue, brown, violet and bright green. Coloured pencils form a compromise between a lead line drawing and a coloured painting. Their colour range is more restricted than oils, acrylics or gouache, but new sets with an increasingly wide choice of colours are appearing continually, and are gaining in popularity. Although the colours cannot be pre-mixed, as with paints, they can be mixed 'optically' on the paper by overlaying different colours to obtain a wide range of colours.

Glossary

ABSTRACT Relying on colour and form rather than the realistic or naturalistic portrayal of subject matter.

ABSTRACTION The creation of an abstract image from a subject or other figurative reference.

ACRYLIC A comparatively new paint in which the pigment is suspended in a synthetic resin. It is quick-drying, permanent and colourfast.

ADVANCING COLOURS Colours which appear to stand out, because they are brighter, stronger or denser than their neighbours.

AERIAL PERSPECTIVE The use of colour and tone to denote space and distance.

ALLA PRIMA Direct painting in which the picture is completed in one session without any underpainting or underdrawing.

BINDER Any liquid medium which forms a paint when mixed with powder pigment.

BLENDING Merging colours together in such a way that the joins are imperceptible.

BLOCKING-IN The initial stage of a painting when the main forms and composition are laid down in approximate areas of colour and tone.

BROKEN COLOUR Paint applied in its pure state rather than being mixed. This stiff paint is usually applied by dragging the brush across the surface, allowing layers of colour underneath to show through.

CHIAROSCURO The exploitation of light and shadow within a painting. Both Caravaggio and Rembrandt were masters of the technique.

COLLAGE A picture made up from pieces of paper, fabric and other materials stuck onto canvas, paper or some other support.

COMPOSITION The arrangement and combination of different elements to make a picture.

COMPLEMENTARY COLOURS Colours which appear opposite each other in the colour circle. Hence, purple is complementary to yellow, green to red, and orange to blue.

COVERING POWER This refers to the opacity of a paint — its ability to obliterate the colour underneath.

CROSS-HATCHING A method of building up areas of shadow with layers of criss-cross lines rather than with solid tone.

FIXATIVE Thin varnish which is sprayed on drawing media, especially charcoal and pastel, to prevent smudging and to protect the surface.

FRESCO A wall-painting usually done with watercolour on damp plaster.

GLAZING Painting a transparent film of colour over another pigment.

GROUND A ground is painted onto a surface to make the surface suitable for painting on. With oil painting for instance, the ground is usually gesso or an oil-based mixture.

GUM ARABIC Used with watercolour and inks to give body and sheen. Obtained from a species of acacia.

GUM WATER A solution of gum arabic used with inks and watercolours to provide extra sheen and body.

HATCHING A shading technique which uses parallel lines instead of solid tones to build up form.

HUE A tint or shade.

IMPASTO The thick application of paint or pastel to the picture surface in order to create texture.

LEAN A term used to describe oil colour which has little or no added oil. The term 'fat over lean' refers to the traditional method of using 'lean' colour (paint thinned with turpentine or spirits) in the early stages of a painting and working over this with 'fat', or oil paint, as the painting progresses.

LINEAR PERSPECTIVE A system for drawing space and objects in space on a two-dimensional surface. It is based on the fact that parallel lines going in any one direction appear to meet at a point on the horizon. This point is referred to as the vanishing point.

LOCAL COLOUR The actual colour of the surface of an object without modification by light, shade or distance.

MASK A device used to prevent paint or any other medium from affecting the picture surface in order to retain the colour of the support or the existing paint in a particular area.

MASKING The principle of blocking out areas of a painting to retain the colour of the support. This is usually done with tape or masking fluid, and leaves the artist free to paint over the masked areas. The masks are removed when the paint is dry to reveal the areas underneath.

MASKING FLUID A rubber solution which is painted onto a picture surface to retain the colour of the paper or support. When the solution is dry, the artist can paint safely over the masked areas. The mask is removed by rubbing it with an eraser or finger.

MEDIUM In a general sense the medium is the type of material used, such as oil paint or charcoal. More specifically, a medium is a substance mixed with paint or pigment for a particular purpose or to obtain a certain effect.

MIXED MEDIA The technique of using two or more established media, such as ink and gouache, in the same picture.

MONOCHROME A painting done using black, white and one other colour.

NEGATIVE SPACE The space around the subject rather than the subject itself.

OPACITY The ability of a pigment to cover and obscure the surface or colour to which it is applied.

OPTICAL MIXING Mixing colour in the painting rather than on the palette. For example, using dabs of red and yellow to give the illusion of orange rather than applying a pre-mixed orange.

PICTURE PLANE That area of a picture which lies directly behind the frame and separates the viewer's world from that of the picture.

PLANES The surface areas of the subject which can be seen in terms of light and shade.

PRIMARY COLOURS In painting these are red, blue and yellow. They cannot be obtained from any other colours.

PRIMER The first coat on the support over which other layers — including the ground — are laid.

RENAISSANCE The cultural revival of classical ideals which took place in the fifteenth and sixteenth centuries.

RENDER To draw or reproduce an image.

SATURATED COLOUR Colour with a high degree of purity. The degree of saturation is assessed by comparing it with a colourless area of equal brightness.

SIZE A gelatinous solution such as rabbit skin glue which is used to prepare the surface of the canvas or board ready for priming or painting.

STENCIL A piece of card or other material out of which patterns have been cut. The pattern or motif is made by painting through the hole.

STIPPLE Painting, drawing or engraving using dots instead of line or flat colour. A special brush is available for stippling paint.

SUPPORT A surface for painting or drawing on, usually canvas, board or paper.

TORCHON A stump used for blending charcoal and pastel. This is often made of rolled paper or chamois.

UNDERDRAWING A preliminary drawing for a painting, often done in pencil, charcoal or paint.

UNDERPAINTING The preliminary blocking-in of the basic colours, the structure of a painting and its tonal values.

WASH An application of ink or watercolour, diluted to make the colour spread transparently and evenly.

WET-INTO-DRY The application of paint to a completely dry surface causing the sharp overlapping shapes to create the impression of structured form.

WET-INTO-WET The application of paint to a surface which is still wet to create a subtle blending of colour.

Index

Credits

Quarto would like to thank all those who have helped in the preparation of this book. We would like to thank all the artists, with special thanks to Daler-Rowney for their patience and generosity in donating materials and items of equipment.

Contributing artists
p *20*, Maurice Wilson; pp *20-23, 33* (*left* and *bottom left*) Stan Smith; pp *80-83*, Gordon Bennett; pp *130-133*, Margaret Clarke; pp *120-123, 168-171*, John Devane; pp *24* (*top right*), *100-107, 116-119, 124-125, 134-141*, Elaine Mills; pp *24* (*top left* and *bottom right*), *52-55, 56-59, 64-65, 70-79, 90-93, 108-111, 146-147, 152-155, 162-165*, Ian Sidaway; pp *40-41, 46-51, 60-63*, Wendy Shrimpton; pp *24* (*bottom right*), *112-115, 156-157*, Jane Wisner; pp *94-95, 142-145*, Marc Winer

Other illustrations
p *6* National Gallery of Scotland (Sutherland loan); p *8* Courtesy of the Trustees, Courtauld Institute Galleries, London; p *9* (*above*) Courtesy of the Greater London Council as Trustees of the Iveagh Bequest, Kenwood; p *9* (*below*) Frans Halsmuseum, Haarlem, the Netherlands; p *35* The Trustees, the National Gallery, London; p *37* By permission of the National Museum of Wales; p *38* Reproduced by permission of the Trustees, the Wallace Collection, London; pp *42-45, 66-69, 96-99, 126-129, 148-151*, photography by David Burch.